MIGRATIONS

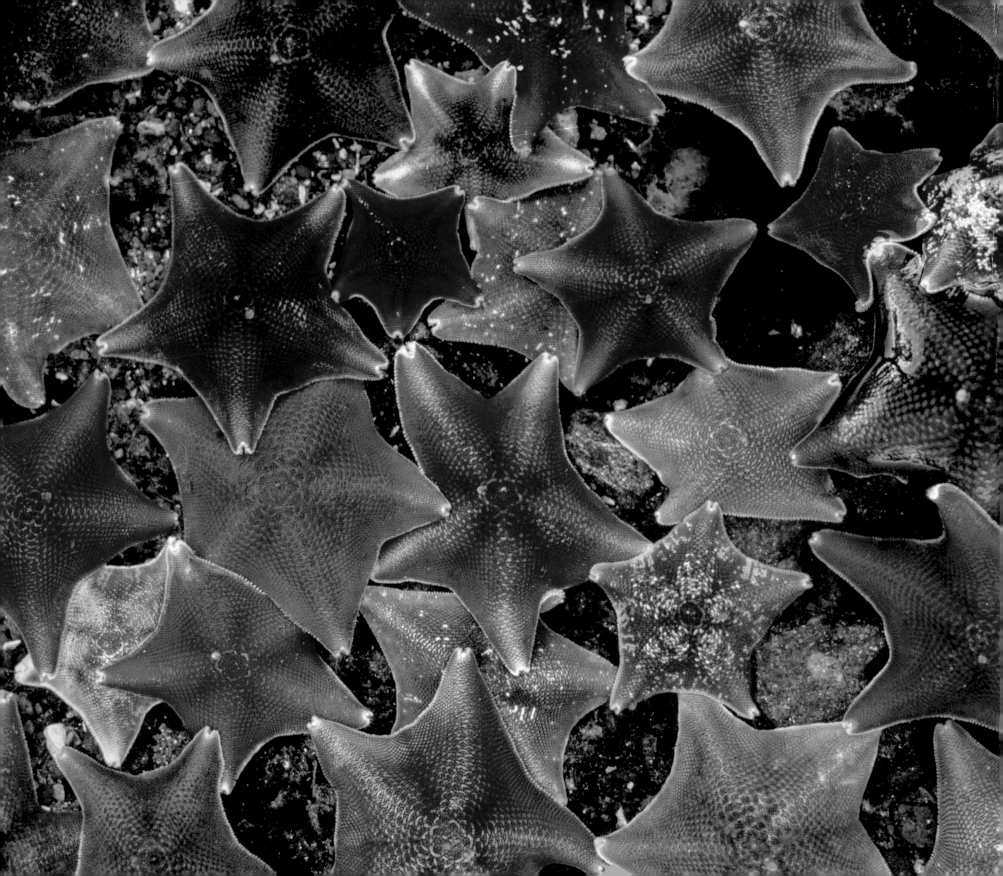

MIGRATIONS

Wildlife in Motion

Photographs by
ART WOLFE

Text by
BARBARA SLEEPER

EARTH AWARE
EDITIONS
San Rafael, California

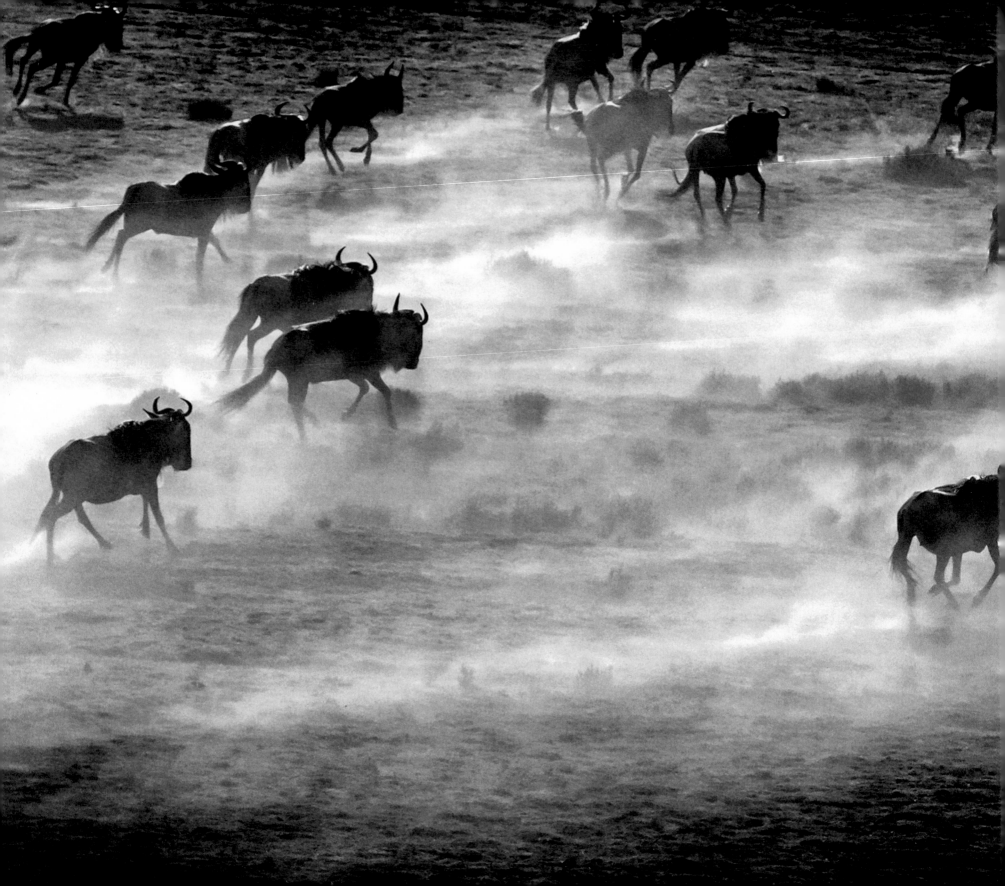

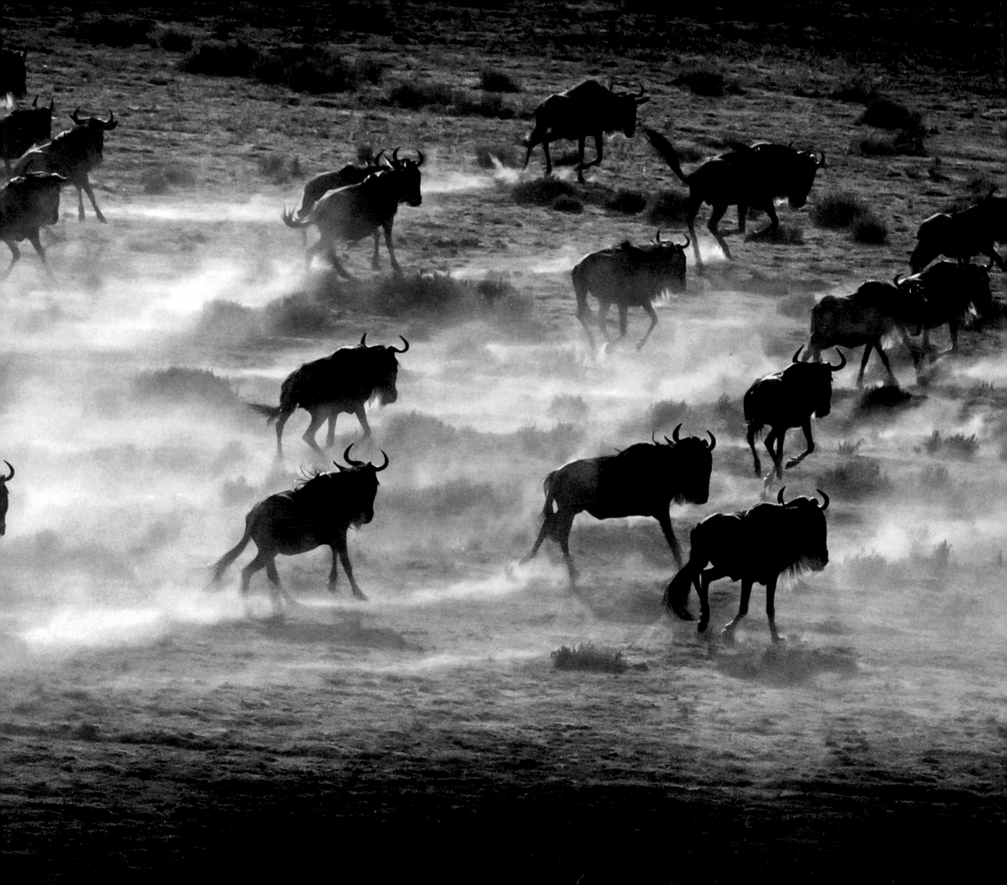

PREFACE

Some may remember the original *Migrations*, published in 1994. At that time a young printer named Raoul Goff worked on the project. Today Raoul is the publisher at Insight Editions, and together, we are very pleased to bring the theme and intent of *Migrations* to a new audience. This is not merely a reprint; instead it is very nearly a completely new work, featuring new images photographed with the latest technology.

Since my initial book publication in 1978—*Indian Baskets of the Pacific Northwest and Alaska*—I have photographed for dozens of books. Each has had a different theme. Each has stemmed from a different interest. For instance, my book on the owls of North America sprouted from an isolated experience when I photographed a young owl in a Seattle park. I was so taken with this owl and so excited at seeing it up close that, from then on, I was drawn toward owls as a camera subject. Over a nine-year period, I developed *Owls: Their Life and Behavior* (1990).

Light on the Land (1991) formed in much the same way. When I participated in the 1984 Ultima Thule Everest Expedition, my interest in landscape photography was heightened, and I was inspired to develop a project around this theme. On my diverse travels around the world, I began to document austere, dramatically lit landscapes. It took me eight years to gather the body of work for *Light on the Land*, and along the way I encountered conditions from the chaotic to the sublime.

Interestingly enough, *Migrations* began before either *Owls* or *Light on the Land*. When I was an art student at the University of Washington, I was exposed to the work of Maurits Cornelis Escher in design class. More than any other artist, M. C. Escher has influenced my work and the manner in which I perceive positive and negative space. Utilizing the motif of animals, he incorporated fish and birds, reptiles and insects into brilliant stylistic designs; the fluid transformation of organic forms is at once mesmerizing and soothing. I decided that if I could emulate Escher's mosaics through photographs, I would—regardless of the results.

Over the decades I have seen vast flocks of birds, thundering herds of animals, and fluttering swarms of insects, and I have photographed them in a multitude of ways. I have flown in helicopters, microlights, and airplanes, floated in boats and canoes, waded in murky caiman-infested waters, and snorkeled beneath the crystalline seas of the South Pacific—always with the intention of gaining a perspective on the pattern that was being created by the wildlife passing before me.

Of course, one of the best places to photograph large masses of animals is East Africa. What was true thirty years ago remains true today. In Kenya I first experienced the exhilaration and fear of photographing from a microlight with a young French pilot who had been commissioned by Amboseli National Park to do an aerial survey of the last unpoached rhinos within park boundaries. (Photographing from a microlight is ideal because the craft is infinitely more maneuverable than an airplane or a helicopter—and certainly quieter, making it much easier to approach a subject without disturbing it.) Over the course of the next three or four days, we flew over Amboseli, enabling me to photograph herds of African elephants and buffalo at a fairly low angle, as well as the flamingos on Lake Magadi. I have revisited the soda lakes of Kenya and Tanzania several times, purposefully striving for new compositions with better technology. The experience never gets old—the same hidden dangers exist now as they did thirty years ago. It can be very disorienting flying over the reflective lake, as height and distance become difficult to read.

It was not until I began photographing for *Migrations* in earnest years ago that I realized the extent of human penetration into the wildest places on Earth. It is simply impossible for terrestrial wildlife to avoid civilization. For example, there are only a few isolated areas in North America where species such as elk and caribou can roam free. There has been a concerted effort to preserve the last remaining areas of elk migration in Wyoming, and the remoteness of Alaska's North Slope has somewhat buffered the range of car-

ibou from the effects of humans, but these are the last remaining outposts. A great part of this book is comprised of images of birds, because, unlike large, land-bound animals, they are still able to follow their migratory routes. They have the distinct and obvious advantage of being able to fly over congested areas to reach their destinations. The rapidly diminishing habitat of all wildlife, which results in restricting both their numbers and their mobility, compelled me to document them before they are sealed into reserves. It is this freedom of movement that artistically paces the pages of *Migrations*.

In completing this work on *Migrations*, I have gained, more than anything else, a better understanding of how wildlife in its multitudes is at the mercy of humankind—how the fragile balance is torn between the urge for development and the need for conservation. I have witnessed a characteristic struggle in my own state of Washington, where a proposed airport expansion would have destroyed wetland habitat that supports a million migrating shorebirds annually. Fortunately, local environmental groups banded together and fought successfully for the preservation of this critical area. The list of similar stories is long. Seven caves in the Midwest support 85 percent of the known population of the tiny Indiana bat. Had this not been brought to light, these caves would have been opened up for exploration, and the bat would have been lost to mankind forever. In Antarctica I have seen entire rookeries of penguins obliterated by oil spilled from a grounded ship. Now entire populations of elephants, rhinos, and tigers are in danger because of uncontrolled poaching. We have both the power of destruction and conservation in our grasp—why do we as a species continually choose the former?

As an art book based on nature, the first edition of *Migrations* was a lightning rod for controversy when it was published in 1994, since I openly embraced digital technology to bridge the gap between artistic photography and nature photography. I wrote in the introduction: "Over the years, as I reviewed the material, I often had to pass over photographs because in a picture of masses of animals invariably one would be wandering in the wrong direction, thereby disrupting the pattern I was trying to achieve. Today the ability to digitally alter this disruption is at hand. For the first time in *Migrations*, I have embraced this technology, taking the art of the camera to its limits. Since this is an art book and not a treatise on natural history, I find the use of digitalization perfectly acceptable, and in a small percentage of the photographs I have enhanced the patterns of animals much as a painter would do on a canvas."

The most famous photo was the cover shot of migrating zebras. I pushed the boundaries as any artist should do and grew through the experience. Had I called the book *Wallpaper*, it probably would not have become as controversial as it did; but it's interesting to note that designers and art critics rallied around the book while some photographers condemned it. Certainly, within the bastion of nature photographers, there is the perception that photography is real and whatever you aim the camera at is a pure recording of reality. I have never maintained that. Just by framing a shot, the photographer is making a judgment call; by using a telephoto or a wide-angle lens, a photographer is compressing and distorting images. A photographer can change the color depending on the chosen film; now every RAW file goes through a series of adjustments in Photoshop or Lightroom just to make it a publishable photograph. The camera is a tool, and photography has always been a reflection of how the artist uses that tool. A master dodger and burner in the darkroom, Ansel Adams would have embraced digital technology had he been alive today. Now few people bat an eye at any of this.

Old and new, *Migrations* incorporates everything that is important in nature photography today. Visually stimulating, mentally engaging, it pulls the reader into a swirling vortex of movement and mass. As you look through the following pages, enjoy the magnificent spectacles of nature, but also pause to understand the delicate thread by which these large populations are dangling. Whenever a choice is presented to you to support a regional, national, or international conservation organization, please take the step for preservation.

—ART WOLFE

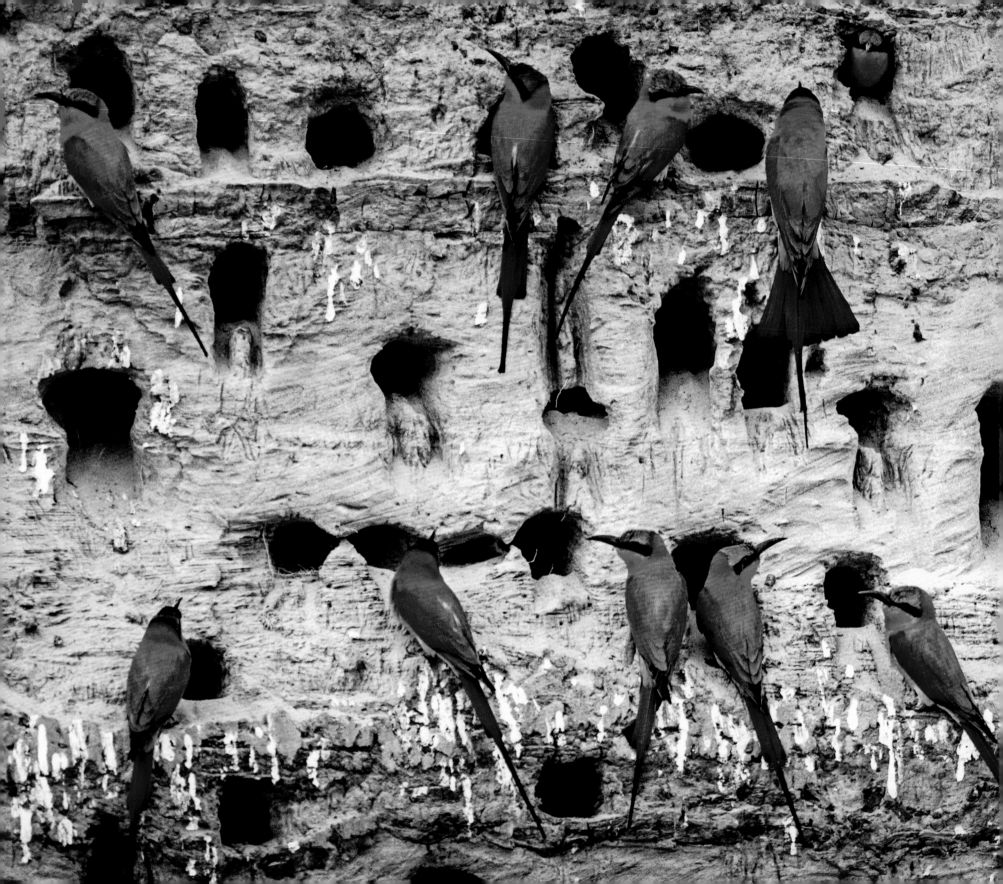

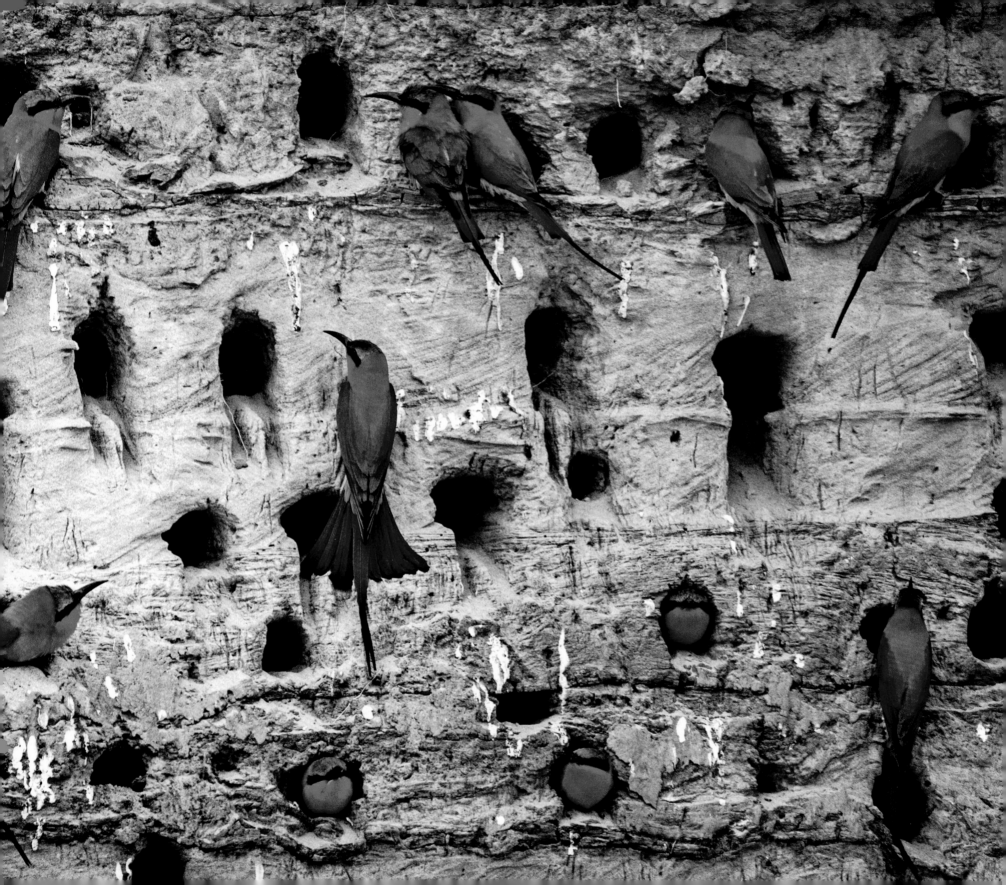

INTRODUCTION

JOURNEYS OF LIFE

It was late June. The humid night air pulsed with frog calls. Most Jamaican natives and beach-weary tourists had long called it a night. Yet in the moonlight along a deserted stretch of Jamaican coastal road, an invasion of white crustaceans was quietly taking place. In what looked like a scene from a Japanese sci-fi film, some of the creatures were poised at the edge of the road, and others cast long shadows as they boldly sidestepped across the pavement, raised high on their eight legs. The sound of chitin tapping tarmac was audible in the darkness. I had stumbled upon, not a beach invasion of aliens, but Jamaica's large, feisty land crabs returning from their annual reproductive migration to the sea.

Meanwhile, in South Africa, another remarkable wildlife exodus was under way. Termites—sprouting wings for the occasion—had emerged from the ground in incredible numbers to launch into the air on dispersal flights. A veritable feeding frenzy resulted as predators, turned brazen with the protein explosion, abandoned their cover. By day, birds, toads, and lizards gulped down the insects on the ground while swallows nimbly caught them on the wing. At dusk, bats swooped after the airborne insect morsels as nocturnal rodents and reptiles continued the feast below.

Everywhere, it turns out, creatures big and small are on the move. Spiders balloon on silken threads, salt-marsh aphids float on the sea surface, rice leafhoppers hitch rides with southwesterly weather depressions from central China to Japan. Bar-headed geese have been spotted flying over India's Dehra Dun at 29,500 feet, and a Ruppell's griffon once collided with a plane at 37,000 feet. African antelope and zebra migrate between dry-season waterholes and rainy-season browse. And in the deep oceans, the world's great baleen whales swim thousands of miles each year between their warm-winter calving areas and remote polar feeding grounds.

Clam worms, native to the European coast, spend the cold months among algae and in rock crevices, but during summer, they "go planktonic," swimming far from shore to reproduce. Near the South Pacific islands of Fiji and Samoa, on the first day of the last quarter of the October–November moon—like clockwork—writhing masses of amorous palolo worms rise to the surface of the water in a reproductive frenzy.

In autumn, thousands of spiny lobsters—normally solitary and reclusive by day—line up to march during the day in parallel, single-file lines across shallow areas between Florida's east coast and the island of Bimini in the Bahamas. Their abrupt mass movement in tight tail-to-antennae formation is a phenomenon unique among benthic crustaceans.

While fish eggs, larvae, and young passively drift with the ocean currents, adults actively swim against them to reach their breeding areas. Migratory cod and herring move into deep water in autumn, spawn in winter, and return to shallow water in the spring. Certain stocks of Chinook salmon migrate thousands of miles in the open Pacific Ocean and then swim 2,000 miles up the Yukon River to spawn and die within yards of their freshwater birthplace. In contrast, European eels spend most of their twenty-year life cycle in freshwater streams, but mate and die in the Sargasso sea.

WHAT IS MIGRATION?

Strictly defined, migration is the regular, seasonal movement of all or part of an animal population to and from a given area—usually between breeding and wintering grounds. More broadly, it is the movement of any organism from one habitat to another. For the most part, this movement is horizontal, from a few miles to several thousand miles—but migration can also be vertical.

Planktonic crustaceans such as krill and squid remain at great depths during the day, rising to mass in the upper waters at dusk. Certain mammals, insects, and birds migrate vertically on mountainsides, frequenting upper zones to produce young, then the foothills or plains to avoid harsh winter weather. Each spring, herds of female Tibetan antelope migrate north across Tibet's vast Chang Tang Reserve to remote calving grounds in the Kunlun Mountains. In autumn, small groups of mountain quail walk literally single file down the slopes of the Sierra Nevada to warmer elevations. Even the parasitic filarial worm makes a nightly vertical migration—from the host's deep tissues to those just beneath the skin for easy transfer to night-biting mosquitoes—their intermediary hosts.

Animal migrations are as regular as the changing seasons and the ebb and flow of the tides. Each spring, horseshoe crabs emerge from the sea like prehistoric trilobites to pile up on the sandy beaches of the Atlantic coast

to mate and lay their eggs. Ruddy turnstones nest on the soggy Arctic tundra during the summer, then head for southern beaches in the fall to fatten on crabs, worms, and insects. Male scarlet tanagers, bright red during the spring breeding season in North America, exchange their showcase plumage for cryptic green feathers in which to winter safely in the jungles of South America. And come spring, barn swallows returning to North America follow the northern advance of the 48-degree isotherm—the very temperature at which insects begin to warm up and fly.

SUPERIOR ATHLETIC PERFORMANCE

Migration often requires extraordinary athletic abilities. Arctic terns hold the long-distance record for birds, migrating more than 12,500 miles in just four or five flights from Iceland, northern Alaska, and Canada to Antarctica, stopping only periodically to eat and rest. It has been said that their annual 25,000-mile, pole-to-pole migration is limited less by their endurance than by the size of the planet.

Using radar, scientists at Swarthmore College tracked millions of migrating warblers and shorebirds flying from Nova Scotia and Cape Cod off the Atlantic coast to the South American mainland. Pushed by trade winds from the Sargasso sea, most flew the distance nonstop in about eighty-six hours—the longest nonstop journey made by small birds over water anywhere in the world.

Most remarkable is the migration of the tiny ruby-throated hummingbird found east of the Mississippi. During summer, they migrate as far north as Canada, in winter, as far south as Panama. To do this, many must make a nonstop, 500-mile flight across the Gulf of Mexico—an Olympian feat considering that these high-metabolic hummers usually need constant flower nectar to maintain wing beats of fifty to seventy-five strokes per second. Scientists have estimated that a pre-migration weight-gain of just two grams of fat provides the fuel necessary for these iridescent jewels to fly 800 miles.

Equally impressive, the one-ounce blackpoll warbler loses half of its body weight during a four-day, 2,400-mile migration between Nova Scotia and South America. To researchers calculating flight energetics, this represents a fuel efficiency equal to 720,000 miles per gallon.

ELK OR **WAPITI** *Cervus canadensis*
NATIONAL ELK REFUGE, WYOMING, USA

This movement of wildlife around the planet went largely unnoticed until the advent of modern technology. Aided by high-tech equipment that extends human perception, we have finally begun to tune in to the animal world as never before—and what we have learned has been eye-opening, if not humbling.

"The great streamings of birds up and down the planet are some of the most precise choreography in nature," wrote Jake Page and Eugene Morton in their book, *Lords of the Air*, "and to participate in them, even as a momentary observer, is to rise for a moment at least beyond the confines of one's own imagination, to imagine sense beyond ours. . . ."

By paying more attention to wildlife in motion, by witnessing ancient cranes dance and bow on their life-sustaining wetlands, by listening to the melodious underwater songs of humpback whales and the deafening, wing-flapping explosion of a million blackbirds erupting from their winter roosts, by watching penguins gleefully toboggan over the Antarctic ice fields, and by discovering the migration routes of animals crisscrossing the planet, we have finally begun to learn more about our own part in this global equation. Life-forms one and all, we are as intricately woven into the ecological tapestry as an armadillo or a slime mold.

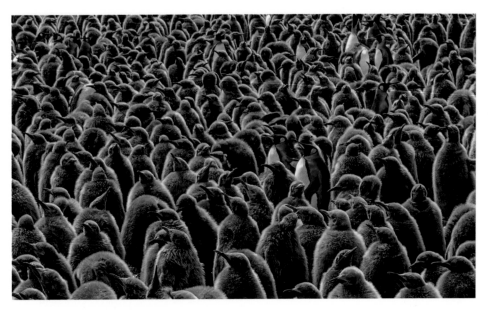

KING PENGUINS *Aptenodytes patagonicus*
SOUTH GEORGIA ISLAND

The perpetual movement of wildlife over the planet is driven by a positive energy force that transcends time to link us as much to the extinct dinosaurs as to a formation of geese flying overhead. Animals, including people, initiate pilgrimages in order to find food, exploit seasonal resources, seek warmth, or find adequate space to establish territories, mate, and raise young. These migrations are often triggered by an interplay of environmental factors—food availability, weather conditions, day length, even the phases of the moon—coupled with subtle directives from an animal's endocrine glands, such as the pituitary, that influence both reproductive development and metabolic rate. Whatever the reason, we all move to survive—because life is *motion*.

HOW DO THEY DO IT?

We've come a long way since Aristotle thought that swallows hibernated in the mud and others believed that birds flew off to the moon each fall. In an effort to study animal movements, ingenious marking techniques have been implemented in order to keep tabs on mobile subjects. Boat-propeller scars on manatees have been photographed and computer-catalogued; butterflies have been sprayed with harmless dyes; numbers have been painted or scratched on tortoise, crab, and snail shells; disks or clips have been attached to the fins of fish and the ears of large mammals; numbered and color-coded tags, rings, or bands have been attached to the legs or wings of birds and bats; stainless-steel pins have been fired into whales; harmless radioactive chemicals have been fed or injected into animals, causing their scats to "glow"; and nocturnal animals have been dusted with fluorescent powders.

To unravel the overwintering migration mystery of the eastern monarch, adhesive price-tag labels were squeezed onto the wings of hundreds of thousands of butterflies. As individual tagged specimens returned over many years, their migration route eventually began to appear in a trail of map pins from Canada to Mexico.

Radar has been used to track bird and insect movements, and sonar to track fish. Now, space-age technology, using microminiaturized transmitters bouncing signals via satellite to computers, is making it possible to track far-ranging animals such as sea turtles, peregrine falcons, whales, and sharks to remote corners of the Earth.

In spite of improved efforts to learn where animals go, how they navigate still remains shrouded in mystery. Most have an uncanny map sense and appear guided as if by built-in compass. When a manx shearwater was experimentally removed from a British nesting colony and released in Boston, it returned to its island burrow among thousands in just twelve and a half days—after flying 3,000 miles across the Atlantic from a starting point unknown to it. Such navigational feats underscore the fact that animals have sensory perceptions far superior to our own.

For starters, pigeons can "see" ultraviolet light and hear low-frequency sounds generated thousands of miles away by landforms such as mountain chains, which actually emit their own infrasonic signatures. Fish not only can hear and smell, but many generate their own electric fields for navigation through murky water. The desert ant has a thousand lenses to our one—eighty specially adapted for receiving polarized light. Recently, biologists painstakingly proved that ants plot compass direction using polarized light patterns from the sky—and that they may reckon distance by actually counting their tiny steps.

Some birds migrate by day, others at night. By aiming telescopes at the moon, it was discovered that most nocturnal flights occur from

shortly after dark until midnight. Night fliers appear to navigate by the position of the stars, and daytime fliers by the sun—possibly with the aid of the Earth's magnetic field on overcast days. Birds also seem to have an internal clock that helps them compensate for the sun's changing position. Similar mechanisms have been proposed for some insects, crustaceans, and fish.

Not only does migration call for extraordinary feats of navigation and endurance, but it can be dangerous. A large number of migrating birds do not live to see the spring. Predators and human hunters eliminate some. Floodlit towers and smokestacks lure thousands more to their deaths. Mortality rates are especially high for the young attempting their first migration. Winds can blow birds off course, and bad weather can throw off their fuel and energy budgets. Feathers of small birds found in the stomachs of deep-sea fish attest to the annual loss of sea-crossing migrants. In foul weather, birds often drop from the sky to cling to a ship's rigging or to expire on the decks. Tired travelers fare slightly better over land, where they can stop and rest. Knowing this, avid bird watchers stock their backyards with birdseed and stake out cemeteries, city parks, and garbage dumps in hopes of adding migrant species to their life lists.

And for many animals on the move, timing is everything—with little room for error. Arrive in the Arctic too early, and snow cover, lack of food, and cold temperatures can eliminate the possibility of breeding. Arrive too late, and food may run out and the weather deteriorate before the young are fledged. When quality of territory is a factor in mate acquisition and reproductive success, males must arrive early enough to stake out a good one, but not so early as to weaken, leaving them unable to defend their precious terrain against stronger, later-arriving males.

GLOBAL ARTERIES OF LIFE

The loss of migration corridors, breeding grounds, and critical refueling stops along traditional migration routes is undoubtedly the biggest threat to wildlife on the move. Many of Africa's great herds of migratory animals—wildebeest, springbok, eland, and zebra—have disappeared along with their migration routes. In Botswana, fences erected to restrict the spread of hoof-and-mouth disease among cattle also prevent migrating antelope herds from reaching their traditional watering places, causing millions to die during drought.

Wetlands are especially important to migratory species. From ethereal swamps, cranberry bogs, and cattail marshes to the Everglades' "river of grass" and the soggy Arctic tundra, these waterlogged lands are crucial refuges for fish, birds, and other wildlife. Yet the Atlantic flyway lost half of its coastal wetlands in just thirty-five years.

With habitat destruction occurring at such alarming rates, scientists are hard-pressed to learn more about the critical habitat requirements—and often secret overwintering areas—of species before these areas are lost. More than 350 species of birds breed in North America but migrate south to winter in either the Caribbean Islands, Mexico, or Central and South America. These Neotropical migrants are highly vulnerable to habitat changes at both breeding and overwintering sites as well as along their migration routes.

The broader implications of animal movement over the planet should not be overlooked. Migratory species make a political statement. When birds fly from state to state, from public to private land, and from nation to nation, they remind us that we are all members of a larger global community. Clearcut a rain forest in Venezuela and it can affect bird populations in New York. As we continue to unravel the mysteries of migration, one thing is clear: From farmer to forester, from politician to scientist, we all need to cooperate to protect these precious global arteries of life. Ultimately, their preservation will require interstate and international cooperation.

Most important, by learning more about the sensory perceptions and ecological requirements that make such magical journeys possible, not only do we share in the sheer wonder and exuberance of life on planet Earth, but we gain invaluable insights into the environmental prerequisites for our own survival. By monitoring the vitality of migratory species, we, in turn, measure our own.

—BARBARA SLEEPER

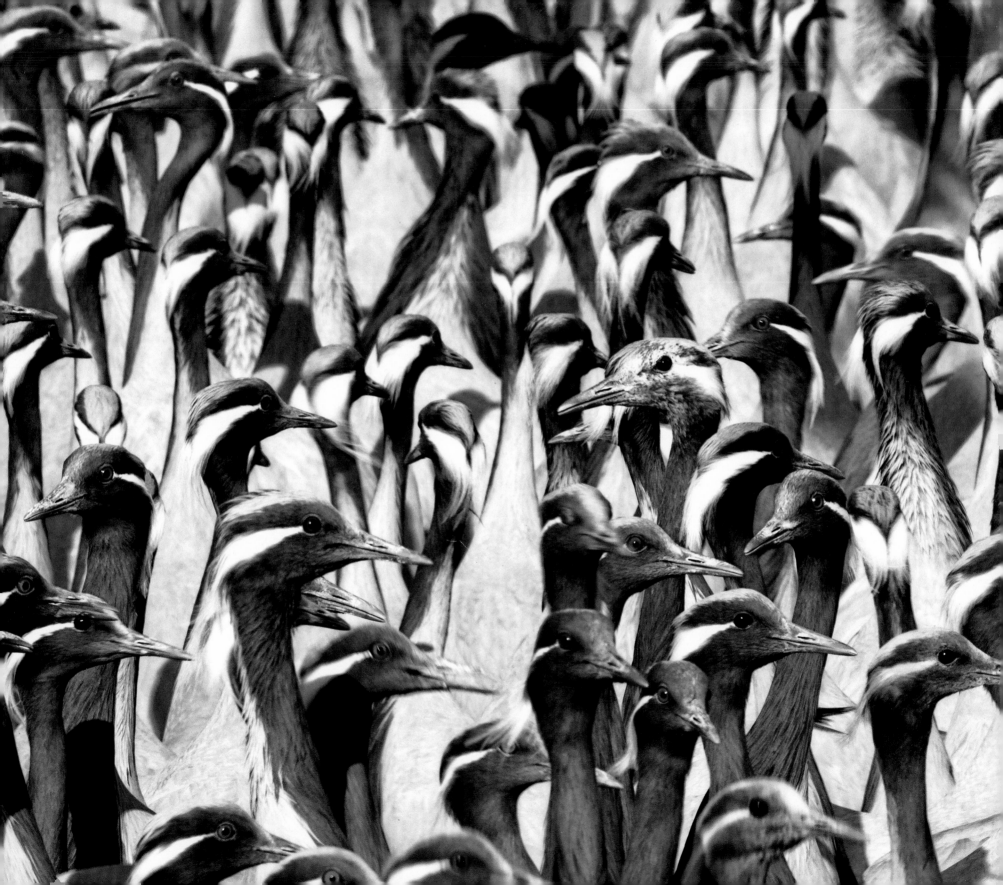

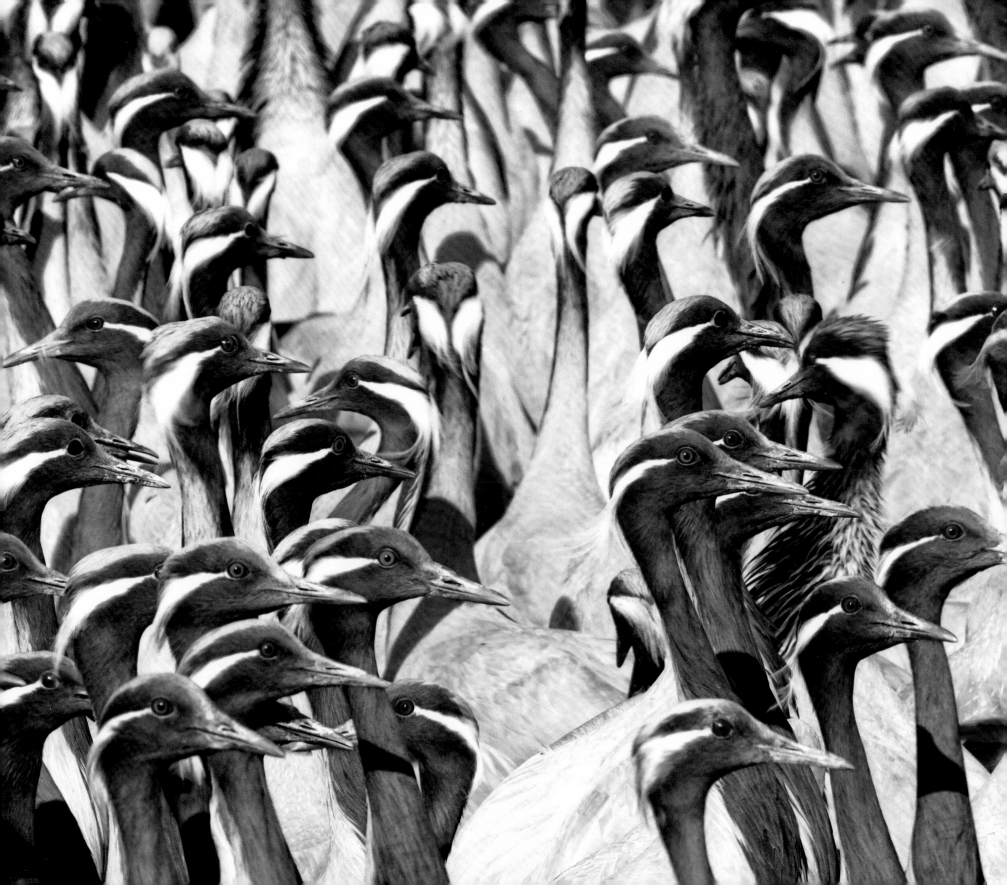

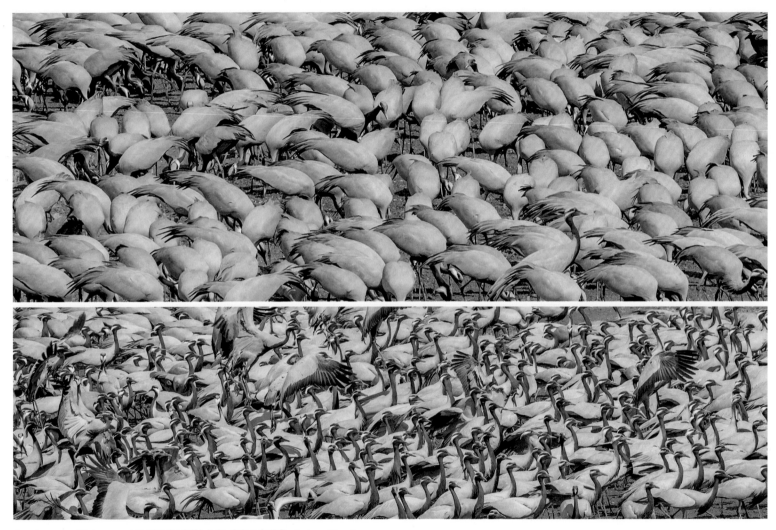

(previous pages & these pages) DEMOISELLE CRANES *Anthropoides virgo*
JAWAI, RAJASTHAN, INDIA

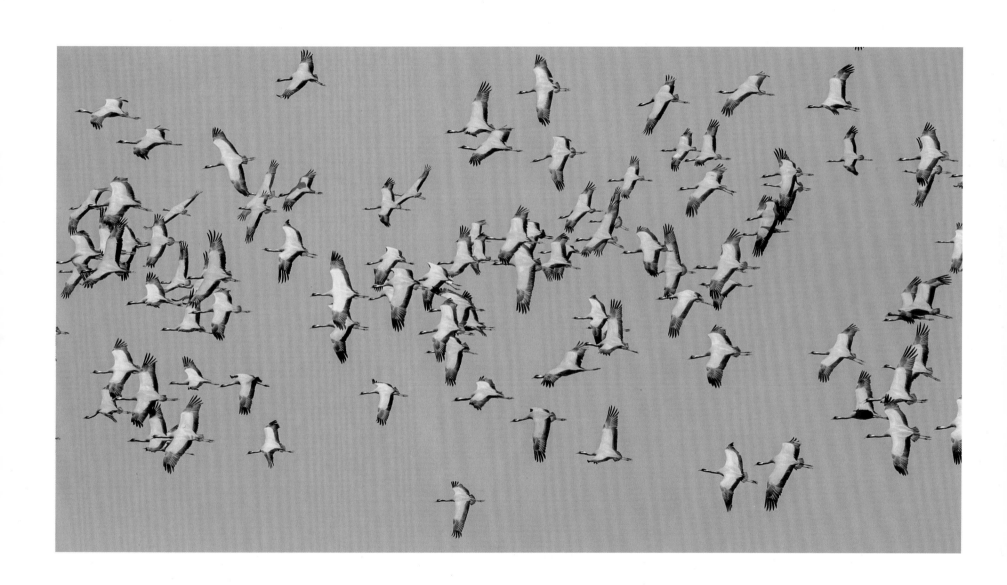

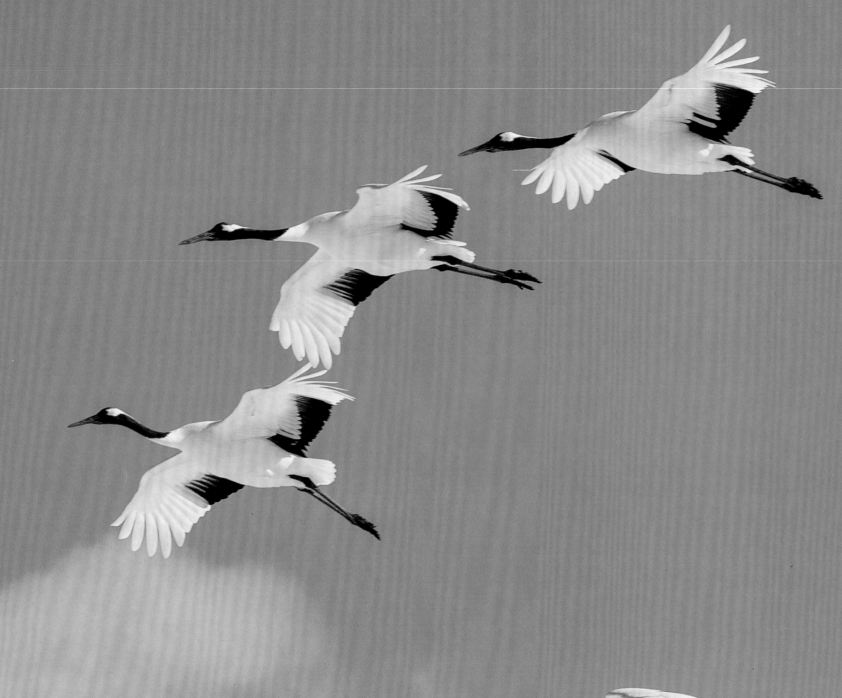

RED-CROWNED CRANES *Grus japonensis*
HOKKAIDO, JAPAN

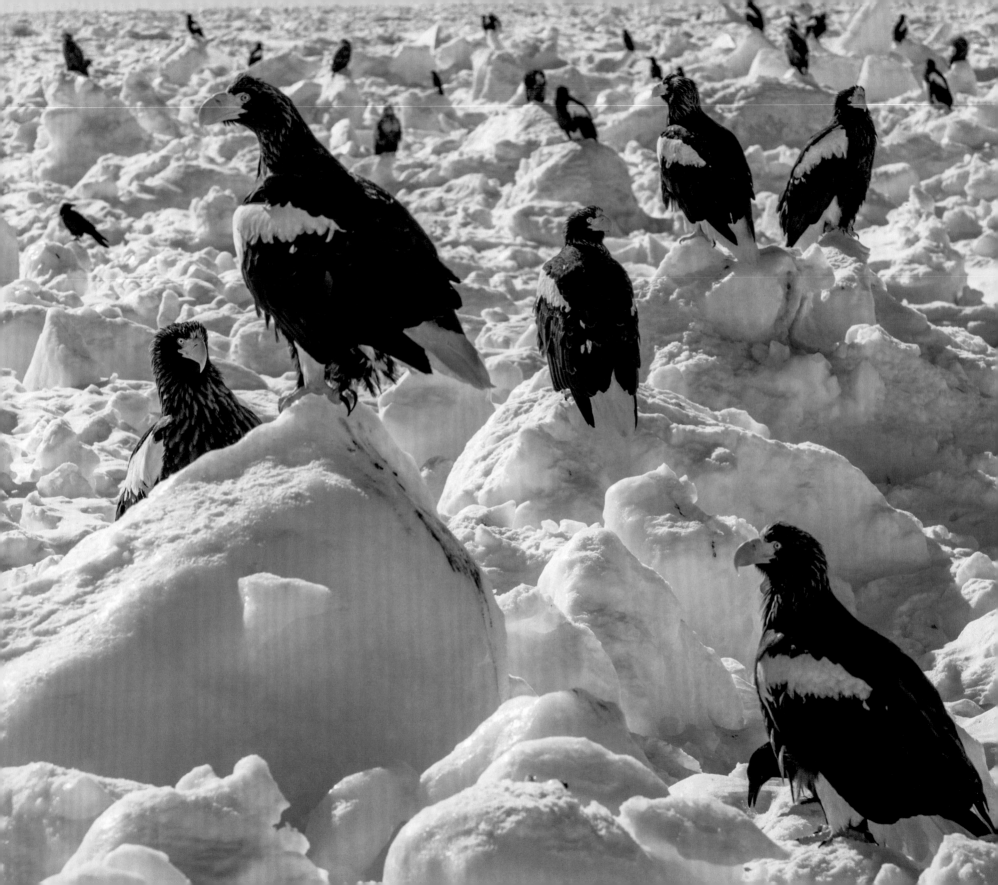

STELLER'S SEA-EAGLE *Haliaeetus pelagicus*
HOKKAIDO, JAPAN

ABOUT THE ANIMALS

BAT STARS *Patiria miniata (page 2)*
HAIDA GWAII, BRITISH COLUMBIA, CANADA

The rocky shores along the outer coast of the Queen Charlotte Islands are a magical place. Not only are they home to colorful bat stars that bejewel tide pools in rainbow hues, but maroon and orange sea cucumbers, red-tentacled tube worms, and sea anemones with scarlet stalks are found here as well. Enchanting underwater forests of bull kelp can grow up to eighteen inches a day. Held afloat by gas-filled bladders, the kelp's towering fifteen-foot blades sway gently in the currents as they reach for surface sunlight. In both color and beauty, the rich marine life found along these shores easily rivals that of a coral reef.

Several elements combine to make this abundance of marine life possible. The magnificent coastal forests can receive 200 inches of rainfall a year—making them one of the wettest places on Earth. The rugged, picturesque coastline, one of the highest wave-energy areas in the world, is pounded by enormous wind-driven swells that are pushed across the Pacific. Each crashing breaker mixes plenty of air into the water, and marine life thrives with the abundant oxygen. Wind, warm surface water, and cooler upwellings then stir the nitrates and phosphates generated from decomposition into the broth. Mesmerizing tide-pool worlds are formed, filled with sea slugs, sculpins, snails, and chitons—and a galaxy of sea stars.

Called bat stars, or "sea bats," because of their webbed rays, these omnivorous, scavenging starfish feed by extending their voluminous stomachs over a variety of sessile or dead plants and animals. Their habit of readily extruding their sexual products—ripe sperm and eggs—when laid out on wet seaweed has made them a popular subject for embryological research. When the sperm and eggs are combined in sterile petri dishes, motile embryos develop overnight and grow into minute larvae, which swim by vibrating their cilia.

SOUTHERN CARMINE BEE-EATERS *Merops nubicoides (page 8)*
OKAVANGO DELTA, BOTSWANA

The fluttering movement and brilliant darting colors of a carmine bee-eater colony are a feast for the eyes. Both sexes are equally colorful—bright red with turquoise highlights. One could easily spend hours watching the social antics and skillful feeding aerobatics of these avian fireballs as they energetically go about their day. As their name implies, they do subsist on bees, but they will also eat other insects, which they adroitly capture on the wing—either while soaring or by darting from stationary perches. These high-speed little birds even utilize brushfires as part of their feeding strategies by foraging along their insect-flushing edges. Bee-eaters nest and roost in large colonies. Like riverbank condominiums, their sandbank burrows are constructed in close proximity. During the breeding season, devoted parents feed their young nonvenomous insects while they are in the nest, then teach them the dangerous art of devouring bees, their primary prey, once they can fly. Carmine bee-eaters breed in southern Africa from September to March, and then migrate to the tropics in April.

DEMOISELLE CRANES *Anthropoides virgo (page 14)*
JAWAI, RAJASTHAN, INDIA

Standing about thirty inches tall and weighing about six pounds, the demoiselle crane is the smallest among the fifteen species of cranes. Small but hardy, the demoiselle crane has one of the most difficult migrations across the high Himalaya. Flocks of hundreds of birds assemble for these journeys, moving from breeding grounds in Mongolia and China to wintering grounds in India. Flying at altitudes of up to 26,000 feet, they die from hunger, fatigue, and predation as they cross mountain and arid desert alike, without alighting to rest or feed. Elegance in flight, their bodies form straight lines from bill to toes; they are lauded in literature of northern India for their grace and constancy.

The cranes are highly gregarious; huge flocks of up to several thousand birds congregate in their wintering grounds. Cranes in general are known for their ecstatic "dancing," which can be contagious in a flock. Once a dance starts birds will join in; dancing is also a courtship ritual among single adults and pairs, as well as a builder of social and physical skills for the young. Demoiselle cranes are particularly noted for their avian ballet, performing extended sequences of bows, leaps, runs, short flights, and picking and tossing of sticks and other objects. When so many birds are packed together, cranes need excellent communication skills. Each species has its own tone and volume—the demoiselle's being low-pitched and raspy.

While most cranes are found in wetland habitat, demoiselles live in the upland grasslands, but never far from water. They have shorter toes and bills, better for running and feeding on the arid steppe. They are omnivorous oppor-

tunists, eating anything they find wild or cultivated; to their detriment many get shot and poisoned each year by farmers protecting their grain and legume crops.

RED-CROWNED CRANES *Grus japonensis (page 18)*
HOKKAIDO, JAPAN

Long a favorite subject of Asian paintings and legends, the rare red-crowned crane, sometimes called the Japanese or Manchurian crane, is one of the most beautiful of the world's fifteen species of cranes. Native to Japan, Korea, China, and Russia, this large bird stands an impressive four feet tall. Its snow-white feathers are offset by designer-black legs, head and neck stripes, and a large pompadour of black tertial feathers. Cranes are graceful wading birds that inhabit open wetland marshes and plains. There they feed on grains, fleshy plant roots, and a variety of small animals. Leaping high into the air with wings half open, courting pairs run around each other in circles, bow, and then leap some more in joyful "dances." Their long coiled windpipes enable them to produce loud, long-distance trumpeting calls during the breeding season and migrations. .

In contrast to their winter densities, each mated pair requires an enormous area of marshland in order to breed in the spring. Both males and females defend their territory, build a ground nest, and tend the eggs and young. Like other crane species, the red-crowned crane is restricted to relatively small breeding areas—one of the main reasons it is now endangered. Another contributing factor is the cranes' incredible site fidelity. They continue to return to their traditional breeding grounds, even after the habitat has been destroyed.

Nearly extinct at the turn of the twentieth century due to hunting and wetland drainage, the red-crowned crane survives today in two separate populations. One breeds in southeastern Siberia and China, migrating to Korea in winter. The Japanese population is sedentary, breeding only on the island of Hokkaido. Dairy farming, forestry, heavy industry, and highway development continue to threaten the Japanese population.

In 1935, the Society for the Preservation of the Japanese Crane was formed in Japan, the same year that the species was designated a Natural Monument. South Korea designated the red-crowned crane as Natural Monument No. 202 in 1968. Ironically, this highly endangered species is considered the symbol for longevity in Japan. Ultimately, the species' own longevity will depend on the strict protection of its remaining marshlands.

STELLER'S SEA-EAGLE *Haliaeetus pelagicus (page 20)*
HOKKAIDO, JAPAN

Nearly a yard in length and weighing up to twenty pounds, with a wingspan of over seven feet, this immense eagle inhabits remote coastal regions along the western Bering Sea, north of Kamchatka, its greatest stronghold, and south to Japan and Korea. It is always found near areas rich in fish, especially salmon and trout, whether on a river or seacoast. Like the bald eagles of North America, these powerful and aggressive birds can be found congregating by the hundreds on spawning rivers in the late summer. Intense consumers of protein in all its forms, they will use their impressive hunting skills to catch birds such as geese and puffins as well as small mammals. They will swoop down on prey with their knife-like talons or stand in water or on ice to grab fish as they swim by. Flexible and cunning, they will even stoop to kleptoparasitism, stealing food from other birds.

Sea-eagles breed and nest in the north, in aeries high in trees and on rocky cliffs. Everything about these birds is huge, including their nests. Consisting of hundreds of sticks and at nearly eight feet across, the nests weigh hundreds of pounds; so heavy that sometimes they go crashing to the ground.

In the winter the drifting ice and food availability determines their migratory patterns; most sea-eagles overwinter further south, and about 2,000 sea-eagles flock every year to Hokkaido where Pacific cod and Alaska pollock are found, and they even move further inland to forage on lead-ridden sika deer carcasses left by hunters. One or two pellets from a shotgun or even a shard from a bullet will kill an adult sea-eagle.

Despite occurring mostly within protected areas in Russia and being declared a National Treasure in Japan, the sea-eagle is increasingly rare due to habitat alternations such as the building of hydroelectric power projects on rivers, drilling for oil and gas, large-scale destruction of old forests, hunting, poisoning, and nesting failures because of decreasing food sources and flooding caused by global climate change. The population is estimated at around 5,000 and sadly in decline over its very limited range in northeastern Asia.

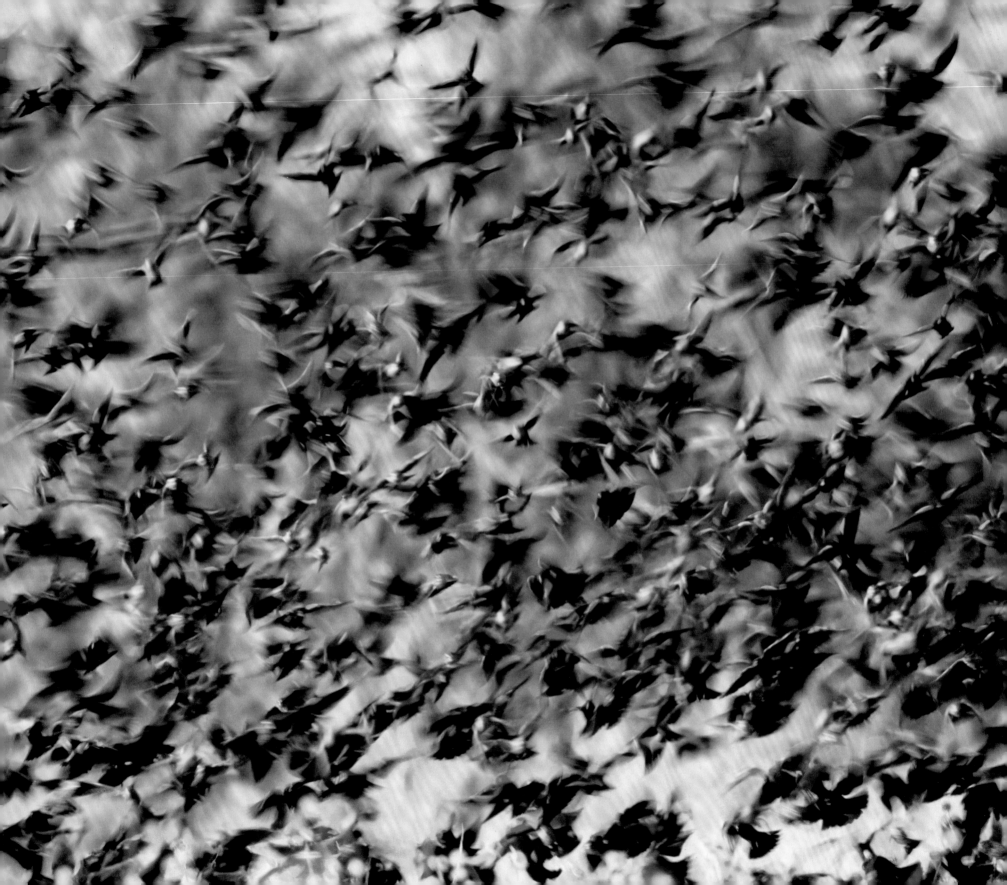

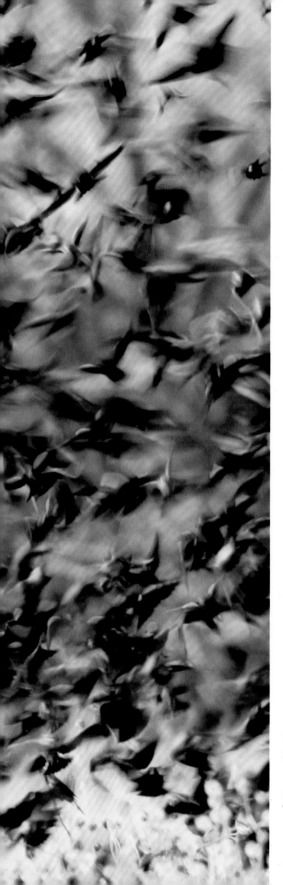

RED-WINGED BLACKBIRDS *Agelaius phoeniceus*
BOSQUE DEL APACHE NATIONAL WILDLIFE REFUGE, NEW MEXICO, USA

(following pages) GUANACO *Lama guanicoe*
TORRES DEL PAINE NATIONAL PARK, CHILE

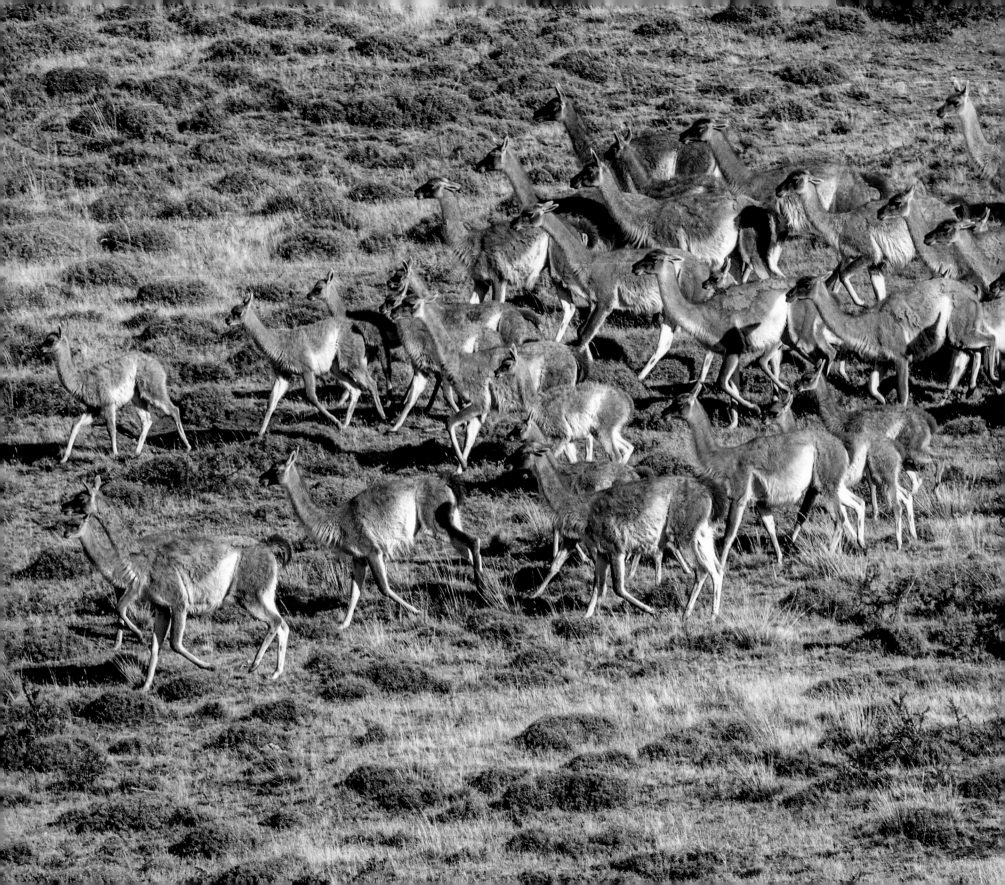

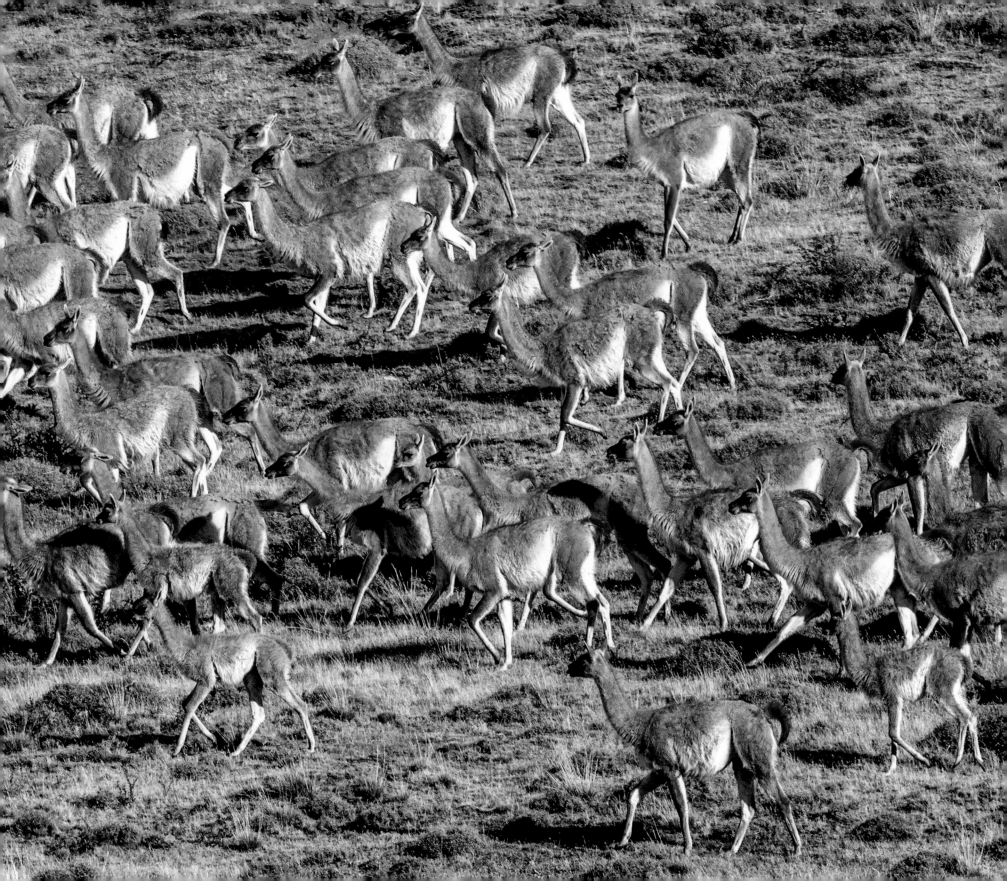

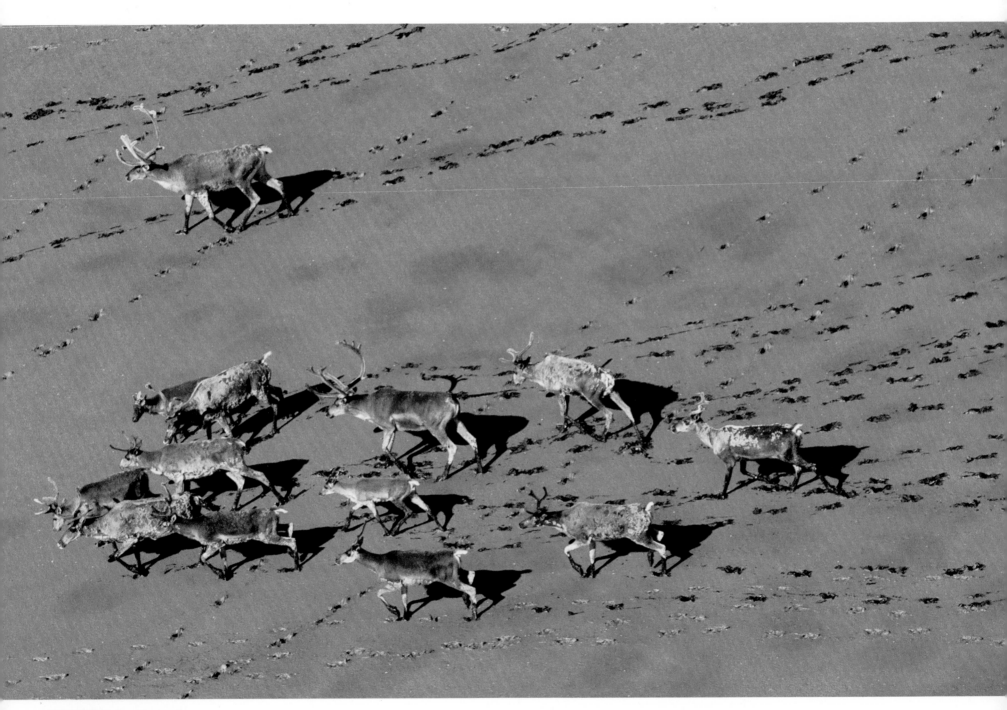

CARIBOU *Rangifer tarandus*
KATMAI NATIONAL PARK AND PRESERVE, ALASKA, USA

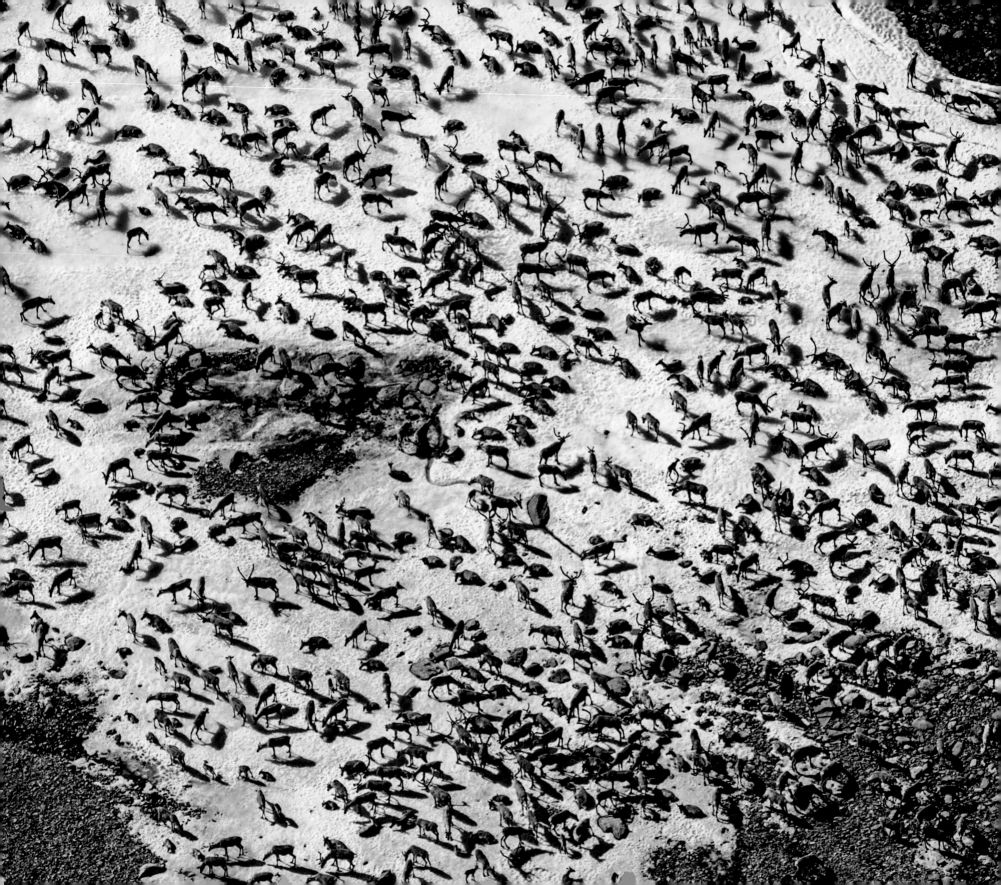

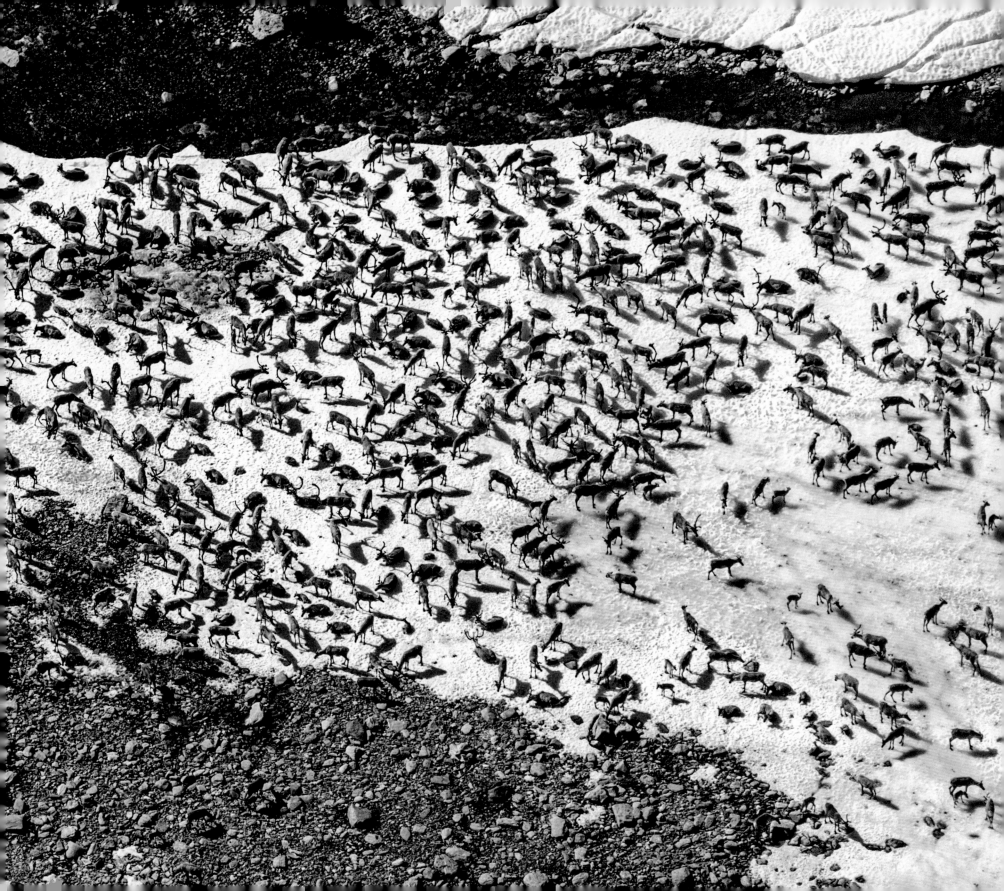

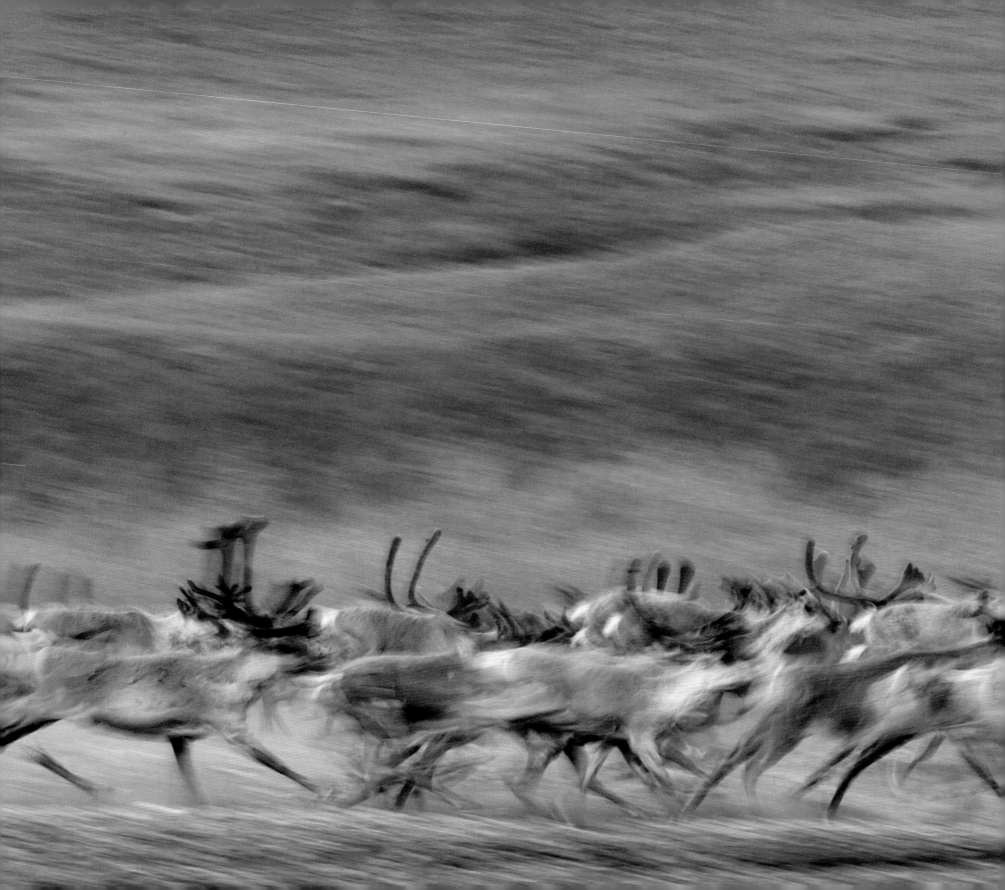

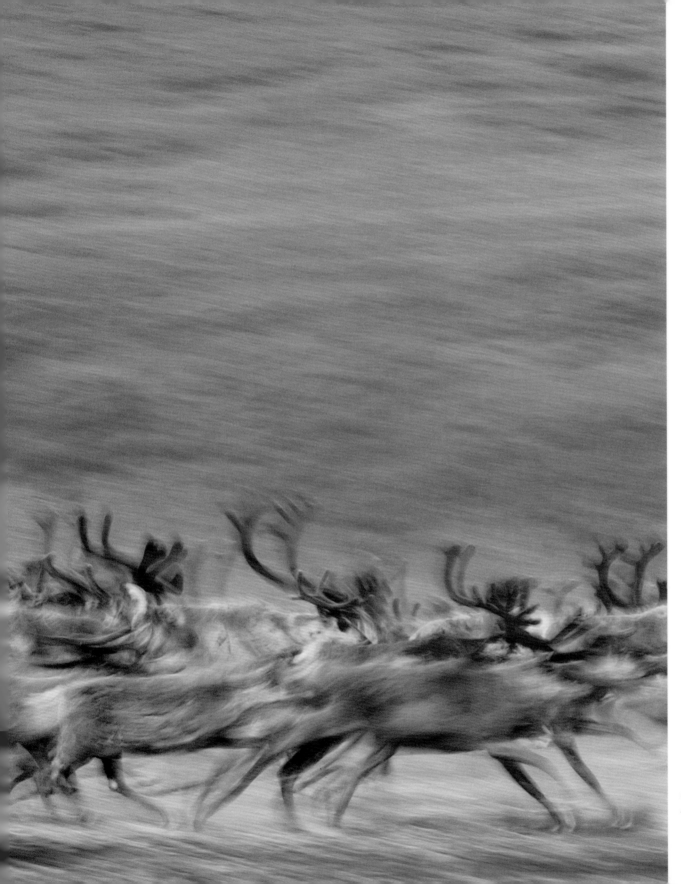

(previous pages & these pages) **CARIBOU** *Rangifer tarandus*
ARCTIC NATIONAL WILDLIFE REFUGE, ALASKA, USA

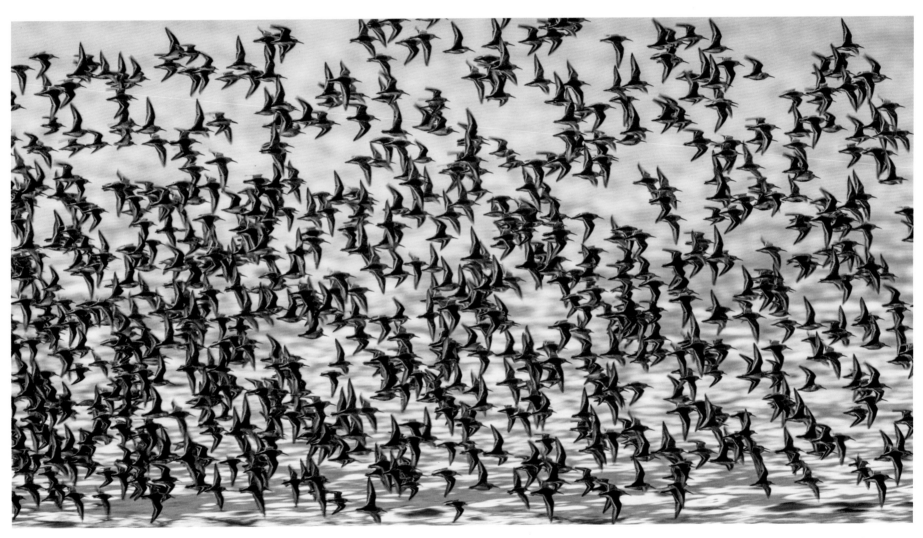

DUNLIN *Calidris alpina*
SKAGIT FLATS, WASHINGTON, USA

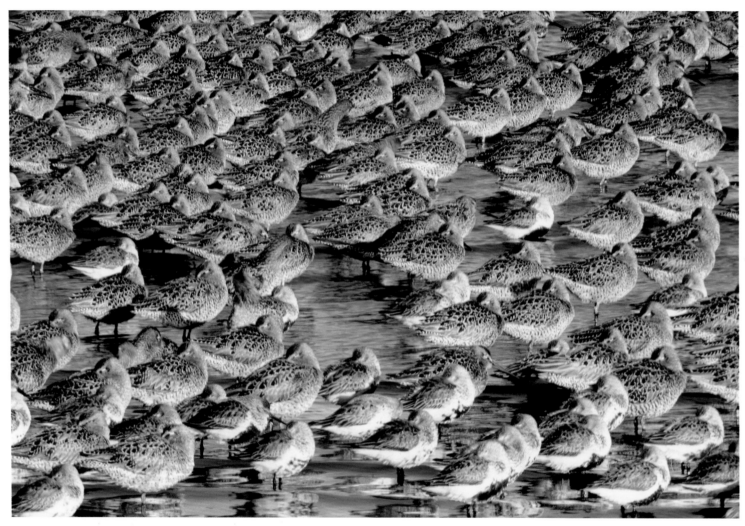

WESTERN SANDPIPERS *Calidris mauri* | **DUNLIN** *Calidris alpina*

BOWERMAN BASIN, GRAYS HARBOR, WASHINGTON, USA

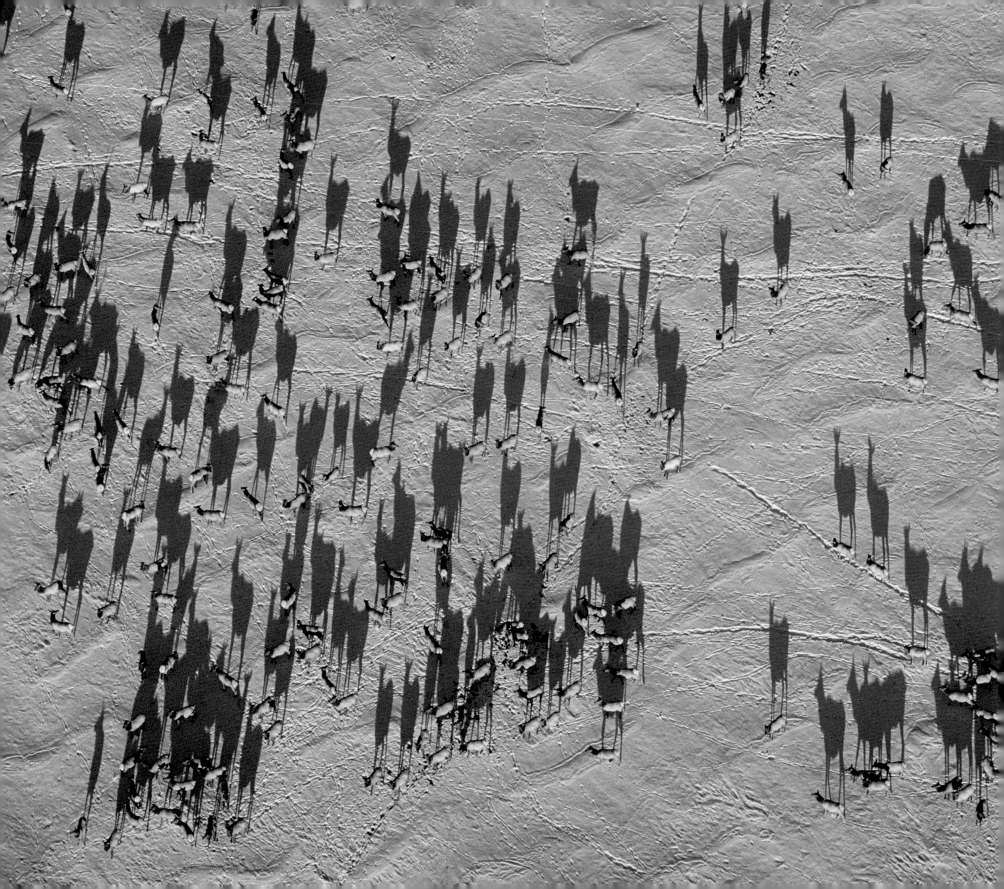

ELK OR **WAPITI** *Cervus canadensis*
NATIONAL ELK RANGE, WYOMING, USA

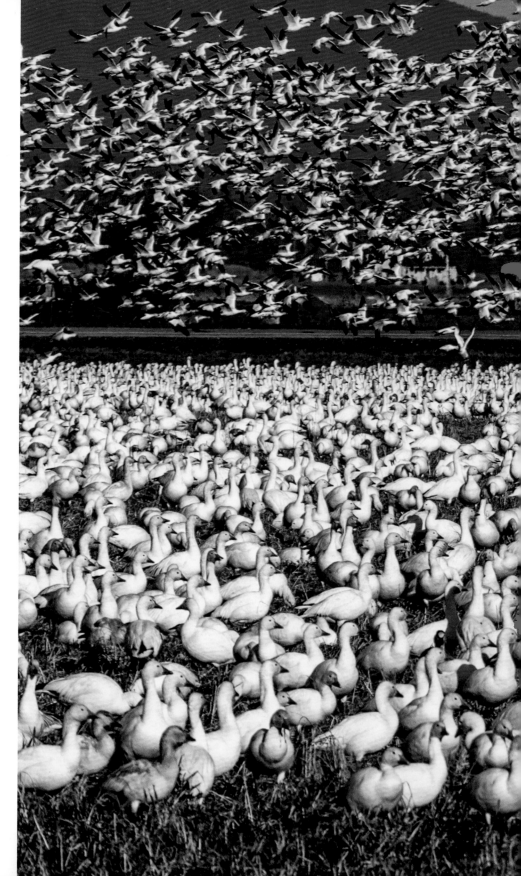

SNOW GEESE *Anser caerulescens*
SKAGIT VALLEY, WASHINGTON, USA

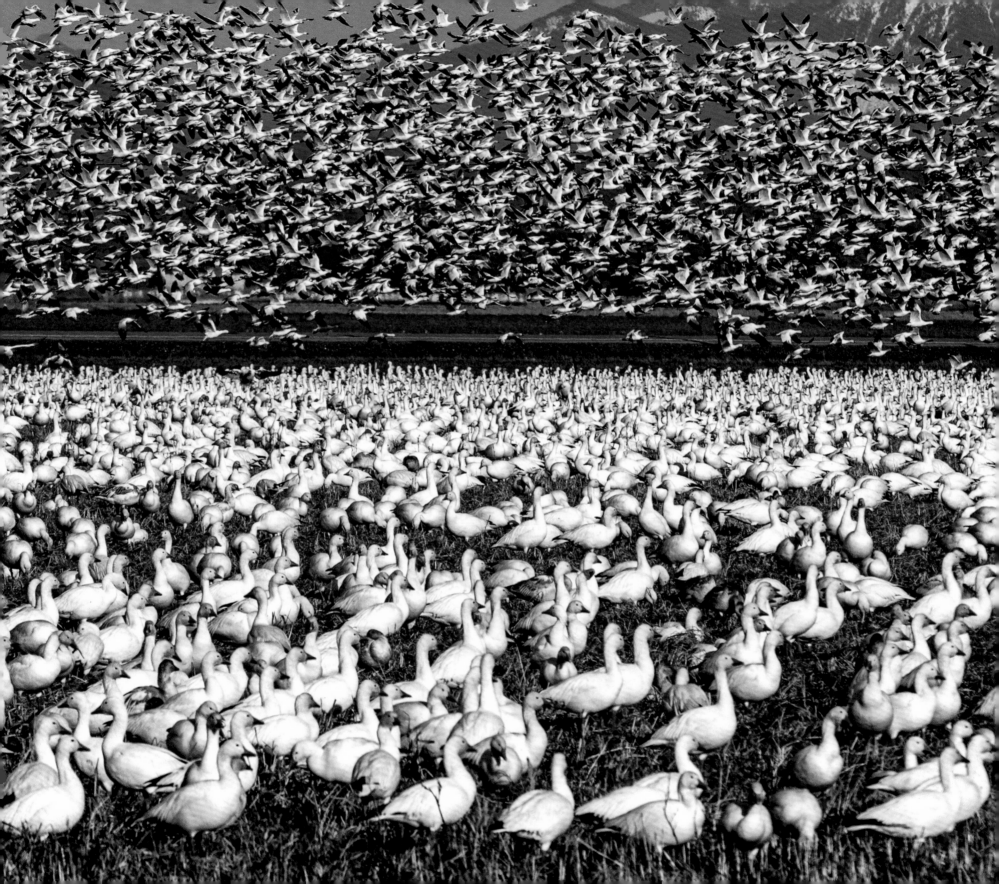

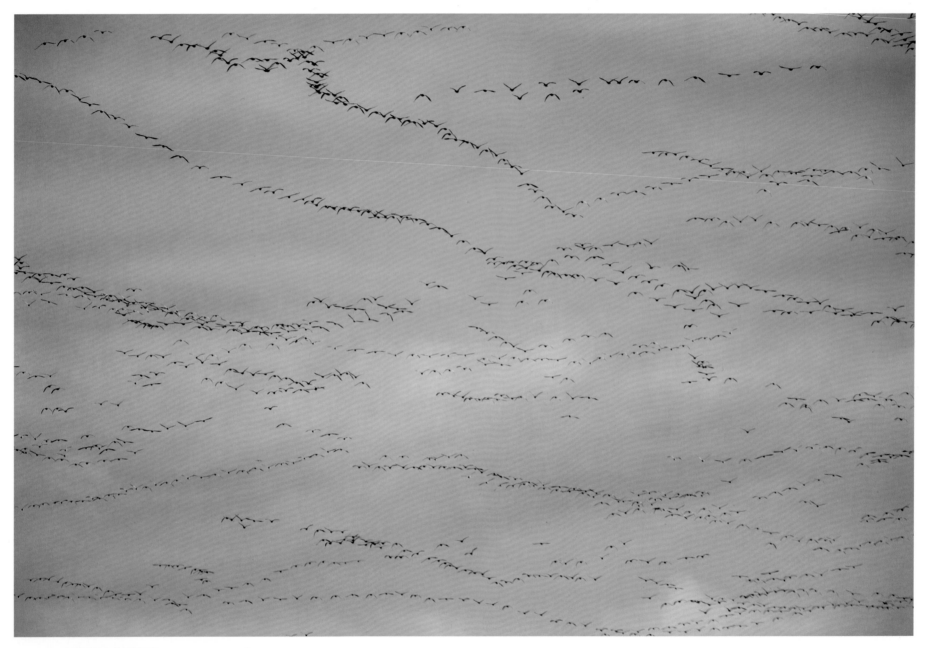

(these pages) **SNOW GEESE** *Anser caerulescens*
SKAGIT VALLEY, WASHINGTON, USA

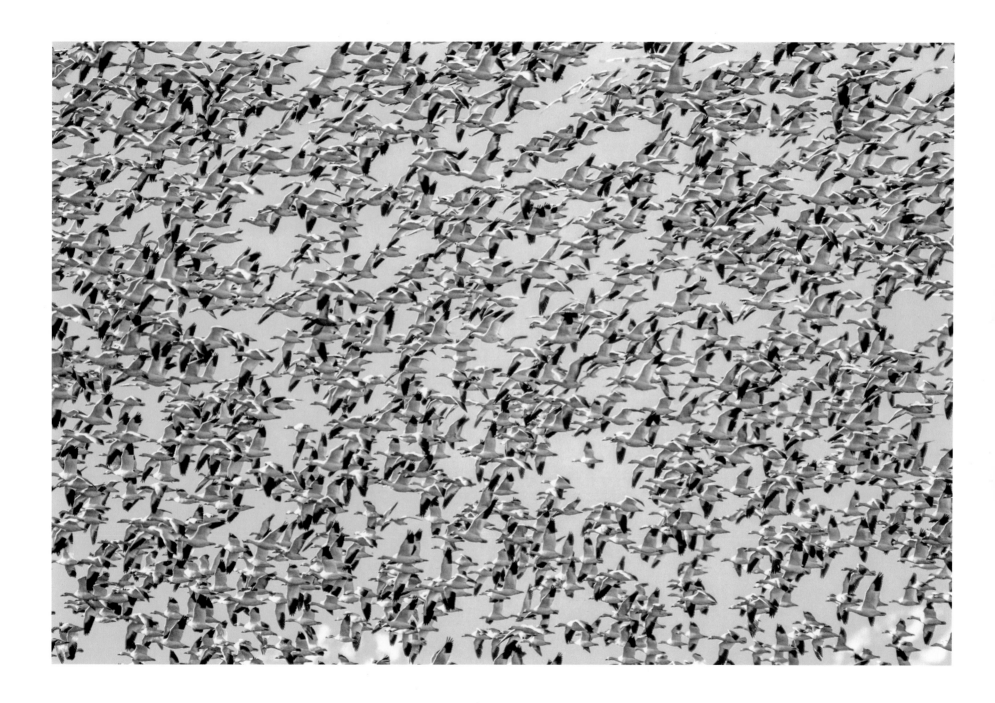

ABOUT THE ANIMALS

RED-WINGED BLACKBIRDS *Agelaius phoeniceus (page 24)*
BOSQUE DEL APACHE NATIONAL WILDLIFE REFUGE, NEW MEXICO, USA

During the breeding season, male red-winged blackbirds cling to cattail stalks and perch high atop bushes to flash their bright red shoulder patches. This visual display warns rival males to keep their distance, while at the same time advertising the male and his territory to passing females. Sparring, displaying male blackbirds sometimes perch side by side, their bills pointing skyward. The contest changes with the onset of autumn. In order to survive to breed again, male territoriality is suppressed, enabling the birds to gather peacefully in enormous flocks at the limited winter refuges offering adequate food and water.

Red-winged blackbirds, known for their gurgling spring songs, are thought to be the most numerous land birds in North America. Numbering in the thousands, huge winter flocks swarm to feed on weed seeds and waste grain. Red-winged blackbirds are just one of 320 species of birds that attract 100,000 people each year to New Mexico's Bosque del Apache National Wildlife Refuge. Although the area was established by the U.S. Fish and Wildlife service in 1939 as a wintering refuge, primarily for geese, ducks, and sandhill cranes, it also serves as home to a tantalizing array of other species, from shorebirds and waders to songbirds and raptors. The refuge is one of 500 national refuges, encompassing nearly ninety million acres, which is managed by the U.S. Fish and Wildlife Service.

GUANACO *Lama guanicoe (page 26)*
TORRES DEL PAINE NATIONAL PARK, CHILE

Standing under four feet at the shoulder, guanacos are small camelids with far more delicate features than their larger relatives in the Old World. They have a slender build and long legs that can power them along at up to thirty-five miles per hour. Hardy guanacos survive in both mountain and plains habitats, though they have been eliminated from most of the lowland portions of their range by sheep and cattle interests. Their hemoglobin has a much higher affinity for oxygen than that of other mammals, allowing them to function at high altitudes up to 13,000 feet. There were as many as 50 million guanacos when Europeans first arrived in the New World, today their population is less than 600,000. Ninety percent of those surviving live in southern Argentina and southern Chile.

CARIBOU *Rangifer tarandus (page 28)*
ALASKA, USA

Caribou are circumpolar. They can be found in almost every direction around the North Pole, from Siberia and Scandinavia to Alaska, Canada, and Greenland. In North America, caribou migrate long distances between their winter and summer ranges—often as much as 800 miles. It is thought that they walk farther than any other animal, their passage accentuated by the incessant clicking of their snow-adapted hooves. Each winter, large herds migrate several hundred miles south from the Arctic tundra in search of food. Should they come to a river, they can swim up to six miles per hour. Woodland caribou and reindeer are essentially the same animal. The Micmac Indians of Canada called them *xalibu*, or "the one that paws." As a source of feed, hides, and even transportation, these roving ruminants have long been a valued resource. In northern Finland, the Lapp people keep domesticated reindeer, drinking their milk and eating their meat. Many Lapps still use reindeer to pull their sleighs, and they fashion caribou hides into clothing.

WESTERN SANDPIPERS *Calidris mauri* | **DUNLIN** *Calidris alpina (page 34)*
BOWERMAN BASIN, GRAYS HARBOR, WASHINGTON, USA

Sandpipers, affectionately called "teeter-tails" for their hand-bobbing gait, are members of the most diverse family of shorebirds. World wide there are more than eighty species of small to medium-sized birds in the sandpiper family, including curlews, sanderlings, snipes, godwits, and dowitchers. It is said that the entire world population of breeding western sandpipers depends on Alaska's Copper River Delta as a staging area during their spring migration to the Arctic. As they gather each year to rest and refuel before heading further north to their breeding areas, it is possible to hear the roar of 30,000 of these inconspicuous one-ounce birds. Similarly, the Western population of dunlin, or red-backed sandpipers, also depends on this vital migratory resource. The delta is the largest coastal wetland in the Pacific Northwest, encompassing 700,000 acres of varying habitat. In May 1990, portions of it were dedicated as part of the Western Hemisphere Shorebird Reserve Network—a designation that indicates that more than one million birds pass through this critical migratory staging area. As many as twenty million birds use the delta each year.

Both species of sandpipers are hardly larger than sparrows. They use their two-inch-long bills to probe the tidal flats in search of mollusks, crustaceans, and insects. During their winter migration, sandpipers are often seen in flocks by the hundreds. When disturbed, they fly up and dart away over the surf, flying so closely, just inches apart, that they look like a flying carpet as they twist and turn over the shoreline. Sandpipers migrating along the eastern United States stop at James Bay, Ontario, to build up fat reserves to fuel their flights to winter refuges in Central and South America. Some double their weight in three weeks on a diet of mollusks and insects.

ELK OR **WAPITI** *Cervus canadensis (page 36)*
NATIONAL ELK RANGE, WYOMING, USA

Migratory mammals such as elk use traditional game trails to reach their winter range. These deeply grooved paths often persist for generations. Where rocks have been worn smooth by such passage, the trails hint at centuries of use. The Rocky Mountain Elk Foundation, based in Missoula, Montana, was established to help protect the habitat of these magnificent animals. From 1984 to 1991, the foundation raised $30 million to conserve more than one and a half million acres of critical wildlife habitat across North America. "Elk add a magical element to the land," says the foundation. "Just knowing they're out there in the hills makes you walk a little slower and look a little harder."

Yellowstone is home to one of the world's largest populations of elk, estimated at more than 30,000 in the summer when the herds graze in timber basins and park meadows. In winter, some of the herds move to lower elevations outside Yellowstone, such as the National Elk Refuge at Jackson Hole, Wyoming. Three hundred years ago, an estimated ten million elk roamed the plains of North America. Today, people are trying to save the elk that remain by establishing wilderness preserves, restricting logging and mining in prime elk habitat—and by helping to provision elk herds with food during the winter.

When the breeding season ends in the fall, male elk often face winter with fat reserves depleted after the rigorous demands of courtship. This puts them at risk for disease and starvation during the cold months ahead. Male reproductive success for an elk ultimately depends on his ability to compete with other males for access to as many breeding females as possible. Larger body size, including antler size, is directly correlated with such success—the larger the male, the more offspring he typically produces. Once the rut ends, the amount of time males invest directly in reproduction is insignificant compared to females. As the hormones subside, the males are left to feed, fatten, and grow new antlers for the next rut. In contrast, the reproductive success for a female elk depends on her ability to rear her offspring and on access to the resources necessary to make that possible. It is the female that invests the major commitment of time and energy in raising the young.

SNOW GEESE *Anser caerulescens (page 38)*
SKAGIT VALLEY, WASHINGTON, USA

Nearly 60,000 snow geese winter in the middle Rio Grande valley each year, making Bosque del Apache National Wildlife Refuge the most popular birding site in New Mexico. Snow geese occur in both a white and a blue phase. The black pigment at the tips of their wings is thought to make their flight feathers more resistant to wear. These long feathers, called *primary feathers*, can be spread out like the fingers of a hand to manipulate the air in flight. The feathers of albino snow geese, lacking such pigment, are more brittle, which probably affects their ability to fly. Like airplanes, a bird's rate of energy consumption is most efficient when pushed by tail winds at high speed and altitude.

As each bird flies, some air is lost over the wing tips, causing the bird a loss in life. By flying in V-formation, snow geese take advantage of the spiraling wingtip vortices and upwelling air created behind the wings of the leading birds. Each flying bird creates a small area of disturbed air behind it called a slipstream. If birds flew directly behind each other, they would be caught in this turbulence and thrown off course. By flying slightly beside or above each other, a second bird can literally rest its inner wingtip on the rising vortex of air produced by the lead bird to receive energy-saving lift. As a result older and stronger birds usually take the lead with the younger and weaker birds positioned farther back in the slipstream where the flying is easier. It is estimated that by migrating in V-formation, birds can fly as much as 71 percent farther than they could if alone.

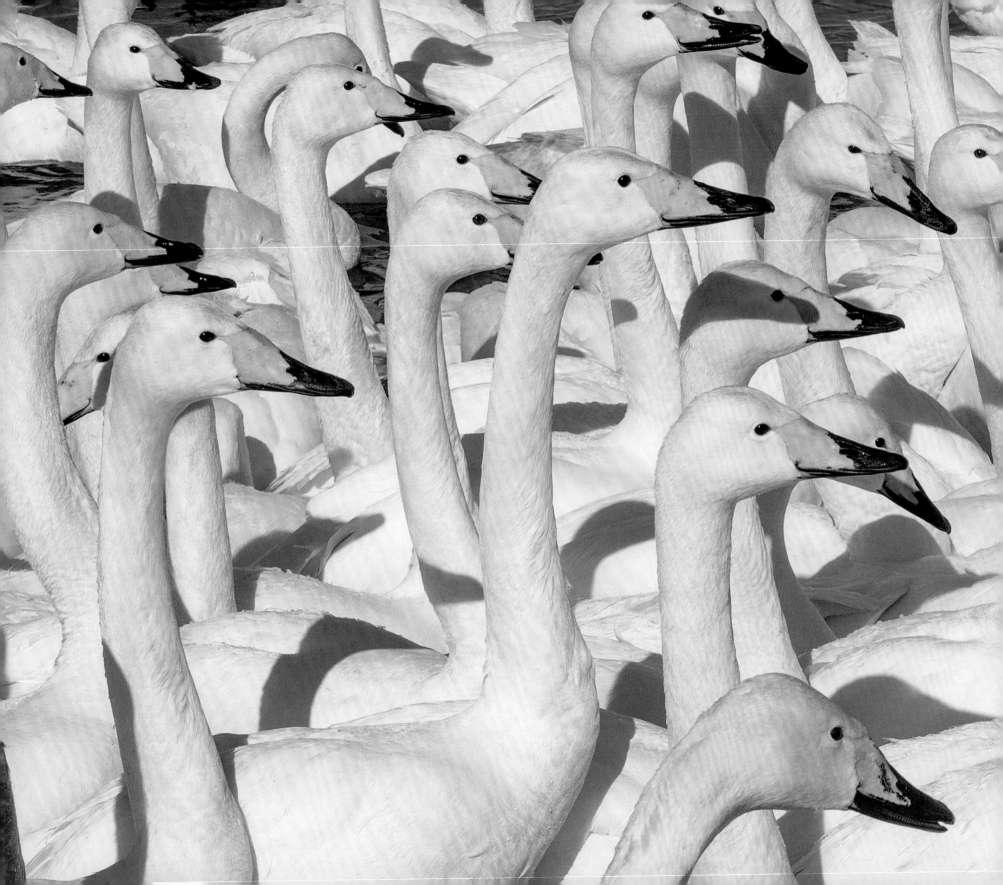

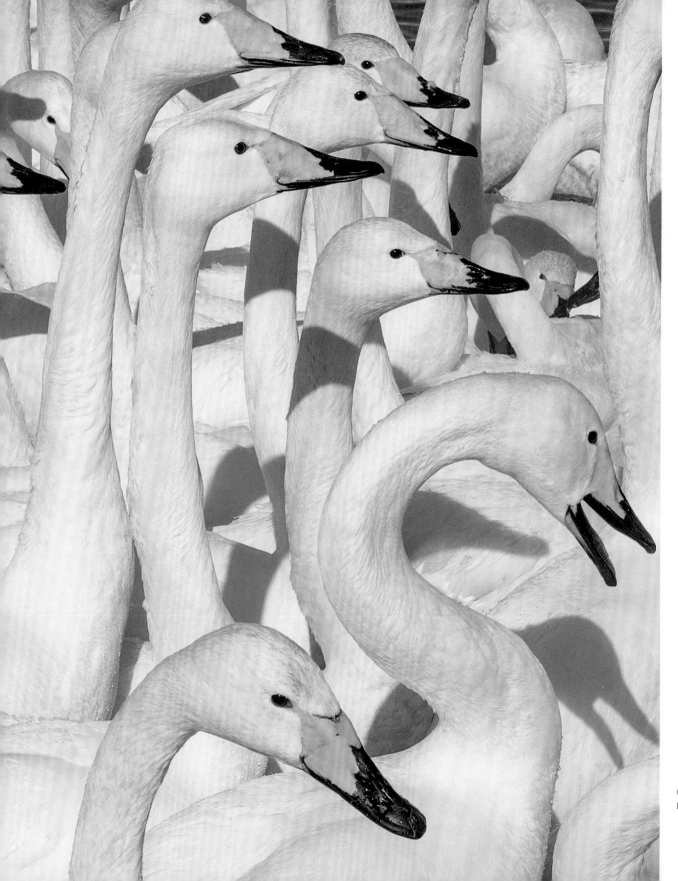

(left & following pages) **WHOOPER SWANS** *Cygnus cygnus*
HOKKAIDO, JAPAN

45

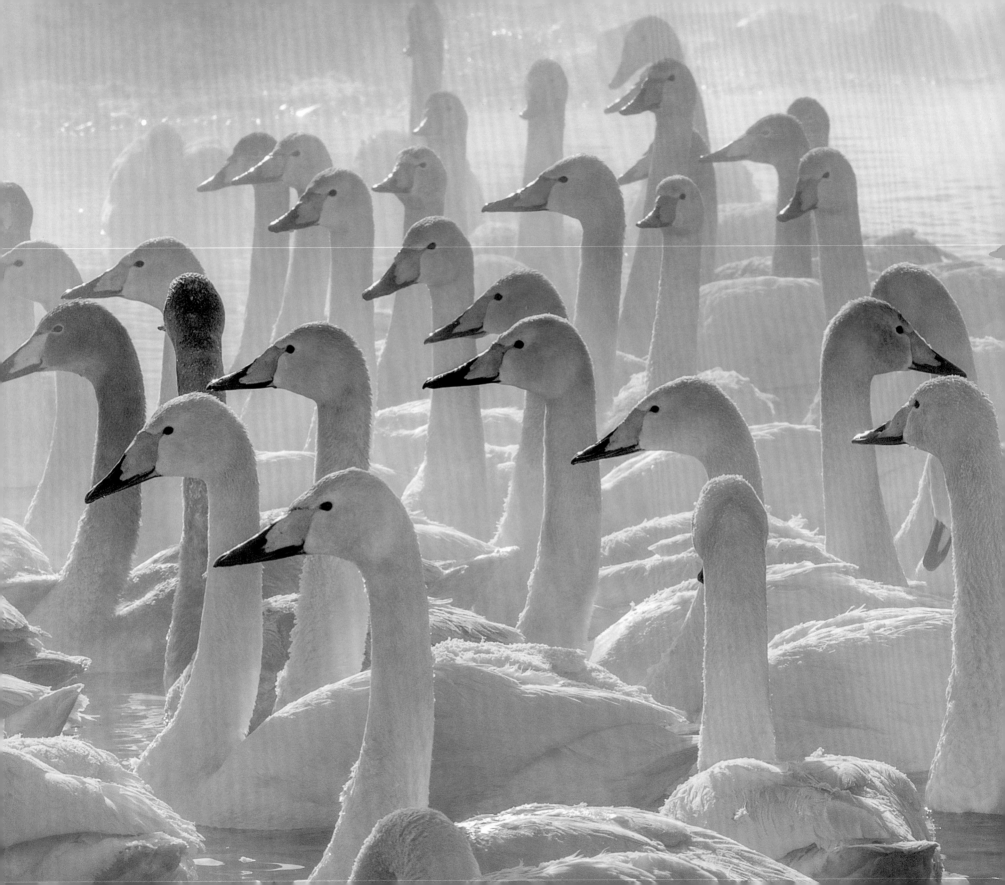

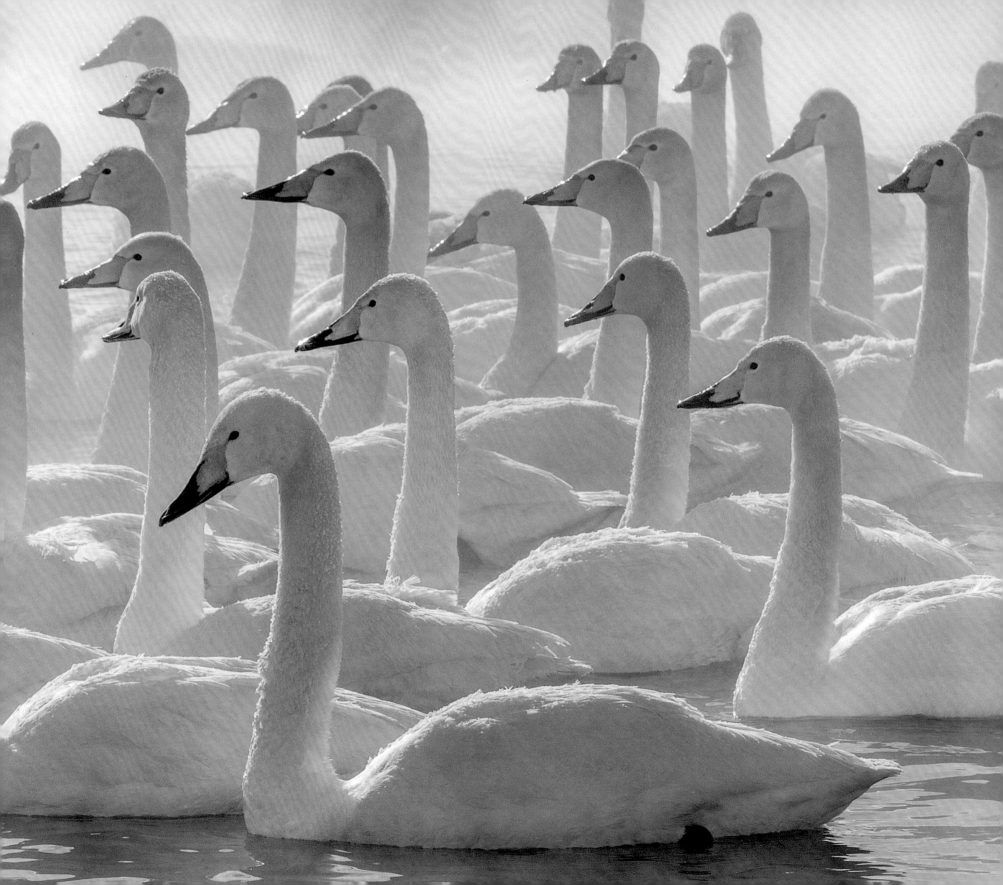

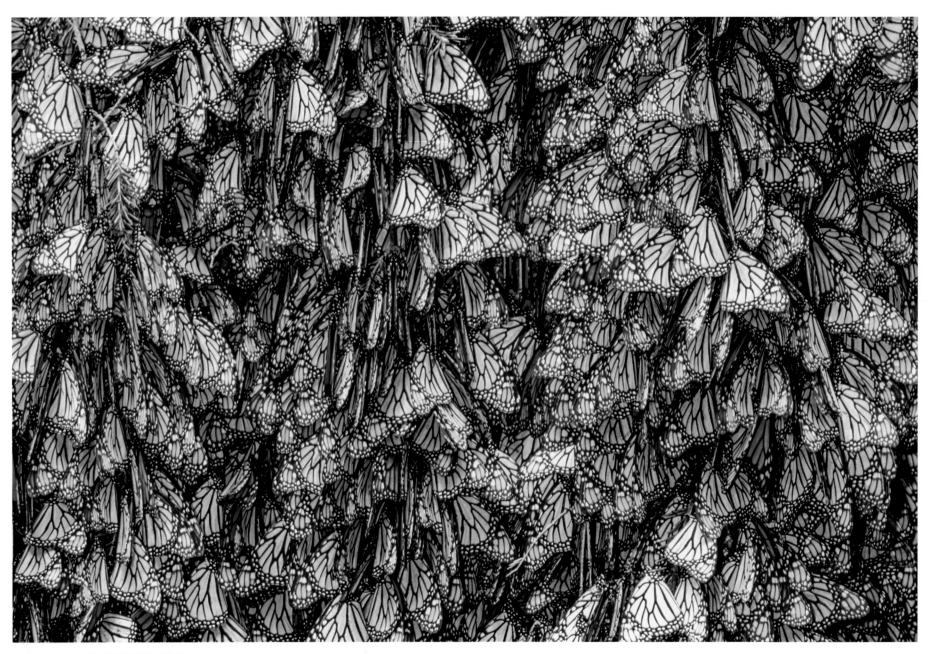

MONARCH BUTTERFLIES *Danaus plexippus*

MEXICO

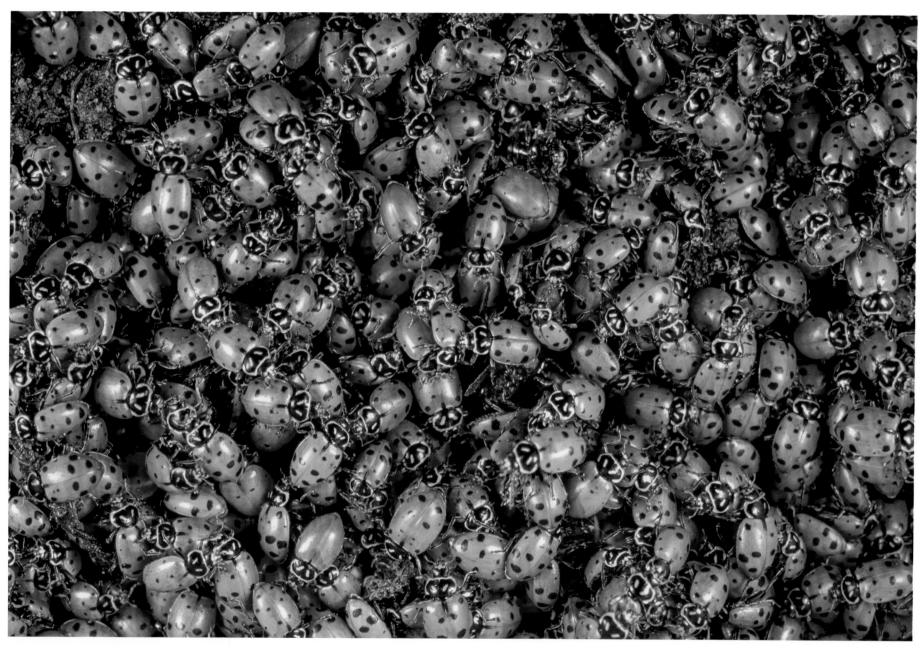

LADYBIRD BEETLES *Hippodamia convergens*

WHITE HORSE, WASHINGTON, USA

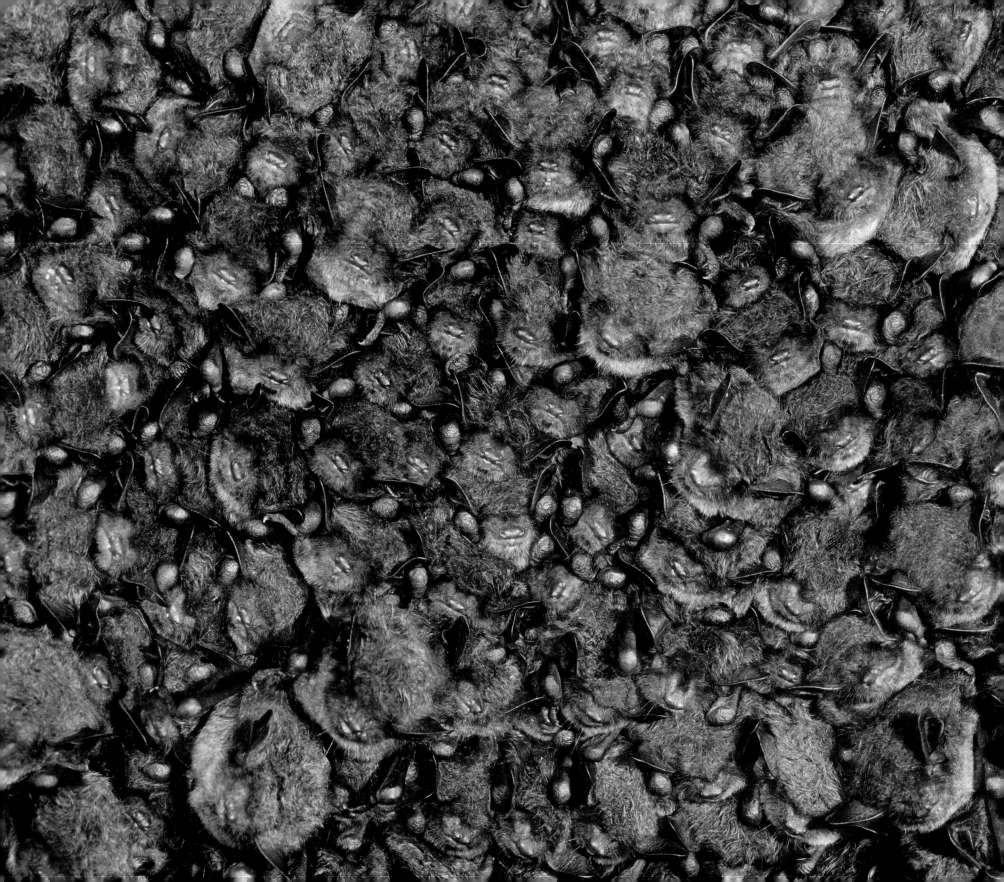

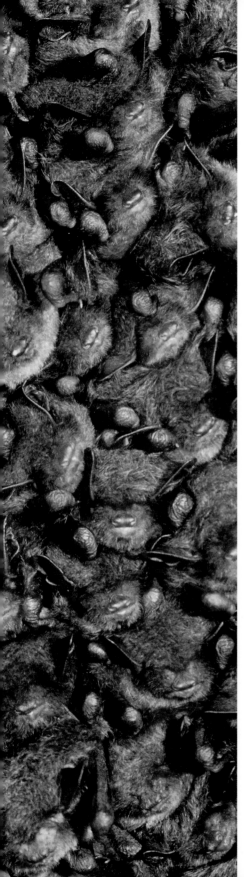

INDIANA BATS *Myotis sodalis*
OZARKS, ARKANSAS, USA

ABOUT THE ANIMALS

WHOOPER SWANS *Cygnus cygnus (page 44)*
HOKKAIDO, JAPAN

Whooper swans are famous for their loud, bugling calls. While vocalizing, they repeat their resonant *hoo-hoo-hoo* call up to a dozen times. This behavior has earned them the reputation of being the noisiest wild swans in the world. Whooper swans breed from Iceland across Eurasia along seacoasts, rivers, and lakes. Most of the eastern population migrates to the Japanese islands of Honshu and Hokkaido to pass the winter months. Others cross the Bering Strait to winter in the Aleutian and Pribilof islands.

At one time Icelanders believed that whooper swans possessed supernatural powers. At the end of the breeding season, the swans were thought to fly off to the moon. Lying on the ground in a tight flock, with their heads tucked under their wings, the white geese do literally disappear under a light blanket of drifting snow.

Whooper swans migrate both by day and by night. Like most birds, they use the position of the sun to tell them where they are during the day, and the position of the stars in the sky to guide them at night. It is thought that birds also navigate using low-frequency sound waves, polarized light, the Earth's magnetic field, and winds and smells. An internal clock tells the birds when to migrate, and an internal compass tells them where to go. How they keep time remains a mystery. Because migration flights are usually long and exhausting, many birds follow direct and unobstructed flyways over oceans or along coastlines and mountain ranges. Fifteen major avian flyways from breeding grounds to wintering areas have been identified around the globe.

Each year several hundred species of birds migrate hundreds of miles following the same traditional flyways. Fidelity to place is an interesting concept. In German, it is referred to as Ortstrue, meaning the tendency of individuals to return to the places used by their ancestors. They return in order to feed, to reproduce, or simply just to rest. The fixed migration routes of many different species of birds and animals best illustrate this phenomenon. Migratory animals stop at the same resting and refueling places en route to the same breeding and overwintering sites used by their ancestors. In many cases, the same nests and breeding territories are use by one generation after another.

MONARCH BUTTERFLIES *Danaus plexippus (page 48)*
MEXICO

Every year, 300 million monarch butterflies from North America vanish into Mexico in what is undoubtedly the greatest of all insect migrations. They flutter from as far north as Canada and the United States east of the Rocky Mountains to twelve ancestral wintering grounds in the remote mountains of Central Mexico. There, in semi-dormancy, they cling together for several months, so tightly packed on fir branches as to bejewel entire groves of trees in orange and black. The tree branches bend under the weight of 30 to 100 million butterflies packed into a three-acre area. From the air, the patch of butterfly forest glows bright orange as if on fire. The monarchs chose their winter roosting sites well. Located in Mexico's volcanic belt at altitudes over 9,000 feet, the sheltered trees sit on cool, north-facing slopes where low, moist cloud cover prevents desiccation and the tree canopy protects against winds and frost. Most important, the sites are thermally stable, with temperatures ranging from 42 to 60 degrees Fahrenheit—not cold enough to freeze the butterflies, but not warm enough to speed up their metabolism and thereby waste energy needed for flight and reproduction in the spring.

Monarchs evolved in tropical climates and are consequently unable to withstand freezing temperatures. Yet they are dependent on milkweed plants—which thrive in cooler climates—for food and protection. For this reason, monarchs spend part of the year in North America, where 100 different species of milkweeds flourish. Females lay their eggs on the underside of the toxic leaves. When the tiny caterpillars hatch three to twelve days later, they begin eating the leaves, ingesting the plants' poisonous cardiac glycosides. In just two weeks, the caterpillars grow to 3,000 times their birth weight. During the ensuing weeklong metamorphosis, the milkweed toxins are passed from caterpillar to butterfly. Birds quickly get the message to leave these brightly colored insects alone, as the bad-tasting toxins make them vomit.

With their food source in the temperate zone and their winter roosting areas in the tropics, monarchs solved the distance problem by becoming the only species in their family that migrates. Weighing one-fifth of an ounce, the fragile insects can fly eighty miles in a day. They reach their summer destinations by leapfrogging north in successive generations—several gen-

erations are born, breed, and die before the last generation reaches Canada in time for the winter migration south. With no previous knowledge of the route or the destination, the last generation fuels up on flower nectar and then flies by instinct 2,000 miles south to Mexico—right back to the same three-acre patch of forest. Propelled on breezes at speeds up to thirty-five miles per hour, these "flying flowers" make the return trip in six weeks.

LADYBIRD BEETLES *Hippodamia convergens (page 49)*
WHITE HORSE, WASHINGTON, USA

In California, the convergent ladybug hides in the forest litter of the Sierra Nevada foothills, thirty million per quarter acre. There they pass the winter months in a state of dormancy until temperatures, and their hormones, rise again. Then they mate, return to the upper valleys, lay eggs, and die. While some entomologists have expressed concern that commercial removal of these hibernating beetles may impact their overall population health, not a second thought is being given to the mass extermination of East Asian ladybugs (*Harmonia axyridis*) that recently invaded homes from Virginia to Washington. Released in the Southeast between 1978 and 1981 to kill tree aphids plaguing pecan orchards, these aggregating beetles have apparently decided that human homes are the next best thing to the granite out-croppings where they usually overwinter in Asia. Several Seattle-area homes have been invaded by 50,000 to 100,000 ladybugs crawling through the rooms and inside the walls.

Under normal circumstances, people are reluctant to kill these harmless insects. Worldwide, more than 4,000 species of ladybugs have been identified—475 in the United States alone. The name *ladybird beetle* originated from the belief that these polka-dotted insects were sent by the Virgin Mary to save crops—and since the Middle Ages, they have enjoyed a good reputation as aphid-killers. Advertised as the natural way to control pests, ladybugs can be purchased at garden stores by the pint or gallon. Pound for pound, they are voracious predators. A convergent ladybug can eat 100 aphids in a day—its fast-crawling larvae, forty in an hour. The recent Asian ladybug infestation illustrates the potential cost of mass migration gone astray. Business has boomed for insect control at the expense of frustrated homeowners. Even benign ladybugs, it seems, given the right conditions, can become pests.

INDIANA BATS *Myotis sodalis (page 50)*
OZARKS, ARKANSAS, USA

Indiana bats are selective when they pick a place to hibernate. They prefer caves where temperatures average 38 to 43 degrees Fahrenheit with relative humidities of 66 to 95 percent. In these climate-controlled subterranean chambers, their metabolism slows for a long winter slumber in pitch-black darkness from October to April. Indiana bats hibernate by the thousands attached to cave ceilings, packed 300 to 480 bats per square foot. In the spring, the females warm up and depart the winter caves before the males in order to arrive at their summer maternity roosts by mid-May. The following month, females give birth to a single offspring, which they raise in maternity roosts located under loose tree bark in insect-rich woodlands bordering streams. The summer roost of adult males is often near the maternity roost. Between August and September, Indiana bats return to their hibernation caves and engage in swarming and mating activity. During this time, they build up their fat reserves for hibernation by gorging on moths and other insects until mid or late October.

Studies of Indiana bats using radio telemetry have revealed that many individuals show site fidelity—they return to the same roosting and foraging areas year after year. Indiana bats can live thirteen years or more. Huddled tightly together on a cool, damp cave ceiling, they are a poignant reminder of the fragility and persistence of life. Should they be awakened during hibernation or lose their hibernation sites, they would perish. Winter bat counts conducted between 1983 and 1989 indicated that Indiana bat populations declined by 34 percent during this period. Now listed as endangered, fewer than 400,000 of these tiny bats range over the eastern United States from Oklahoma to northwestern Florida. Because roughly 85 percent of the species hibernate at just seven cave locations, the bats are particularly vulnerable to habitat loss or disturbance during the cold winter months. Often such endangered species owe their existence to a handful of dedicated people who understand their plight and work hard to protect them. Research biologist Michael Harvey is one such individual. He not only counts the bats to record fluctuations in their numbers but helps make sure that no one disturbs their winter sleep.

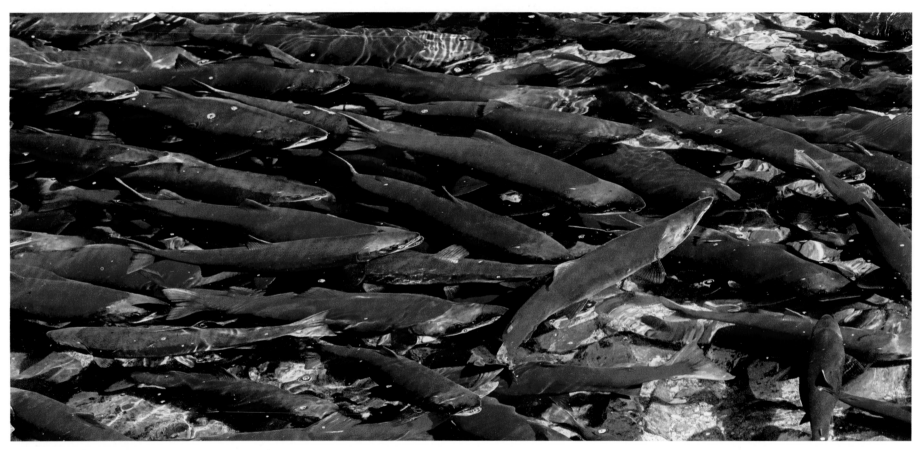

SOCKEYE SALMON *Oncorhynchus nerka*

KATMAI NATIONAL PARK AND PRESERVE, ALASKA, USA *(above)*

WOOD RIVER LAKES REGION, HANSEN CREEK, ALASKA, USA *(opposite)*

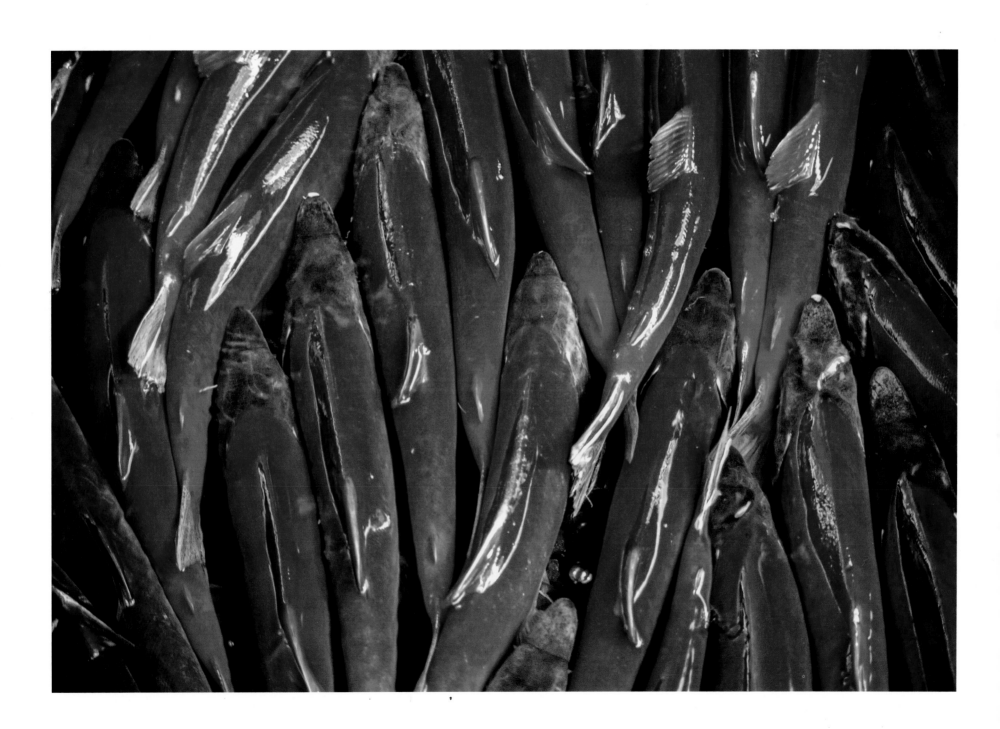

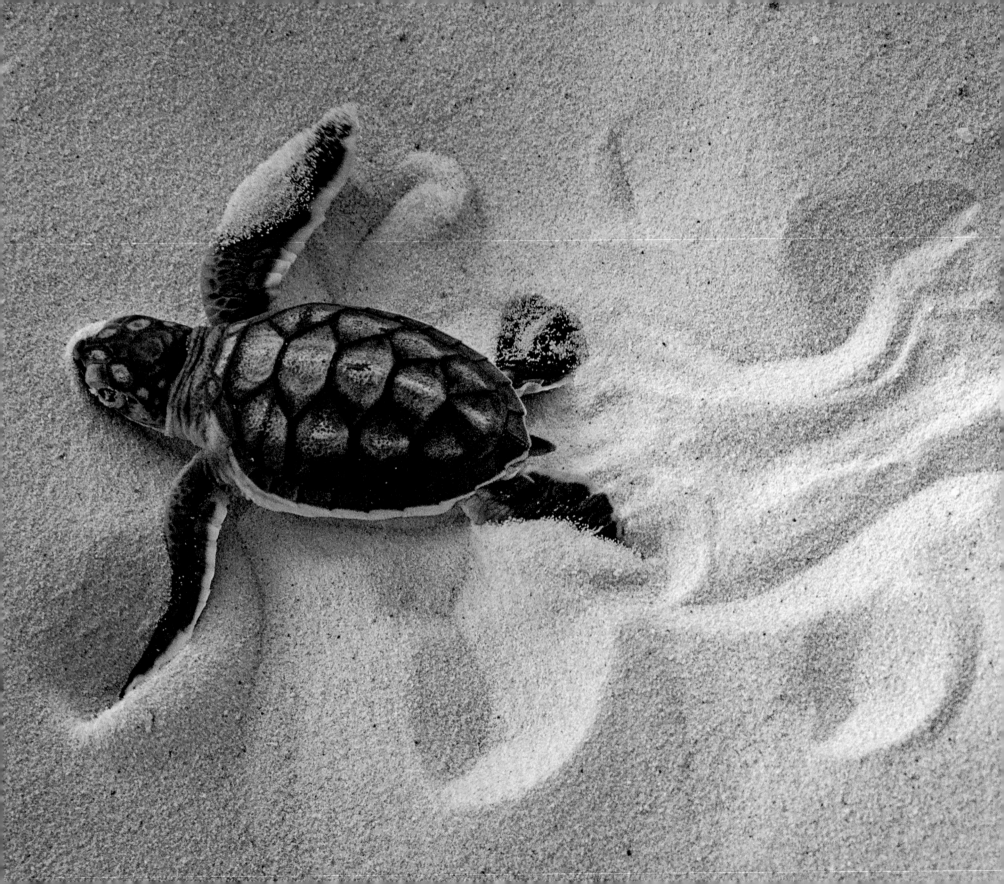

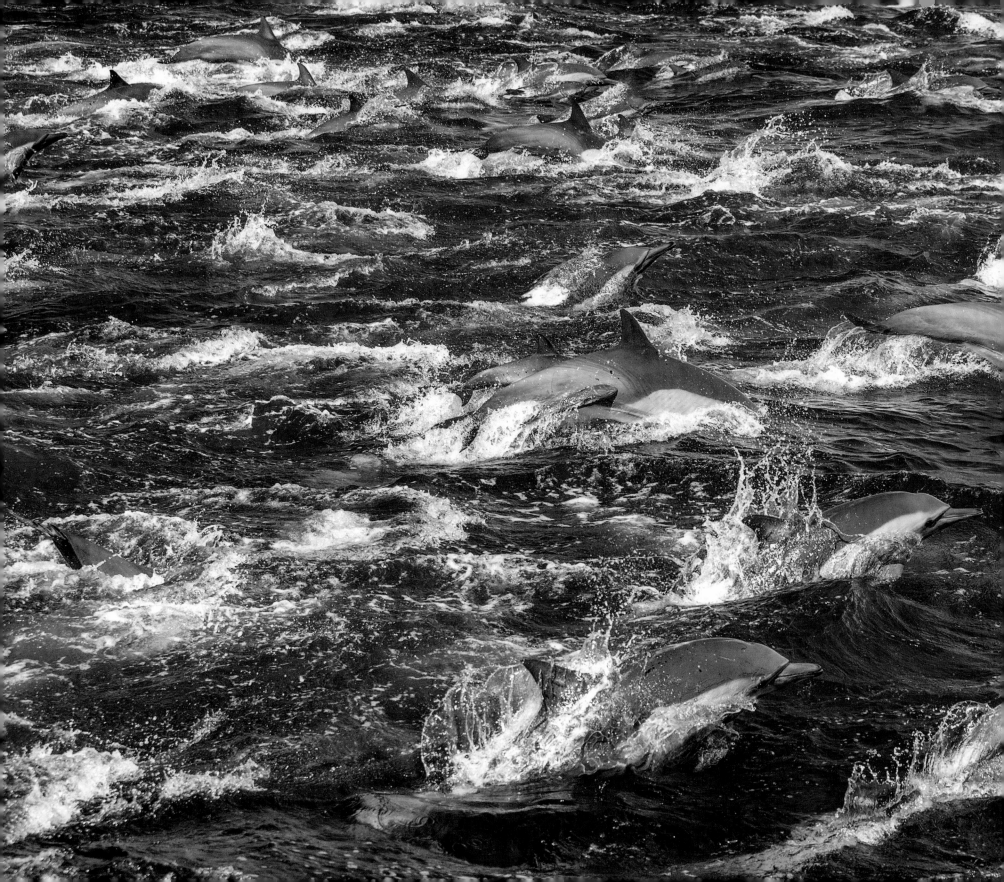

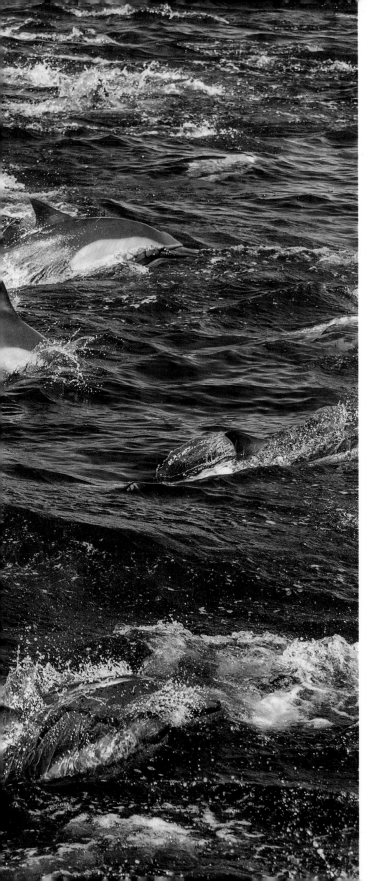

(previous pages) **GREEN SEA TURTLE** *Chelonia mydas*
MNEMBA ISLAND, TANZANIA

(left) **LONG-BEAKED COMMON DOLPHINS** *Delphinus c. capensis*
SEA OF CORTEZ, BAJA CALIFORNIA, MEXICO

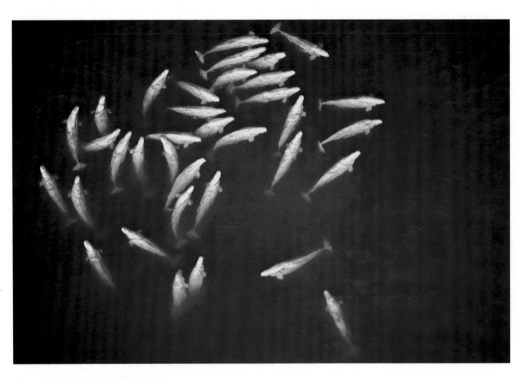

(above) **BELUGA WHALES** *Delphinapterus leucas*
SOMERSET ISLAND, CANADIAN ARCTIC

(right) **HUMPBACK WHALES** *Megaptera novaeangliae*
VAVA'U, TONGA

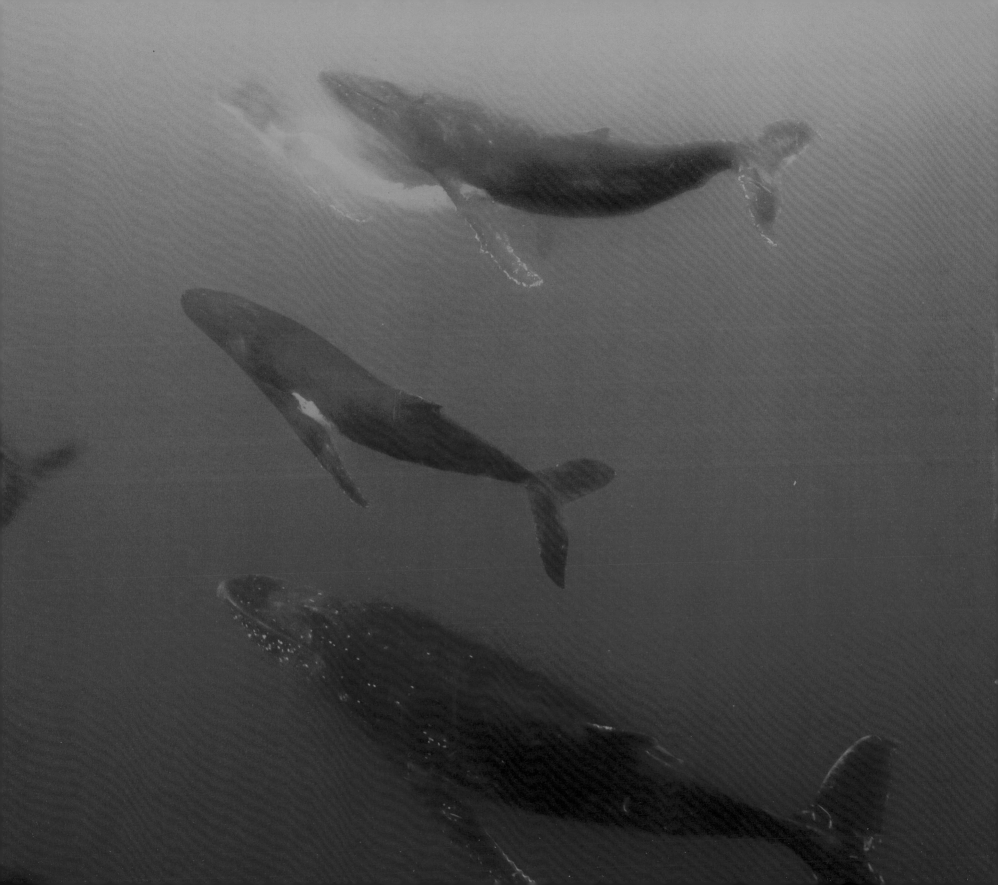

ABOUT THE ANIMALS

SOCKEYE SALMON *Oncorhynchus nerka (page 54)*
ALASKA, USA

After migrating thousands of miles in the open ocean, sockeye salmon return to spawn within yards of their birthplace. Salmon partially use topographical features to navigate, but they rely primarily on olfaction to relocate their freshwater birth streams. Fish have a keen sense of smell, and each river has its own odor signature created by the vegetation and soil. In addition, each genetic stock of salmon produces its own unique odor tag by releasing pheromones into the water. During the return migration, males sport vivid spawning colors and develop pronounces hooks and large canine teeth—and both sexes stop feeding. The journey upstream is difficult, and many never reach their spawning grounds. Those that do will die, exhausted, shortly after mating. Females lay two to four thousand eggs in gravel nests, or redds, which they guard until they die. The eggs hatch following a sixty-day incubation period. Sockeye fry live in large lakes for twelve to twenty-four months before they migrate downriver to the sea.

Many species of pelagic fish make regular seasonal movements and migrate long distances. Salmon are unique in that they spend time in fresh water at both the beginning and the end of a life cycle that also takes them out to sea. While at sea, the maturing salmon feed on baitfish and zooplankton, which thrive only in a narrow range of ocean temperature and salinity. Should surface temperatures rise more than a few degrees above normal, the production of zooplankton may be reduced, causing salmon populations to decline. Salmon are equally sensitive to changing river conditions. Because the ecological balance they require is so precise, salmon are a good indicator of the overall health of an environment. Their loss serves as a quiet warning.

Salmon are to the Pacific Northwest what bison were to the Midwest. They are intricately woven into the culture, history, and spirituality of the region. The annual return of the fighting, leaping fish has traditionally brought a renewal of life, not just for the spawning salmon, but to the many people and animals that depend on them as a source of food. In 1992, "Lonesome Larry" was the only sockeye salmon to return to Idaho's upper Salmon River. His precious sperm was frozen and used to fertilize one of the only two sockeye females that returned to Idaho in 1993. Conservation efforts to restore salmon runs in the Columbia River system now cost more than $300 million a year in taxes and lost power revenues. In 1994, virtually all commercial and recreational salmon fishing was banned along the Pacific coast from Mexico to Canada as a last-ditch effort to protect salmon stocks near extinction due to loss of habitat, overfishing, and warm ocean waters. The Clinton administration subsequently agreed to pay $16 million in federal disaster relief to the Northwest coastal communities hardest hit by this historic ban.

GREEN SEA TURTLE *Chelonia mydas (page 56)*
MNEMBA ISLAND, TANZANIA

Green sea turtles are found throughout the warm waters of the Atlantic, Pacific, and Indian oceans. They have been tracked swimming 2,800 miles in their circular migrations to and from nesting sites. Research conducted by the late zoologist Archie Carr showed that hatchlings enter the sea in a sort of swimming frenzy, paddling toward open sea with enough yolk attached to them to survive without food for two or three days. The frenzy subsides when the baby turtles reach huge rafts of floating seaweed, often fifty miles out to sea. They remain there to safely feed and grow until they are big enough to swim and glide around the coastal reefs and shallow-water flats.

LONG-BEAKED COMMON DOLPHINS *Delphinus c. capensis (page 58)*
SEA OF CORTEZ, BAJA CALIFORNIA, MEXICO

Ocean dolphins range from the 12,000 pound killer whale, or orca, to the 120 pound Hector's dolphin. Although they vary greatly in size and appearance, they do have several commonalities: a single blowhole on the top of the head, conical teeth, and a dorsal fin at the center of the back. There are at least thirty-three species, if not more; the common dolphin species was split into two in the 1990s, the long-beaked and short-beaked. They are medium-sized, reaching about nine feet in length and 330 pounds. The long-beaked common dolphin is somewhat more restricted than its short-beaked cousin, living within about 110 miles of coastlines where the water is shallower, warmer, and more productive from the upswelling from deep underwater canyons. Aggregating in numbers sometimes into the thousands, these dolphins are playful, acrobatic, and extremely intelligent.

They work together in groups to herd together prey, and they will bow-ride ships for hours at a time jockeying for the best position where they can be pushed along by the force of the waves. They are very noisy, their high-pitched vocalizations can be heard above the water's surface.

Capable of diving to at least 900 feet and holding their breath for up to eight minutes to feed on prey, they hunt in the afternoon and at night. They use echolocation, emitting sounds into the environment and listening for the echoes that return from nearby objects. The majority of their diet consists of small schooling fish such as anchovies and sardines, krill and squid, which they grasp with their small, sharp teeth. In fact, they have the highest number of teeth of all delphinids with up to sixty-seven in each row. Little escapes these streamlined swimming machines as they can swim at speeds approaching twenty-five miles per hour.

BELUGA WHALES *Delphinapterus leucas (page 60)*
SOMERSET ISLAND, CANADIAN ARCTIC

From June to September, beluga whales congregate by the hundreds and thousands at the traditional breeding estuaries where they give birth. These ten- to sixteen-foot-long whales are unusual in the whale family because of their white coloration, well-defined necks, and ability to make a variety of agile body movements and facial expressions. Belugas have remarkable control of their bodies, using their flippers to swim in reverse, glide within inches of objects, and literally "stop on a dime." Their Latin name, *Dephinapterus*, which means "dolphin without a wing," refers to the fact that these smooth-backed whales lack true dorsal fins. Highly vocal, belugas moo, chirp, clang, clap their jaws, and whistle so loudly that at times their loquacious vocalizations can be heard above water—which explains why they have been affectionately dubbed "sea canaries." While feeding on schooling fish, belugas work closely together in small groups, forcing the fish into shallow water where they are more easily caught. To dislodge prey from the bottom, the white whales use suction and carefully aimed jets of water. Newborn belugas are camouflaged in brown, lightening to gray and then to white as they mature. Suckling for up to two years, the young whales remain close to their mothers during this time.

HUMPBACK WHALES *Megaptera novaeangliae (page 61)*
VAVA'U, TONGA

Weighing thirty to forty tons and reaching lengths up to forty-five feet, the singing, somersaulting humpbacks are found in all the world's oceans and adjoining seas. The humpback gets its Latin name *Megaptera*, or "big-winged," from its enormous front flippers, the largest of any cetacean. These showstopper fins enable these gentle giants to jubilantly leap and glide through the water and to embrace their mates during amorous courtship displays. It has been said that few creatures lead a happier life or enjoy it with greater zest than the humpback. In addition to their playful acrobatics, they are the most vocal of all cetaceans, producing siren-like serenades through their blowholes. Humpbacks produce one of the longest and most patterned songs in the animal kingdom. Heard only in the tropics during the winter breeding season, their plaintive, rhythmic moans and cries are repeated over and over for hours at a time.

Humpbacks migrate to temperate and polar latitudes to feed during summer and toward tropical latitudes to breed in winter. These bus-sized behemoths maintain their girth by eating the tiniest of prey—small fish and crustaceans. With pleated throats that expand like bellows and a meg-mouth full of stiff baleen brushes, humpbacks playfully corral their prey in a net of air bubbles.

Easily exploited by commercial whalers due to their offshore accessibility and predicable migration routes, humpbacks were nearly decimated by the middle of the twentieth century. From an original population of 125,000, as few as 3,000 remained when hunting was finally banned by international treaty in 1964. While their populations have now stabilized at around 10,000, humpbacks remain at risk. Vulnerable to pollution, increasing boat traffic, and disturbance from well-meaning whale-watchers, humpbacks also get entangled in fishing nets. More important, krill, the humpbacks' prime food resource, is now being harvested for consumption by people and livestock. Whale biologist Roger Payne has commented, "If we can't save the whales, we can't save anything." The humpback whale is another example of the international cooperation required to save an endangered species.

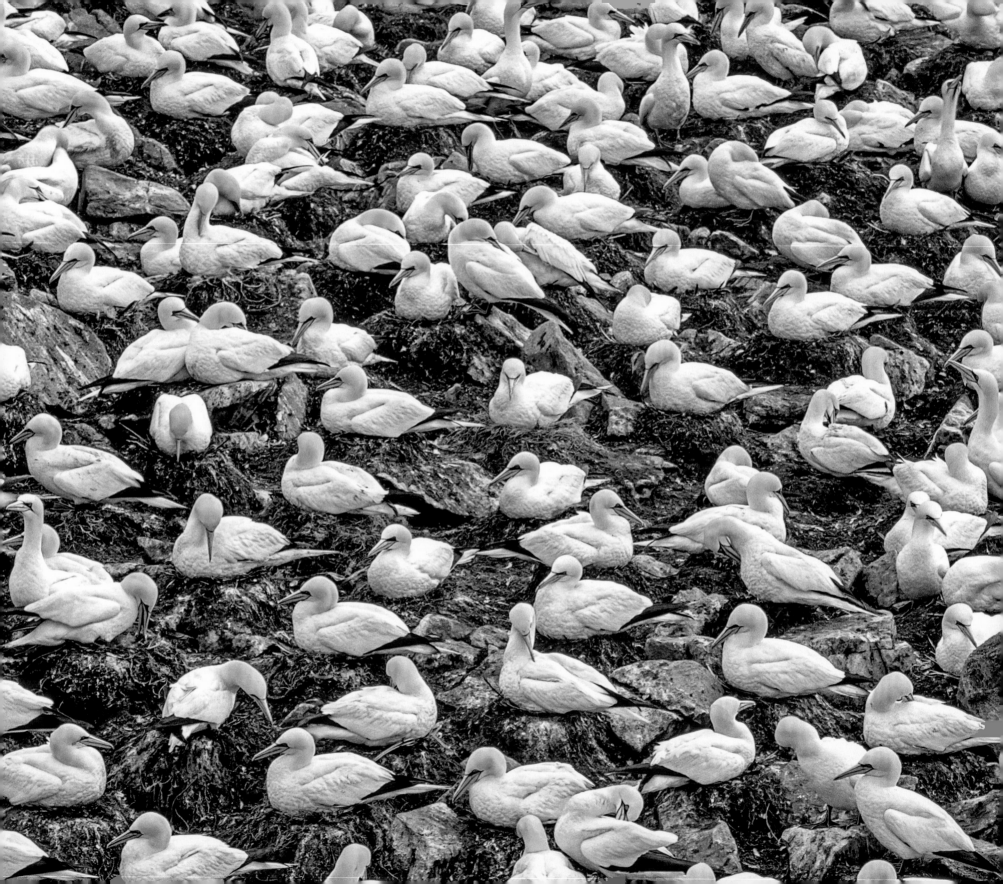

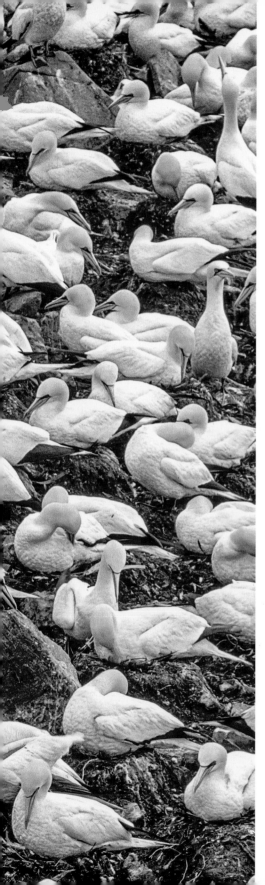

NORTHERN GANNETS *Morus bassanus*
NEWFOUNDLAND, CANADA

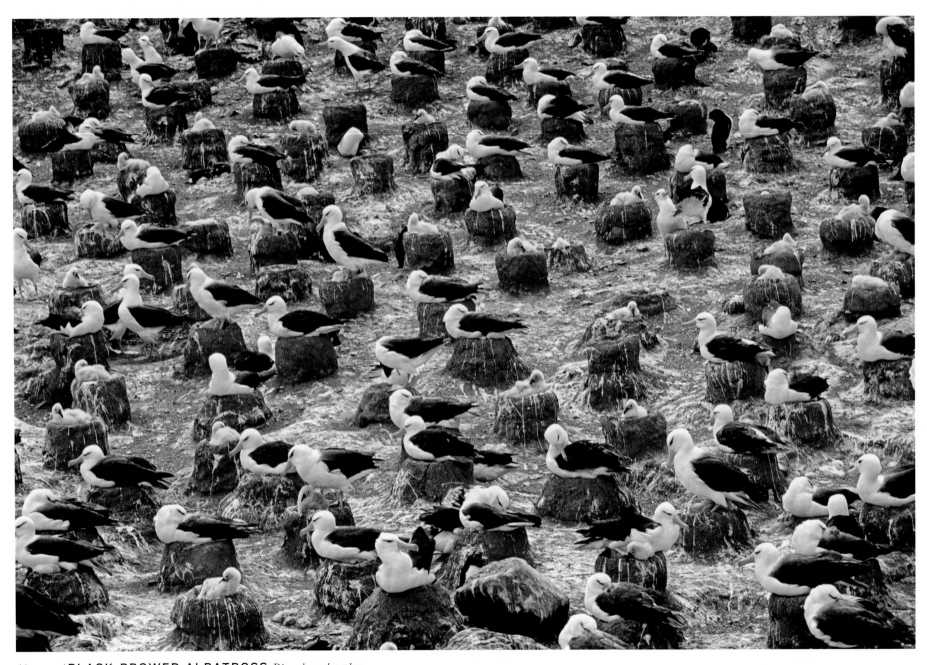

(these pages) **BLACK-BROWED ALBATROSS** *Diomedea melanophrys*

FALKLAND ISLANDS

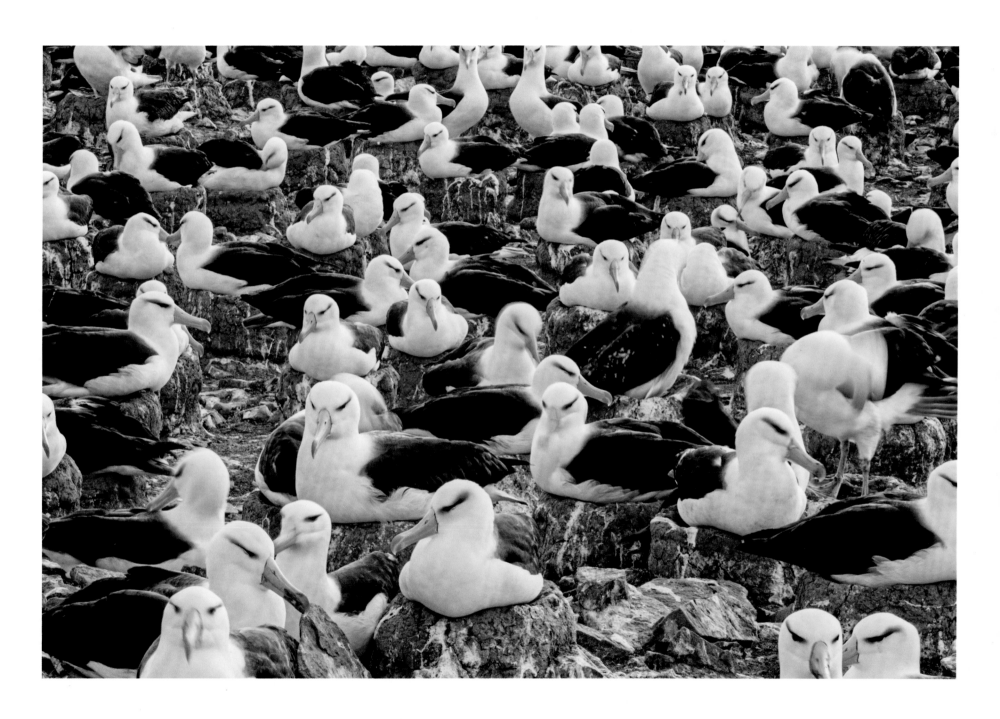

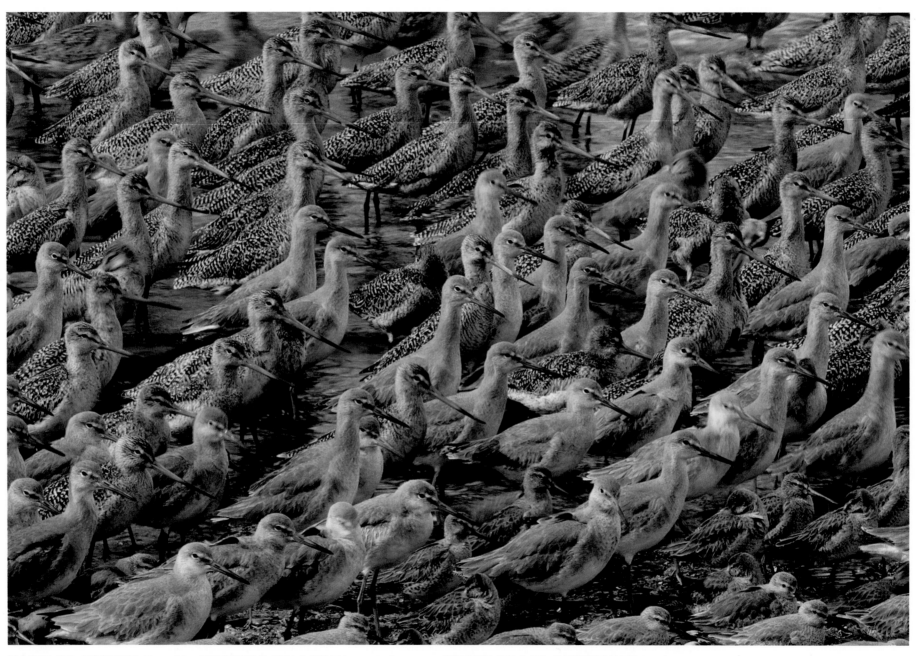

MARBLED GODWIT *Limosa fedoa*, **WESTERN WILLET** *Tringa semipalmata*, AND **SHORT-BILLED DOWITCHER** *Limnodromus griseus*

LAGUNA SAN IGNACIO, BAJA CALIFORNIA, MEXICO

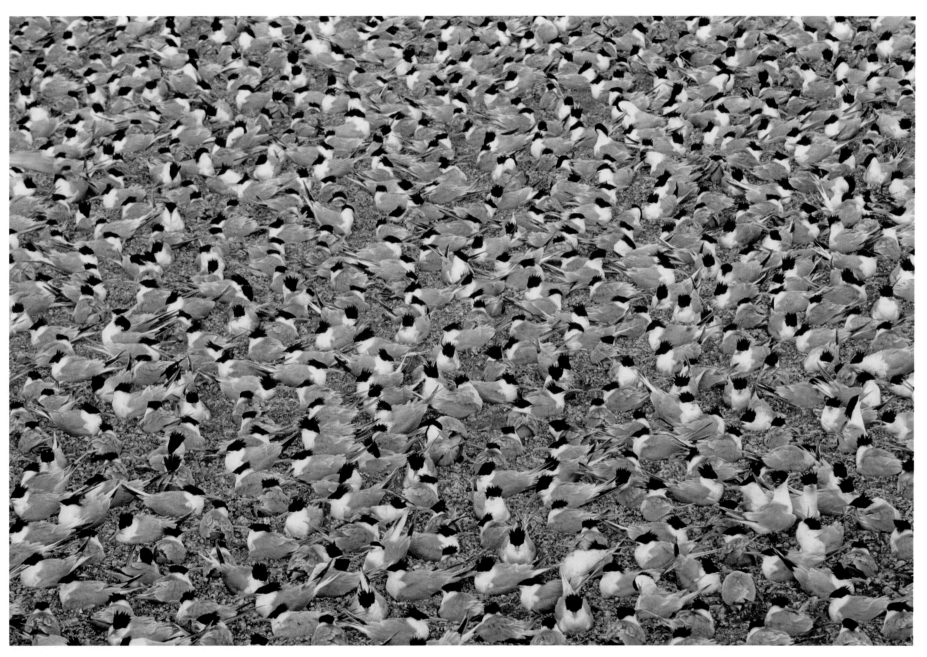

ELEGANT TERNS *Sterna elegans*

ISLA DE RASA, MEXICO

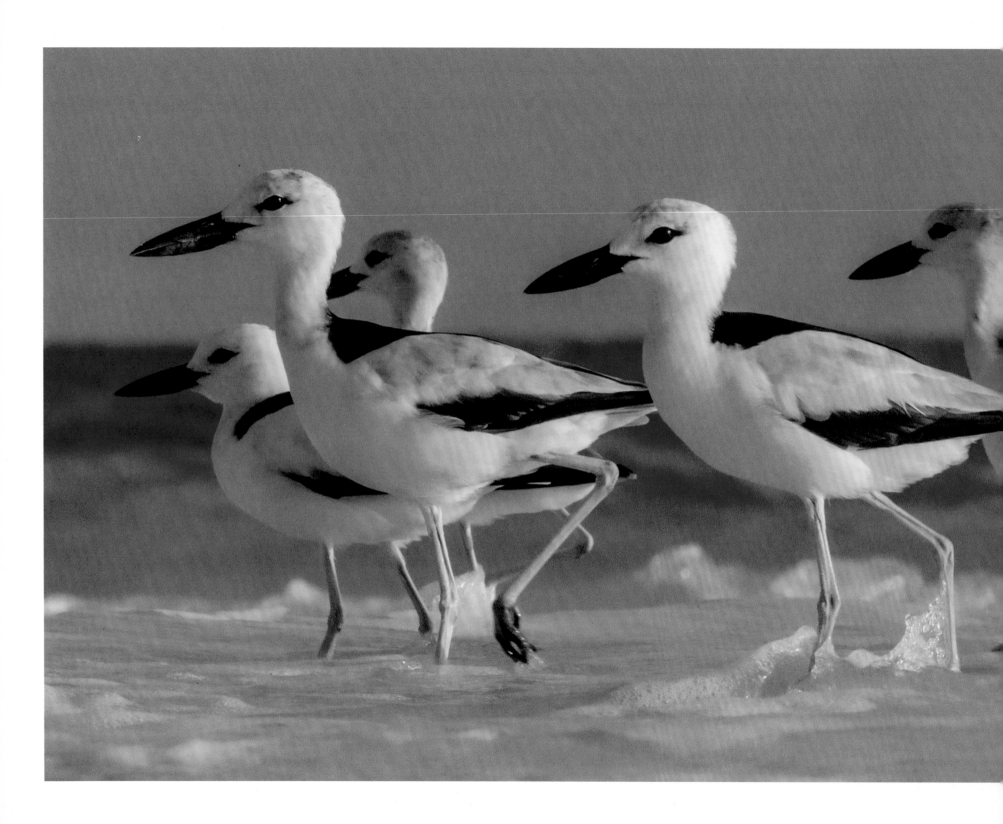

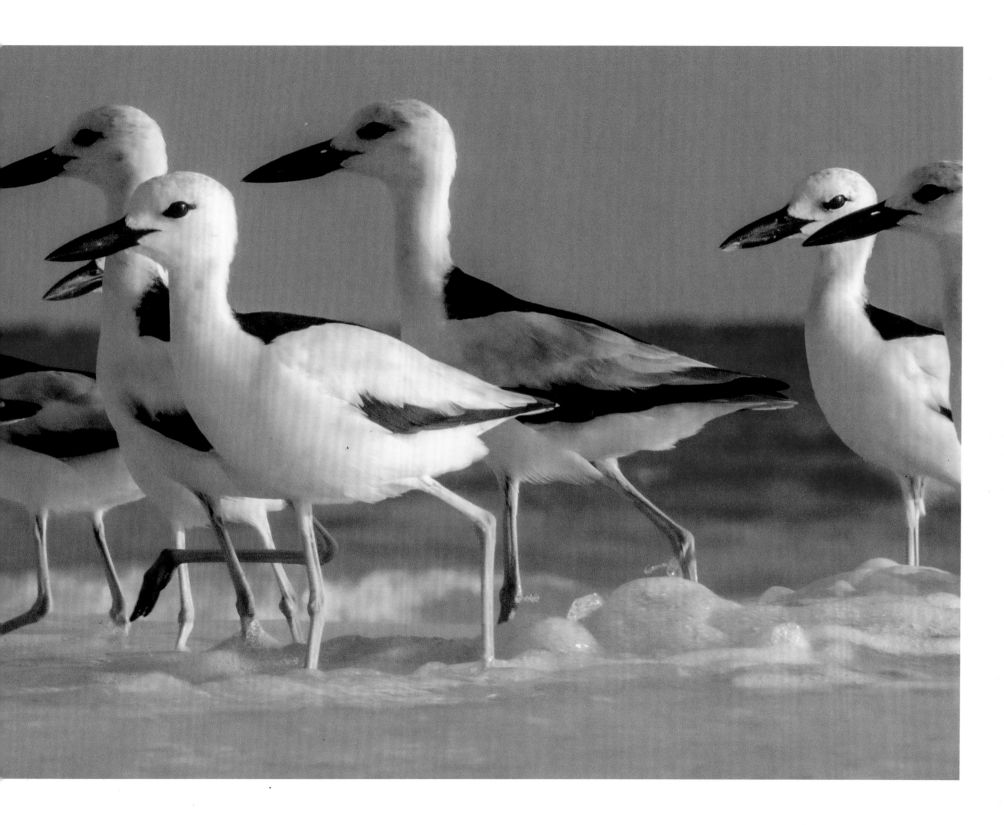

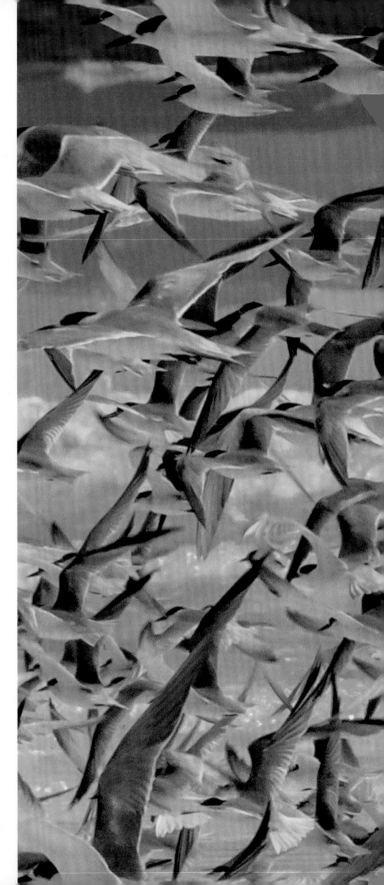

(previous pages) CRAB-PLOVER *Dromas ardeola*
MNEMBA ISLAND, TANZANIA

(right & following pages) WHITE-CHEEKED TERNS *Sterna repressa*
MNEMBA ISLAND, TANZANIA

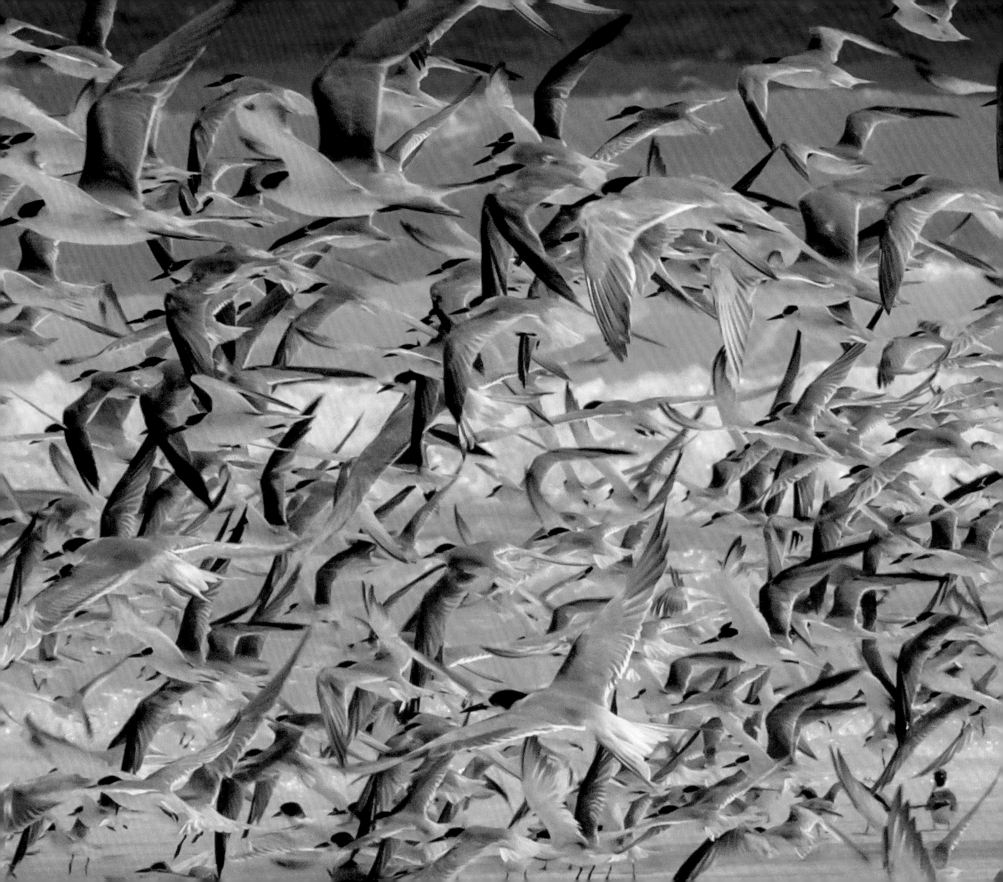

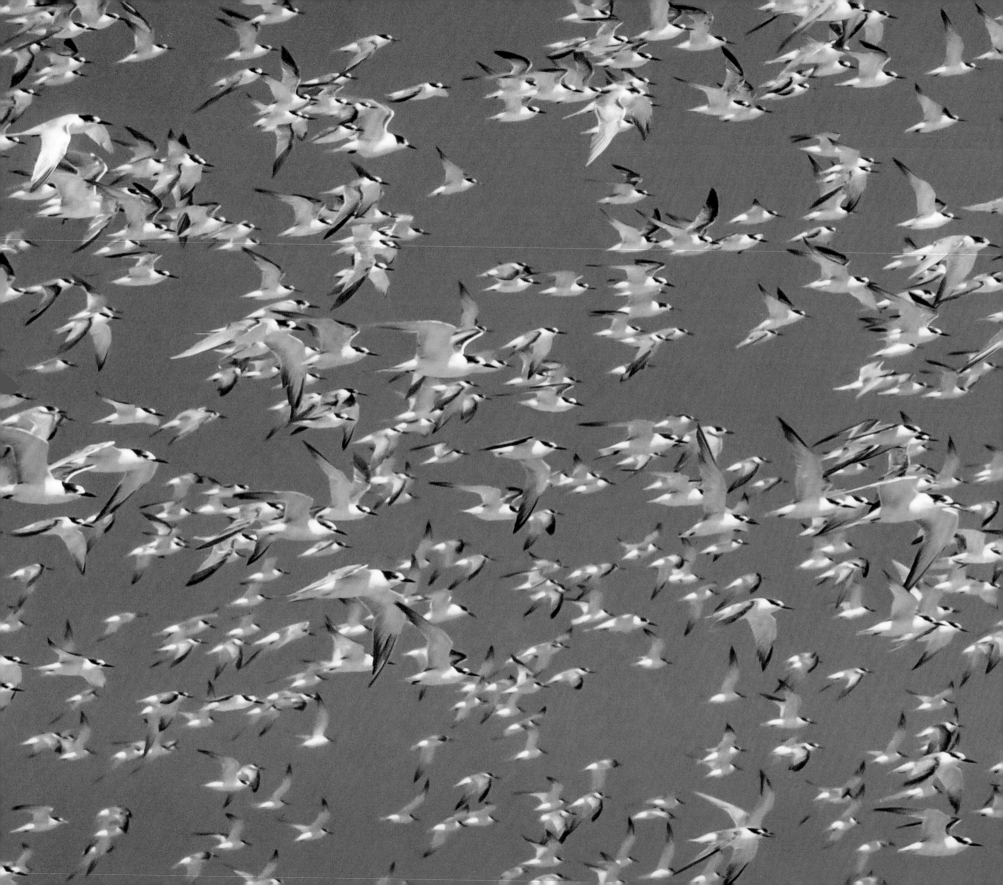

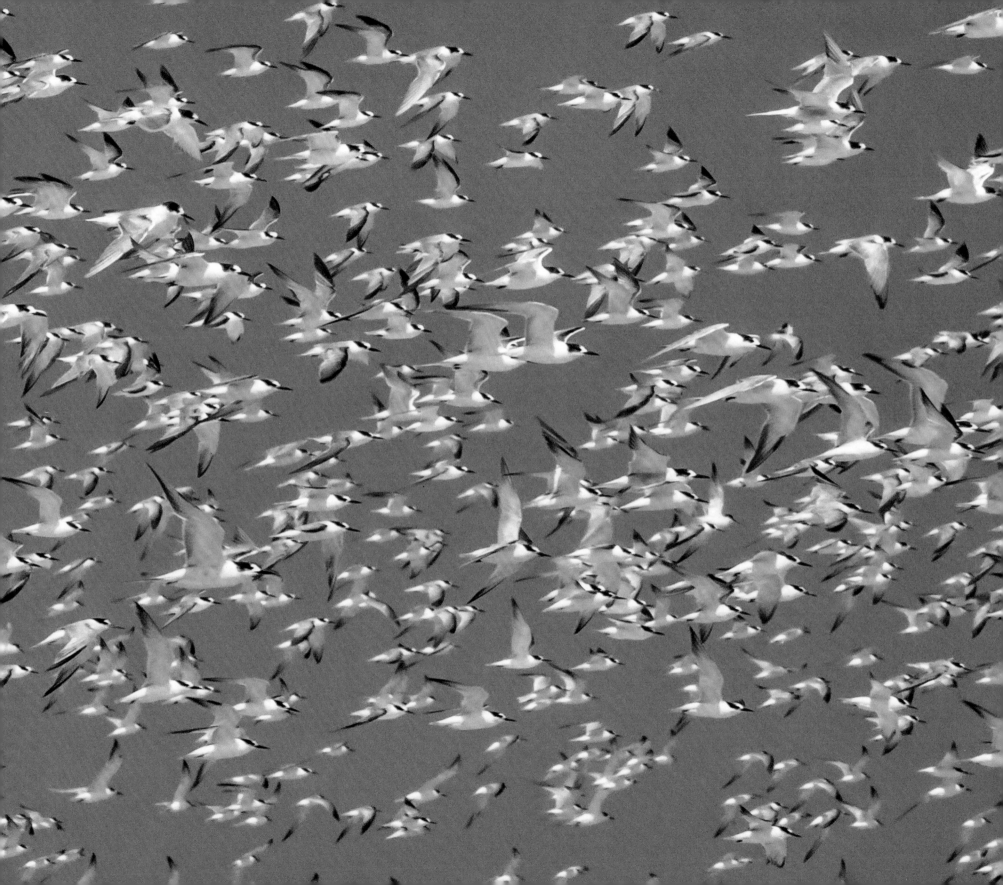

ABOUT THE ANIMALS

NORTHERN GANNETS *Morus bassanus (page 64)*
NEWFOUNDLAND, CANADA

The northern gannet is the only member of the booby family that nests in northern latitudes. They winter along the eastern coast of the United States from Massachusetts south to Florida. At their summer rookeries farther north, they utilize every available niche to build their nests. Quarreling over space is common. When hungry, gannets turn into fish-seeking missiles, plunging into the water from heights of fifty feet or more. A reinforced skull and air cells in their chest and neck help to absorb the impact. Hatchlings are fed a diet of partially digested fish regurgitated by both parents. The adults take turns guarding their nest, using a series of vocalizations and displays that help the approaching mate find its nest and partner among thousands. The start of the southward migration in September is a tough time for young gannets. Too fat to fly, they jump or fall off cliffs and glide into the sea. Learning how to fish and waiting until their wings are strong enough for sustained flight, they survive for several weeks on their body fat. Under fledgling conditions such as these, it is little wonder that only 26 percent of young gannets survive their first year, and only 18 percent reach adulthood. One of the largest northern gannet rookeries in North America is located on Bonaventure Island in the Gulf of St. Lawrence. Approximately 45,000 birds congregate there every summer.

BLACK-BROWED ALBATROSS *Diomedea melanophrys (page 66)*
FALKLAND ISLANDS

Albatross are the largest of all tube-nosed seabirds. The black-browed albatross glide on stiff outstretched wings that measure seven to eight feet across. Because they weigh nearly nine pounds and their legs are rather short, albatross usually take off on land or water by running into the wind or by simply dropping off a cliff into the air. Their long wings, their ability to drink salt water, and their diet of small seabirds and fresh seafood make it possible for albatross to ride the winds of the world's oceans for months at a time. They need to be on land only to breed, at which time they head for remote, uninhabited oceanic islands, where monogamous pairs perform elaborate courtship displays.

The black-browed albatross, named for the black line running through and over its eyes, is the most abundant of the albatross species found from the Antarctic to the Tropic of Capricorn in the Southern Hemisphere. Fearless at sea, they can often be seen closely following ships in pursuit of tossed garbage. Because of this trait, they were easily caught by European sailors in the nineteenth century who baited barbless hooks with fat. Black-browed albatross nest on ice-free oceanic islands during the summer months. They fill the air with cacophonous calls as they compete with each other for space. Mated pairs build cuplike, foot-high nests out of mud and grasses, and both parents incubate the single egg. It takes their chick nearly four months to mature. During that time, the chick is almost helpless—except for one defense. Should a skua or other bird of prey come too close, it will be hit with a fishy blast of projectile vomit.

Rockhopper penguins, adorned with decorative yellow or orange head plumes, are the smallest and most widespread of the six species of crested penguins. Millions of them live on the Falkland Islands, millions more on islands in the southern Indian Ocean. Nesting in huge noisy colonies, the birds seem to bicker and bray constantly. They are called rockhoppers because of their habit of bouncing from one rock to another as they travel about the boulder-strewn islands where they nest. Unlike many of the other penguin species, rockhoppers also jump into the water feet-first.

MARBLED GODWIT *Limosa fedoa,* **WESTERN WILLET** *Tringa semipalmata,* AND **SHORT-BILLED DOWITCHER** *Limnodromus griseus (page 68)*
LAGUNA SAN IGNACIO, BAJA CALIFORNIA, MEXICO

The godwit, willet, and dowitcher are wading birds in the sandpiper family that primarily nest in the tundra, prairies, and marshy shores of North America and winter in warm southern coastal marshlands. The dowitchers are among the first to migrate south, leaving their northern breeding grounds as early as July and flying as far as Brazil. The largest of the three is the godwit, weighing in a over a pound and with a wingspan of up to

thirty-five inches. While also on the large side, the willet is a very noisy bird with several distinct calls.

Different bill lengths enable these different species to co-exist in the same habitat; they probe in the mud, soil, and sand for small insects, mollusks, crustaceans, and worms. All three lay their spotted, camouflaged eggs in simple scrapes and depressions in open areas. Because some of their breeding grounds are also suitable for farming, their populations are in decline.

The Laguna San Ignacio is part of the El Vizcaino Biosphere Reserve, the largest wildlife refuge in Mexico and home to species as diverse as desert bighorns and pronghorns, resident and migratory birds, and marine mammals such as gray whales and northern elephant seals.

ELEGANT TERNS *Sterna elegans* *(page 69)*
ISLA DE RASA, MEXICO

If people drink seawater, they become more thirsty, dehydrate, and eventually die. The reason is because our kidneys need additional fresh water in order to eliminate the excess salt, and get it by desiccating body tissues and organs. In order to survive, birds also must limit the concentration of salt in their blood and body fluids to about 1 percent—less than a third the concentration of salt found in seawater. Elegant terns, like all seabirds, ingest large amounts of salt in their food and drinking water, yet they avoid dehydration. Their survival secret lies in the two salt glands positioned near their eye sockets. The glands draw excess salt from the bird's circulatory system to produce a fluid with a concentration of salt higher than seawater. Petrels forcibly shoot this saline liquid out of their tubular nostrils, whereas in most seabirds it just dribbles out. This explains why vigorous head-shaking is so characteristic of seabirds—they are literally shaking away their excess salt.

CRAB-PLOVER *Dromas ardeola* *(page 70)*
MNEMBA ISLAND, TANZANIA

A bird of the coasts and islands of the Indian Ocean, the crab-plover is fascinating in that it makes use of solar-assisted incubation. Also unusual is that it uses its surprisingly powerful, slightly webbed feet to excavate burrows in sandy banks on islets and coastal dunes. The insulating and humid properties of the sandy burrow make for ideal conditions for egg development and the parent birds are able to leave for many hours at a time, only returning to turn the egg and slightly warm it if needed. Only one other family of birds, the stocky, chicken-like megapodes of Australasia, are known to hatch their eggs without contact incubation.

Raucous and gregarious, crab-plovers look like oversized plovers with thick, tern-like bills, with which they stab and break open crabs, small mollusks, and probe for marine worms. They are easy to identify with their conspicuously white head and neck, black saddle, and white "V" on the lower back. Because of its nocturnal and crepuscular feeding habits, its eyes are large. Sometimes in the thousands they flock together at communial high-tide roosts as well as to feed on mud- and sandflats and on exposed coral reefs. They are also colonial breeders, with 1,500 pairs of birds not uncommon at remote and isolated places. While the species remains present throughout its range, many do migrate south between August and November and return north between March and April.

WHITE-CHEEKED TERNS *Sterna repressa* *(page 73)*
MNEMBA ISLAND, TANZANIA

Highly gregarious, white-cheeked terns are endemic to the northwestern Indian Ocean, ranging from the Red Sea south to around the Horn of Africa and east to India. They nest with other tern species on islands and coral barrens. A small scrape in the rock or sand suffices for a nest.

Terns are champion migrators. Their long tails, narrow wings, and lighter bodies allow for exceptional long-distance flight. In addition to being tireless fliers, they are aerial acrobats, hovering over prey then diving knife-like into the water. Opportunistic, they often hunt with predatory marine animals like tuna and porpoises, as these animals drive prey species to the ocean's surface. This makes for easier pickings.

Unfortunately, like most terns, the white-cheeked is in decline because of loss of habitat, chemical exposure, and egg-hunting.

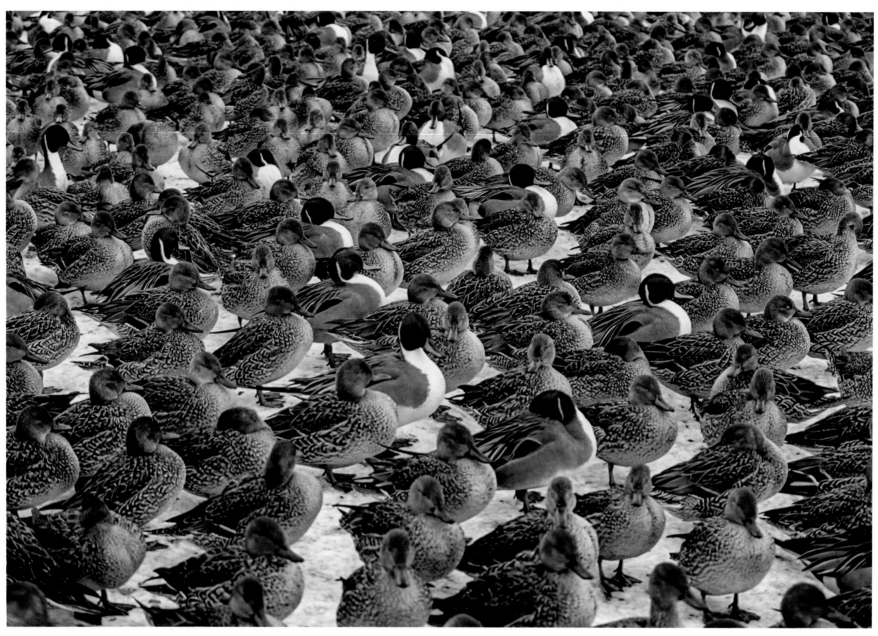

NORTHERN PINTAILS *Anas acuta*

HONSHU, JAPAN

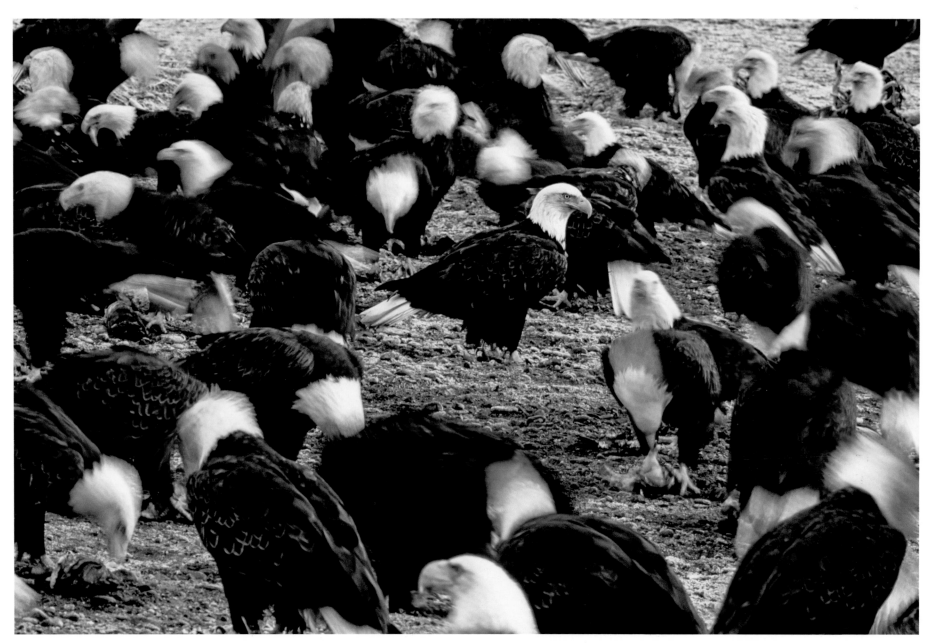

BALD EAGLES *Haliaeetus leucocephalus*
SOUTHEAST ALASKA, USA

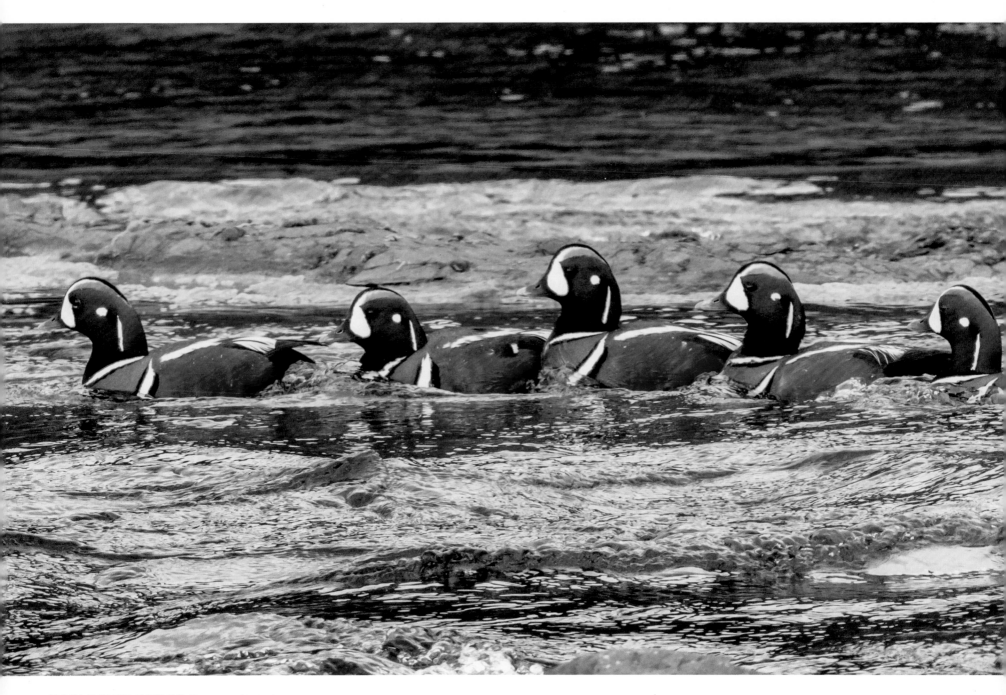

HARLEQUIN DUCKS *Histrionicus histrionicus*
ICELAND

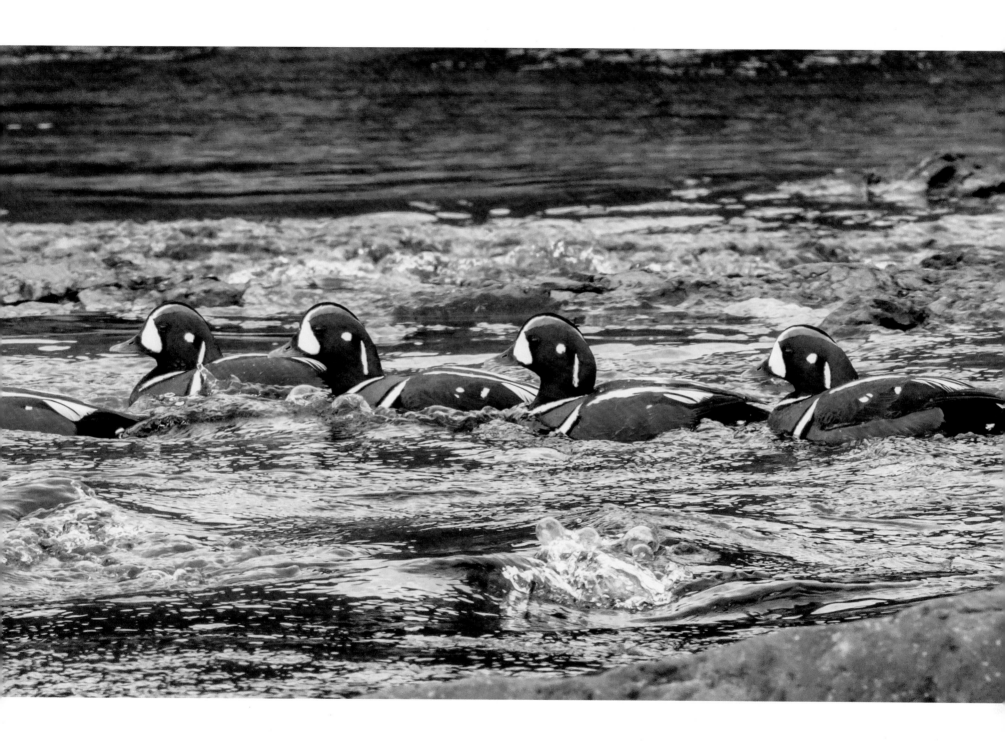

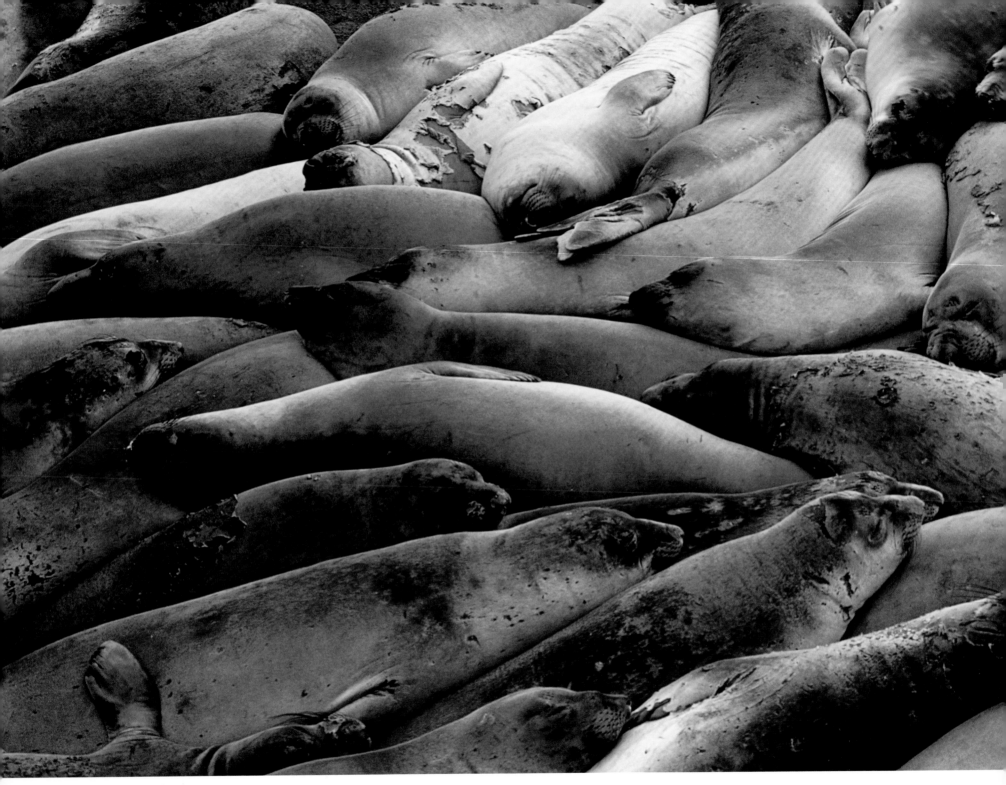

NORTHERN ELEPHANT SEALS *Mirounga angustirostris*
AÑO NUEVO STATE RESERVE, CALIFORNIA, USA

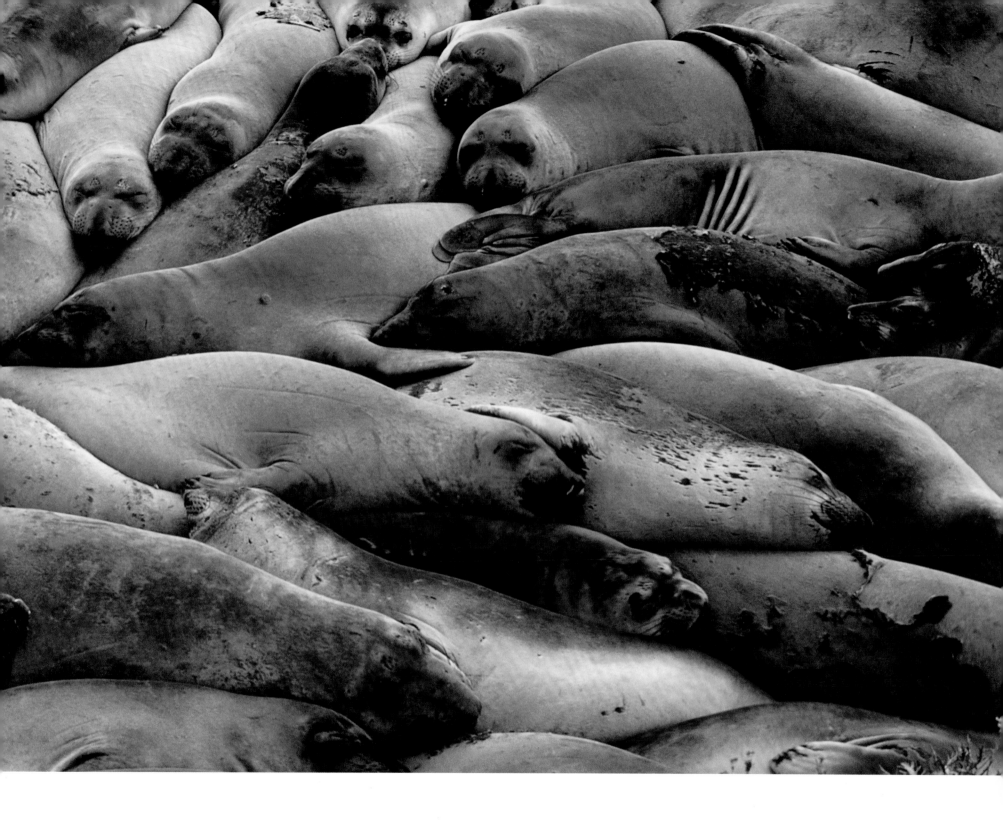

ABOUT THE ANIMALS

NORTHERN PINTAILS *Anas acuta (page 78)*
HONSHU, JAPAN

With the rapid wing beats typical of most ducks, pintails are fast, graceful fliers. During takeoff, they leap out of the water and launch immediately into the air. As with other dabbling ducks, pintails feed almost exclusively in shallow water on a diet that includes everything from seeds and plants to crayfish, worms, and aquatic insects. Pintails search for food by bobbing at the surface, "tails up," and extending their long necks underwater. They maintain this feeding position with forward thrust from their paddling webbed feet.

Found in ponds and lakes throughout the Northern Hemisphere, these familiar dabbling ducks are second only to the mallard in abundance. Their nickname, "sea pheasants," refers both to their coloration and palatability. Pintail females resemble female mallards in their cryptic brown plumage, but they have longer necks and pointed tails. A coating of oil on their feathers keeps them waterproof and warm, even in the coldest weather.

Pintails begin their northern migration to spring nesting sites early in the new year. Females build nests of moss, leaves, sticks, and grass, lining them with their own downy feathers. Feathers are important to all waterfowl, making it possible to fly, stay waterproof and warm, and advertise the identity of their species to others. A single duck may be covered with more than 11,000 feathers. These it carefully preens, literally zipping up the barbules, or spines, of each feather to keep them structurally waterproof. While preening, ducks also coat their feathers and the scales of their feet with an oily substance produced by a special heart-shaped gland located above the base of the tail. This secretion of fatty acids, wax, and fat helps waterproof the feathers and maintain the gloss and surface structure of the bill. It is also said to contain a precursor of vitamin D, which when activated by sunlight, may help prevent the development of rickets in some birds.

BALD EAGLES *Haliaeetus leucocephalus (page 79)*
SOUTHEAST ALASKA, USA

Both in legend and symbolism, bald eagles figure prominently in Native American cultures. According to Haida legend, the bald eagle is Chief of the Sky Beings. Zuni Indians carve stone fetishes to pay homage to the Eagle, Hunter God of the Upper Regions. In keeping with this tradition, the majestic bald eagle was also chosen as the national symbol of the United States. These fierce-eyed predators once bred throughout North America. Habitat loss, pesticide poisoning, and poaching subsequently endangered the white-headed eagles in all the lower forty-eight states except Washington, Oregon, Minnesota, Wisconsin, and Michigan, where they are considered threatened.

For years, field research has been conducted on local animal populations using radio telemetry. In a landmark study conducted in 1984, scientists at the Army Research and Development Office at the Aberdeen Proving Grounds in Maryland tracked the movements of a bald eagle using satellite telemetry. Researchers attached a specially designed transmitter pack to a bald eagle. Signals from the transmitter were received by Argos DCLS instruments aboard two Tiros-series weather satellites on polar orbits. The signals were then transmitted to ground telemetry stations and relayed via commercial communications systems to processing facilities in Suitland, Maryland. From there the information was isolated and forwarded to Argos data-processing centers in Landover, Maryland, and Toulouse, France. It was then made available to the scientists via computer, telex, telephone, and other data-transmission networks. In all, it took between thirty minutes and three hours to transmit a message from the eagle to the scientists via satellite and ground links.

During the 244 days that the transmitter functioned, it provided one location fix per day on the bald eagle. To the surprise of everyone involved, the eagle flew from the Chesapeake Bay area to central Pennsylvania, then south to northern Florida, then north to the James River region of Virginia, and

then on to North Carolina, returning within miles to its birthplace and the site where it had first been banded. The groundbreaking results were the first indication that a migrating bald eagle does not travel a straight route between two points. The study also provided the first look at how far a migrating bald eagle flies in a day and which habitats it uses during migration.

Today, satellite telemetry is making it possible to learn about the daily movements, migration patterns, and critical habitats of remote wildlife around the world. In fact, as this is being written, a satellite circling the cold vacuum of space is picking up signals from migrating caribou in North America, elephants in Africa, narwhals in Greenland, and migrating whales in the Pacific. By revealing the previously unknown migration paths of numerous wildlife species, space-age technology is now giving animals a "voice" in their own management and conservation.

HARLEQUIN DUCKS *Histrionicus histrionicus (page 80)*
ICELAND

Widespread and common in the Northern Hemisphere, the harlequin duck is a short distance migrant. They nest in the uplands near boulder-strewn, whitewater streams and winter on rocky seashores. In more temperate areas they are seen all year round on rugged headlands where currents create surges. They thrive in rough water—even the downy ducklings can dive quickly and navigate rapids easily. The harlequin duck is named for the clownish plumage of the males, unmistakable by virtue of their flamboyantly patterned slate gray and chestnut plumage. The females are an unremarkable brownish-gray with white patches on their heads.

NORTHERN ELEPHANT SEALS *Mirounga angustirostris (page 82)*
AÑO NUEVO STATE RESERVE, CALIFORNIA, USA

Northern elephant seals are a recovery success story. Nearly annihilated for their oil by sealers in the nineteenth century, their population has increased from an estimated twenty animals to over 170,000 today. Their Latin name refers to the more slender snout of the northern elephant seal as compared to its relative the southern elephant seal, the largest seal in the world.

These massive and imposing animals are found in the eastern North Pacific. Males have been weighed at over 8,000 pounds and over sixteen feet in length, but more commonly about 4,400 pounds and thirteen feet long; the females are much smaller at 1,400 pounds and eleven feet long, still a big seal. The giant bulls throw their weight around during breeding season; while they are not very territorial, they compete mostly vociferously, though at times violently, to mate with as many females as they can.

Once they leave the rookeries, of which there are over a dozen well known in California and Baja California, the seals spend nearly ninety percent of their time underwater. The deepest diving seals, they can dive easily to 2,600 feet for over an hour at a time; the deepest recorded is 5,141 feet. Squid is the most common food source along with fish that inhabit the mesopelagic or oceanic twilight zone from 660 to 3,300 feet; some even forage for slow-moving rays, skates, sharks, and rockfish. Bioluminescent prey aids the seals in their hunt. During this eight- to ten-month period at sea, the massive seals are able to replenish the significant weight they lose during winter breeding and spring/summer molts.

Northern elephant seals migrate to and from their rookeries twice a year, returning once to breed from December to March and again later for several weeks to molt, at different times depending on sex and age. It is this very fact that they do not all return to the rookeries at the same time that saved the species in the late 1800s. During migration the females head farther west, some ending up in the Hawaiian Islands, while the males go north to the Gulf of Alaska. Great white sharks and orcas are their predators.

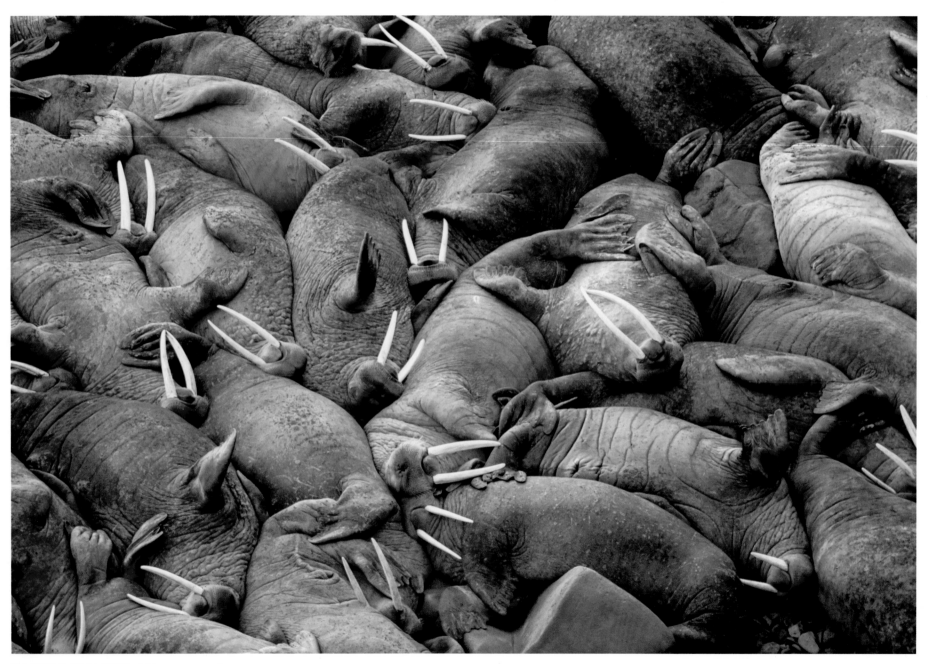

PACIFIC WALRUS *Odobenus rosmarus divergens*
ROUND ISLAND, ALASKA, USA

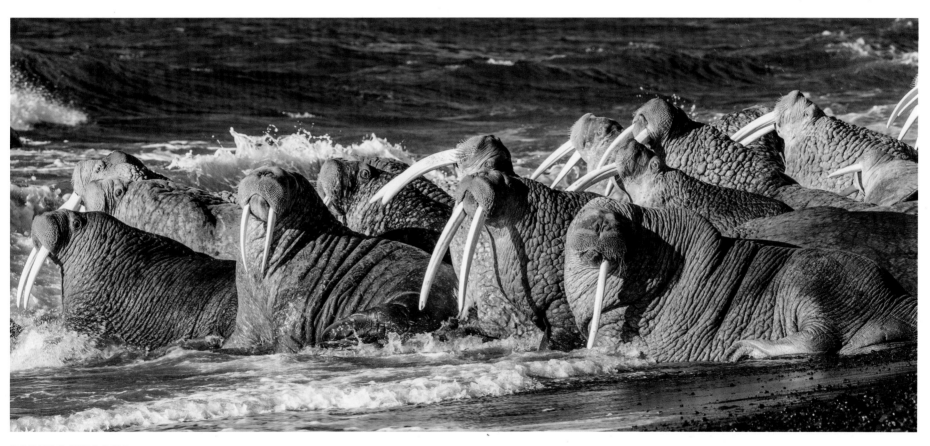

PACIFIC WALRUS *Odobenus rosmarus divergens*

WALRUS ISLANDS STATE GAME SANCTUARY, ALASKA, USA

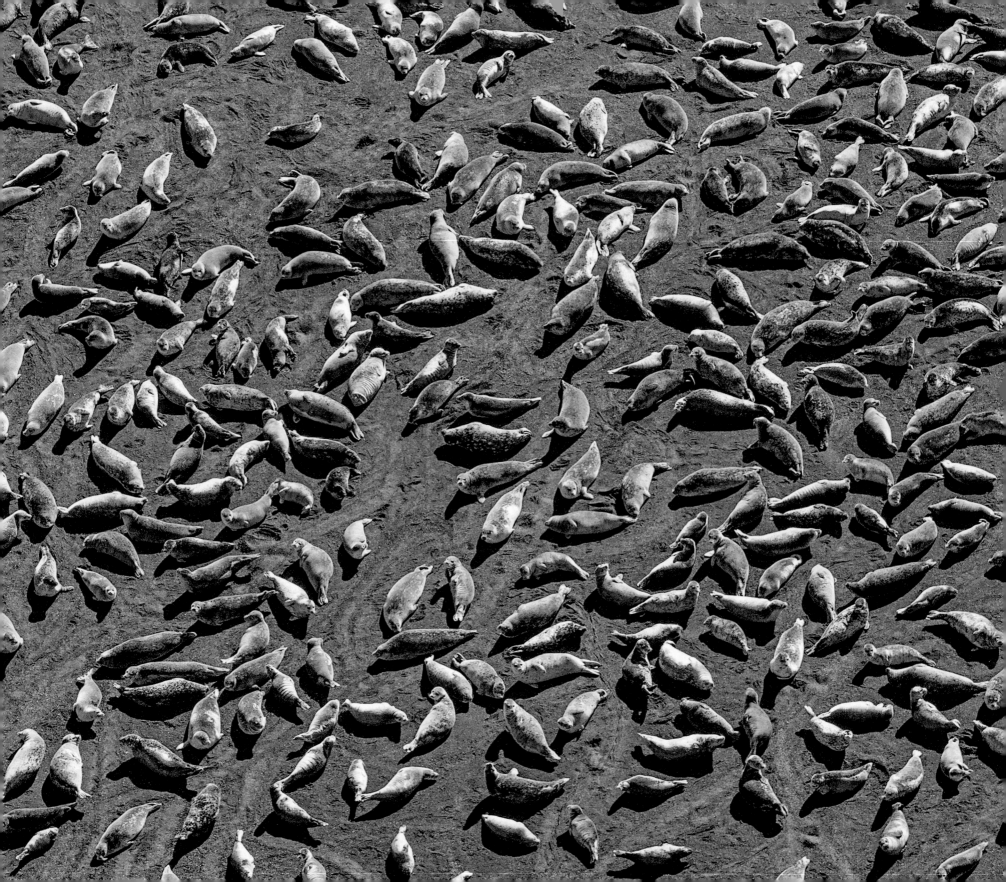

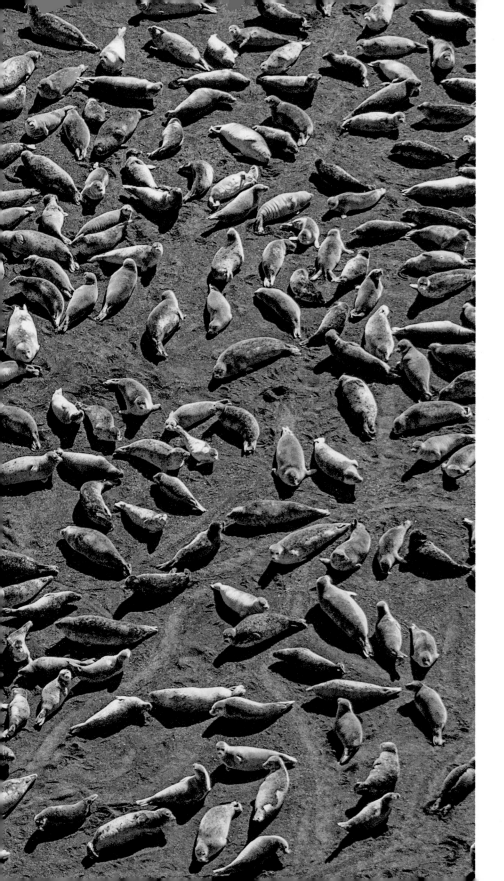

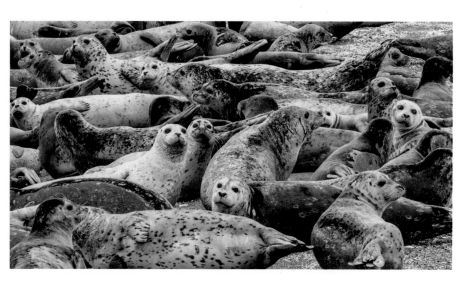

EASTERN PACIFIC HARBOR SEAL *Phoca vitulina richardii*
WASHINGTON, USA *(above)*
BRISTOL BAY, ALASKA, USA *(left)*

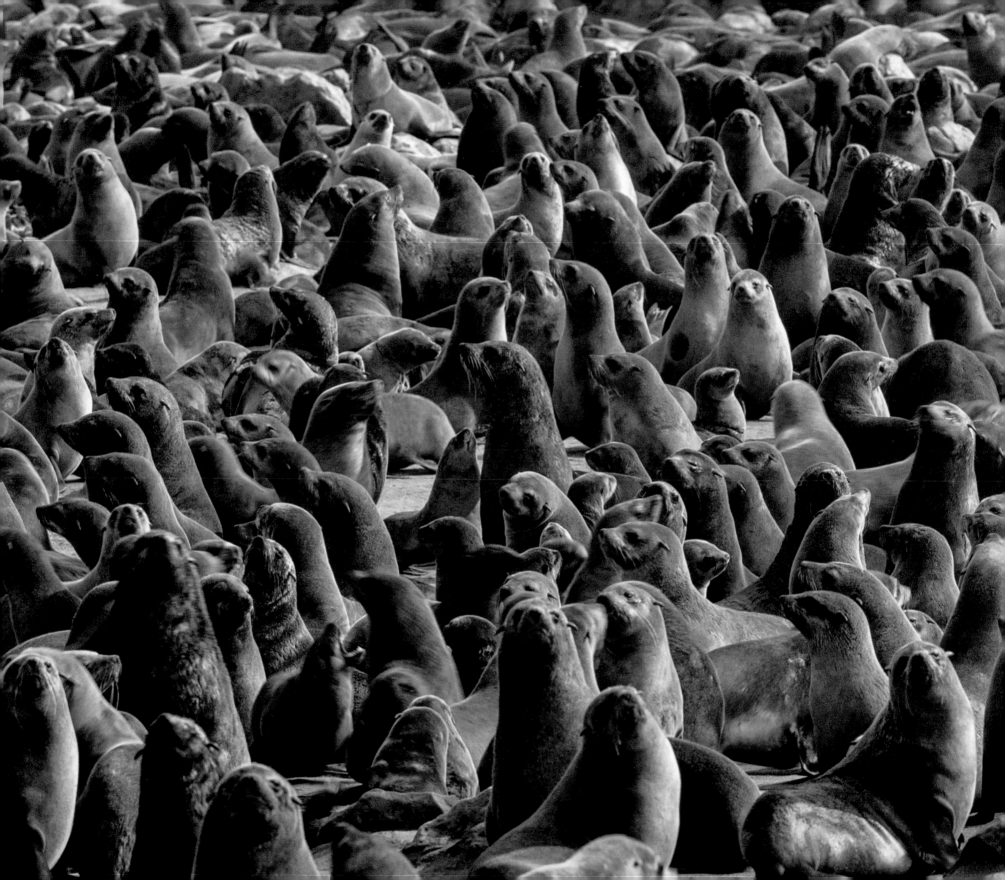

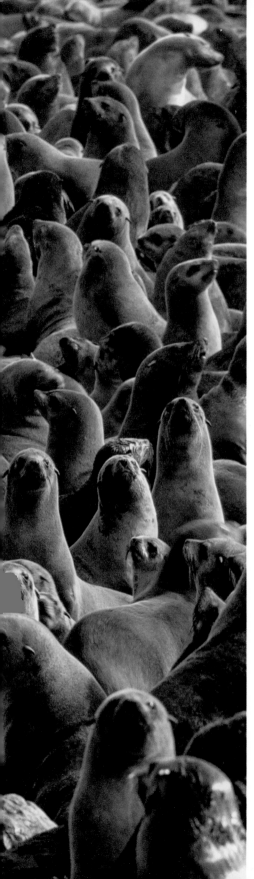

CAPE FUR SEALS *Arctocephalus pusillus*
CAPE CROSS, NAMIBIA

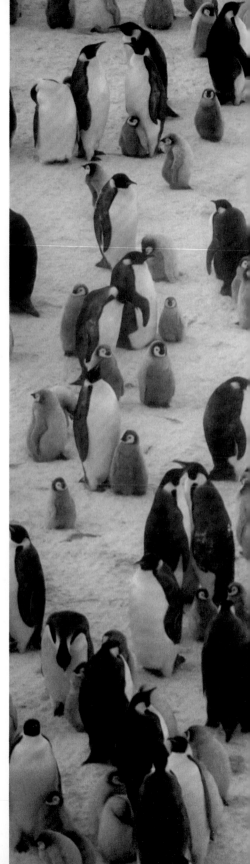

EMPEROR PENGUINS *Aptenodytes forsteri*
HALLEY BAY, ANTARCTICA

(following pages) ADÉLIE PENGUINS *Pygoscelis adeliae*
PAULET ISLAND, ANTARCTICA

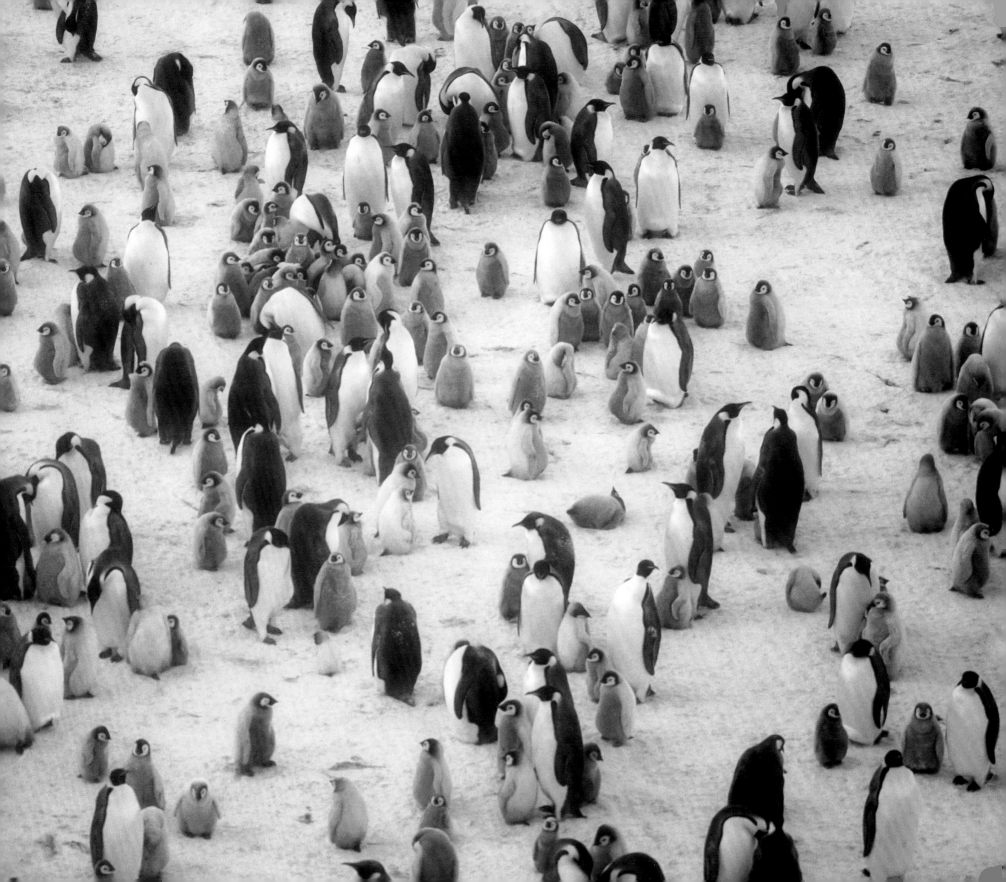

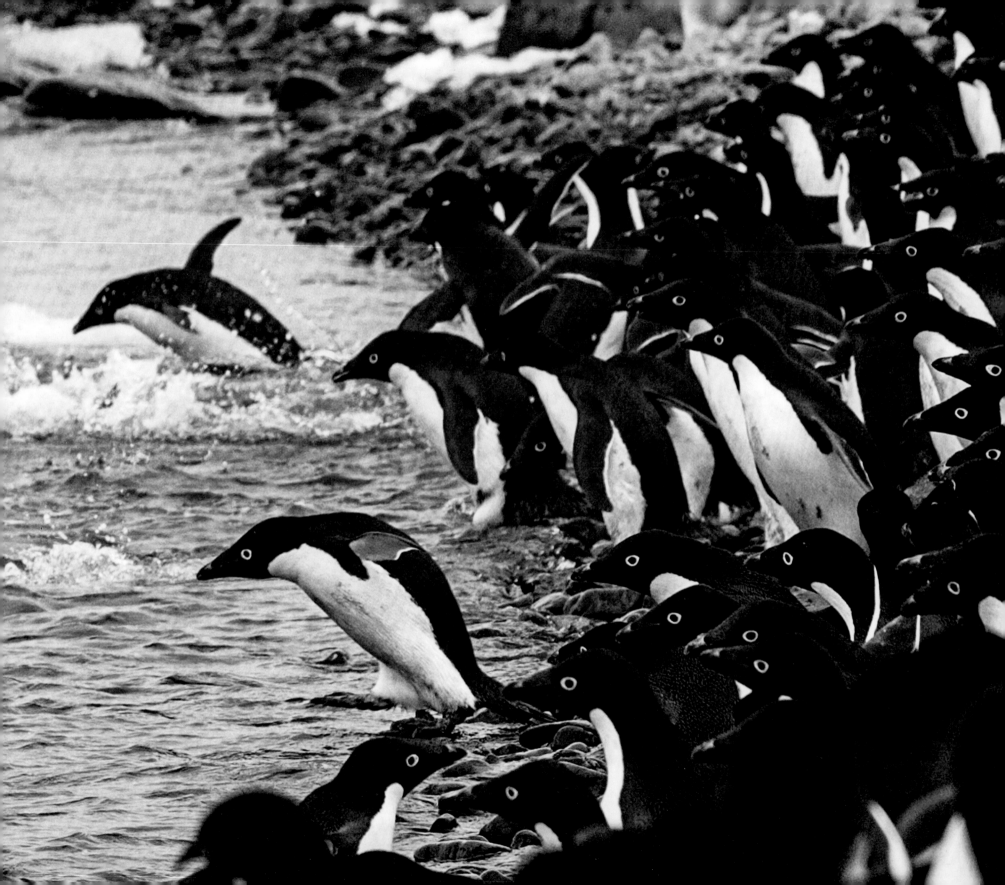

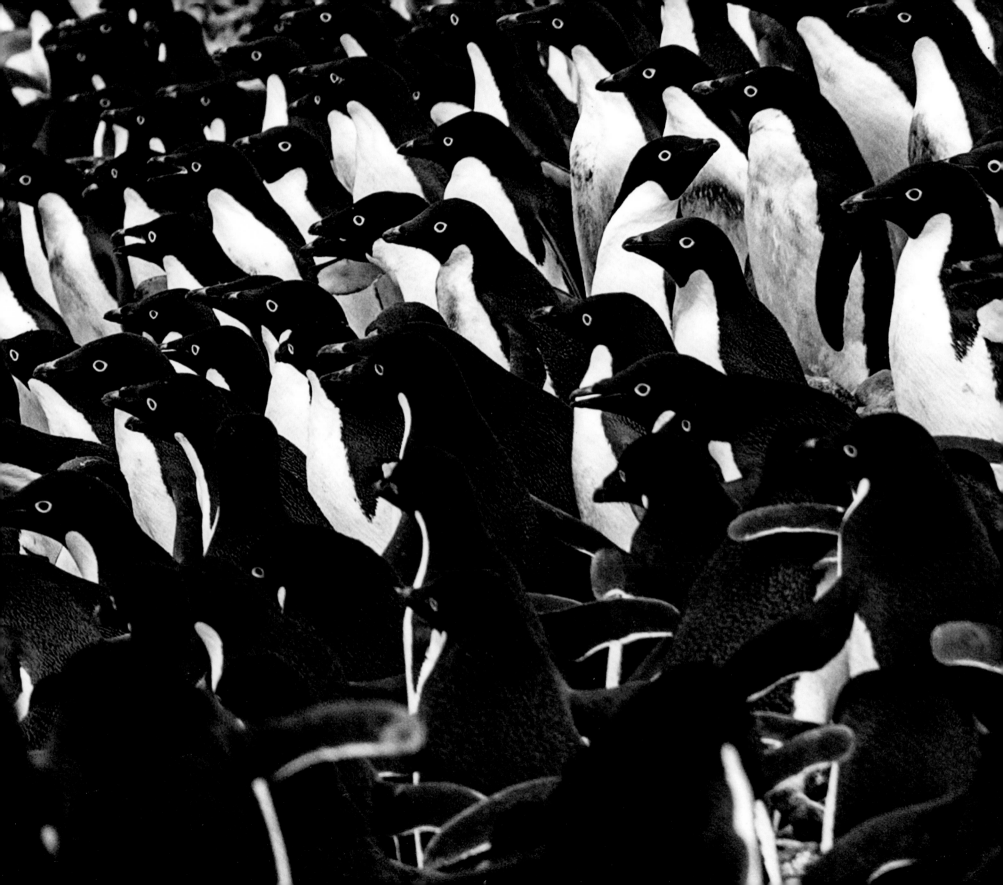

ABOUT THE ANIMALS

PACIFIC WALRUS *Odobenus rosmarus (page 86)*
ALASKA, USA

These extremely gregarious, tusked, and bewhiskered symbols of the Arctic seas haul out in vast aggregations on ice and on certain rocky islands in the Bering and Chukchi seas. The upper canines in both sexes have developed into long white tusks, which are used as head props, defensive weapons, ice picks, probes to find food, and a fifth limb to "tooth-walk" into the ice. Their most important function, however, is to convey status—the biggest walrus with the biggest tusks tends to be the most dominant. Male Pacific walrus can reach lengths of ten feet or more and weigh up to a ton. Walrus breed in January and February during the coldest part of the winter. During this time, breeding bulls engage in incessant vocal displays, which have been compared in function to the repetitive territorial calls of birds. The sexes segregate seasonally. Bulls congregate in separate haul-out and feeding areas in the Bering Sea during spring, while the cows and most of the immature animals migrate northward into the Chukchi Sea. The sexes remain separate throughout the summer, rejoining when the females return to the Bering Sea in the fall. Segregating this way, Pacific walrus minimize the potential conflict between adult and adolescent males in the breeding season as well as distribute their impact on the food supply.

EASTERN PACIFIC HARBOR SEAL *Phoca vitulina richardii (page 88)*
WASHINGTON AND ALASKA, USA

Spindle-shaped harbor seals are one of the most widespread of the pinnipeds, with several different subspecies ranging throughout the northern Pacific and Atlantic Oceans. The Eastern Pacific subspecies occurs from the Bering Sea to Baja California. The speckled and spotted seals haul out on protected beaches, spits, bars, and log rafts as well as on ice from calving glaciers to bask in the sun and sleep. During the summer pupping takes place. The pups are very precocious usually swimming within minutes of birth. Their mothers may leave them on the beach while foraging, but soon they will accompany their mothers to sea. On land, harbor seals are usually extremely wary and shy unless habituated to human activities. Most harbor seal haul-out sites are used daily, based on tidal cycles and other environmental variables, although foraging trips can last for several days. Their diet is extremely varied from schooling fish, octopus, and squid to shrimp.

While harbor seals are gregarious at haul-out sites, they are generally intolerant of close contact with other seals. At sea they are most often seen alone, though they are rather curious around scuba divers and snorkelers. Their predators include killer whales, great white sharks, steller sea lions and walrus, and even feral dogs in some locales. They are protected from humans, though, by the Marine Mammal Protection Act of 1972.

CAPE FUR SEALS *Arctocephalus pusillus (page 90)*
CAPE CROSS, NAMIBIA

Cape fur seals haul out of the cold South Atlantic by the thousands to bask and bark at the edge of Namibia's "Great Dune Sea." They are found along the sandy, rocky shores of southwest Africa and Cape Province from Cape Cross south to the Cape of Good Hope and east to Birds Island in Algoa Bay. Their colonies echo with a perpetual chorus of snorting and bellowing. These brown-coated seals are active by day, entering the water to chase fish. At night they sleep on shore, safe from attack by sharks and killer whales. Underwater, seals have superior vision, but on land they are nearsighted and are able to detect only motion.

Toward the end of October, the largest bulls begin to establish breeding territories on shore, threatening and fighting other males to defend them. Females group in harems of variable size on the male territories and give birth to single pups sired the previous year. Females come into estrus within a week after giving birth, yet once mated, they are able to delay implantation of the embryo until March or April. This adaptive strategy enables them to take care of breeding and birthing in the same season. Then the males and the females with young live apart until the breeding season begins again.

EMPEROR PENGUINS *Aptenodytes forsteri (page 92)*
HALLEY BAY, ANTARCTICA

Measuring four feet tall and weighing ninety pounds, emperor penguins are the largest of all penguins. Equipped with white bellies and underparts to camouflage them from prey below, spiny fish-gripping tongues, and keen underwater vision specially adapted to the submarine hues of blue, green, and violet, penguins are superb aquatic predators. To prevent heat loss in cold water, dense fur-like feathers trap an insulating layer of warm air next to their skin.

Emperor penguins are the only bird that does not breed on land or use a nest of any kind. They breed on the Antarctic sea ice in the darkness of winter. Emperors form breeding colonies in March as the icepack begins to form. After the female lays a single egg, she leaves the male to incubate the egg nestled in fat and feathers on top of his feet, and she returns to the sea, now sixty miles distant. The male stands watch for two months, living off his fat reserves, while the female regains her strength. The thousands of males left on egg duty huddle together for warmth in Antarctic temperatures that can drop as low as minus 90 degrees Fahrenheit with winds up to 100 miles per hour. After incubating the egg without food for more than sixty days, the male then feeds the hatchling "crop milk" produced in his esophagus. The composition of this nutritive fluid has been compared to marine mammal milk both in protein content and composition. Nourished only by the milk, the chick increases in weight from 300 to 800 grams. The males lose half their body weight by the time the females return to help feed the young. Until the chicks are old enough to join a crèche, both adults make fishing trips to the edge of the melting sea ice. When the ice pack breaks up in December, the emperors drift northward on a migration of ice floes.

ADÉLIE PENGUINS *Pygoscelis adeliae (page 94)*
PAULET ISLAND, ANTARCTICA

Adélie penguins have been aptly compared to champagne corks, as they pop eight feet straight up out of the water to land on icebergs or rock ledges. And they seem almost gleeful as they jump and belly glide off ice walls back into the water. While relegated to clumsy waddling and hopping on land, penguins are beautifully designed for energy-efficient swimming and diving. Using their featherless, leathery wings for propulsion, they literally fly underwater at speeds of twenty miles per hour or more. Hydrodynamically shaped like flying ovals, with their heads tucked into their shoulders and webbed feet held straight back to steer, penguins transform underwater into high-speed avian torpedoes. Thick down, waterproof outer feathers, and layers of fat protect these aquatic gymnasts from the cold, and solid bones serve as ballast for dives as deep as 850 feet. Porpoising at the surface to breath like tiny dolphins, they also add a lubricating coat of air bubbles to their body surface which helps reduce frictional drag. Except when they come ashore to breed, penguins spend most of their time at sea, flying underwater to feed on fish and krill.

Life would be idyllic for the Adélies if not for the meat-eating leopard seals that patrol their rookery shoreline. Hunting solo, the predatory seals hide beneath ice floes waiting for penguins to plop into the water. They also single out birds as they return to the rookery. Once a target is spotted, the large seal drops beneath the surface to ambush its prey from below. Leopard seals can swim faster than penguins and will pursue their intended victim over and under ice floes until the bird eventually tires. Then, like skinning a grape, the seal grabs the bird by its feet, and with a violent snap of its head, rips the penguin right out of its skin. Each nesting season, leopard seals kill an estimated 5 percent of the Adélies' breeding population.

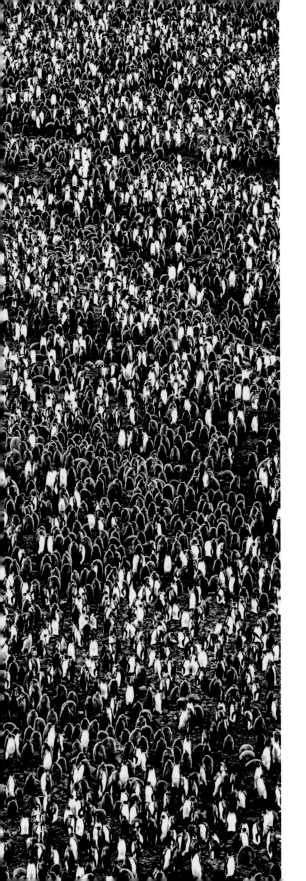
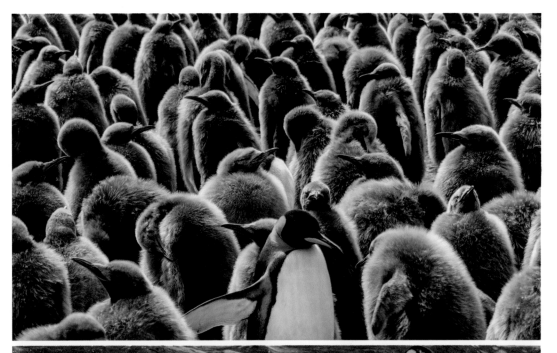
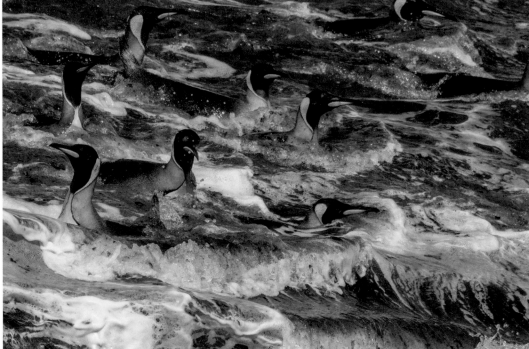

(these pages & following pages) **KING PENGUINS** *Aptenodytes patagonicus*
SOUTH GEORGIA ISLAND

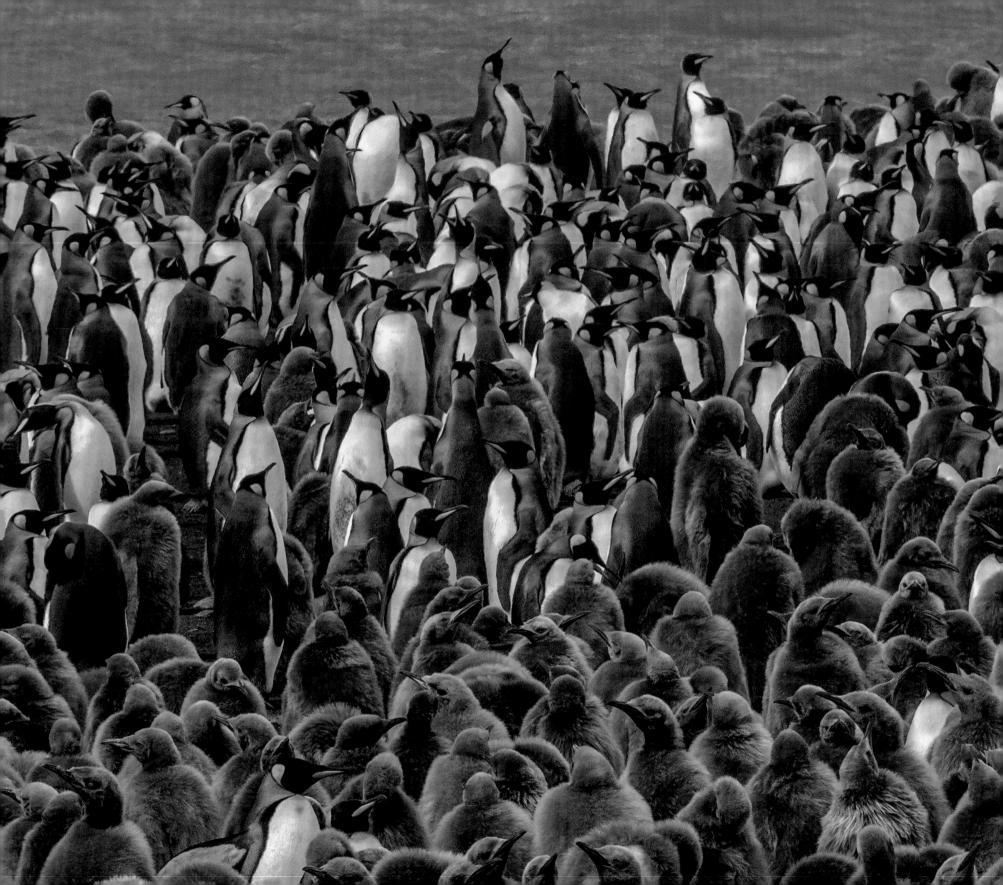

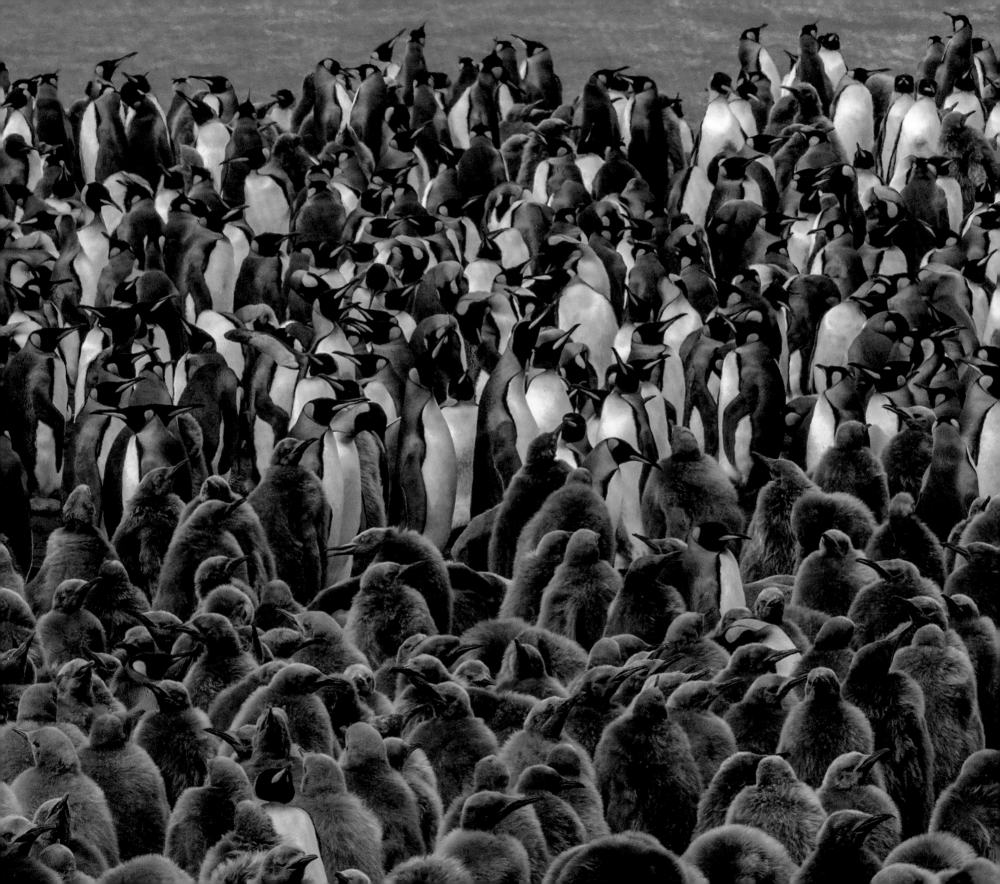

(these pages & following pages) **THICK-BILLED MURRE** *Uria lumvia*
SVALBARD, NORWAY

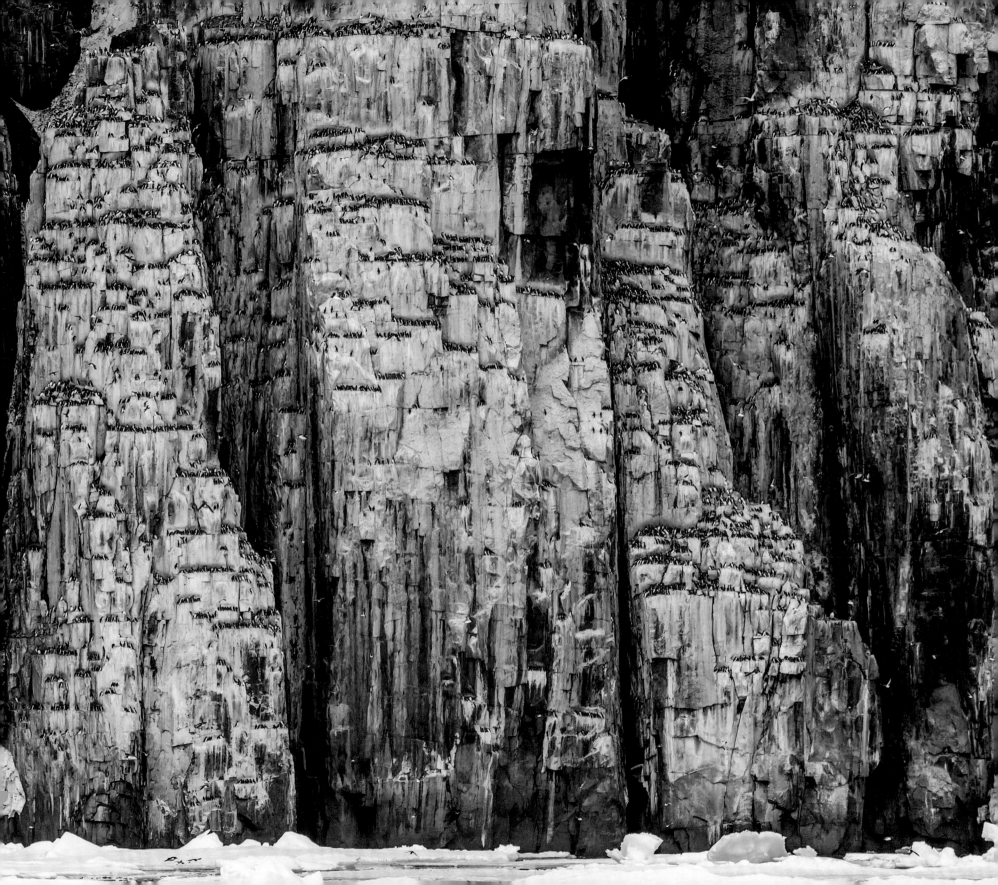

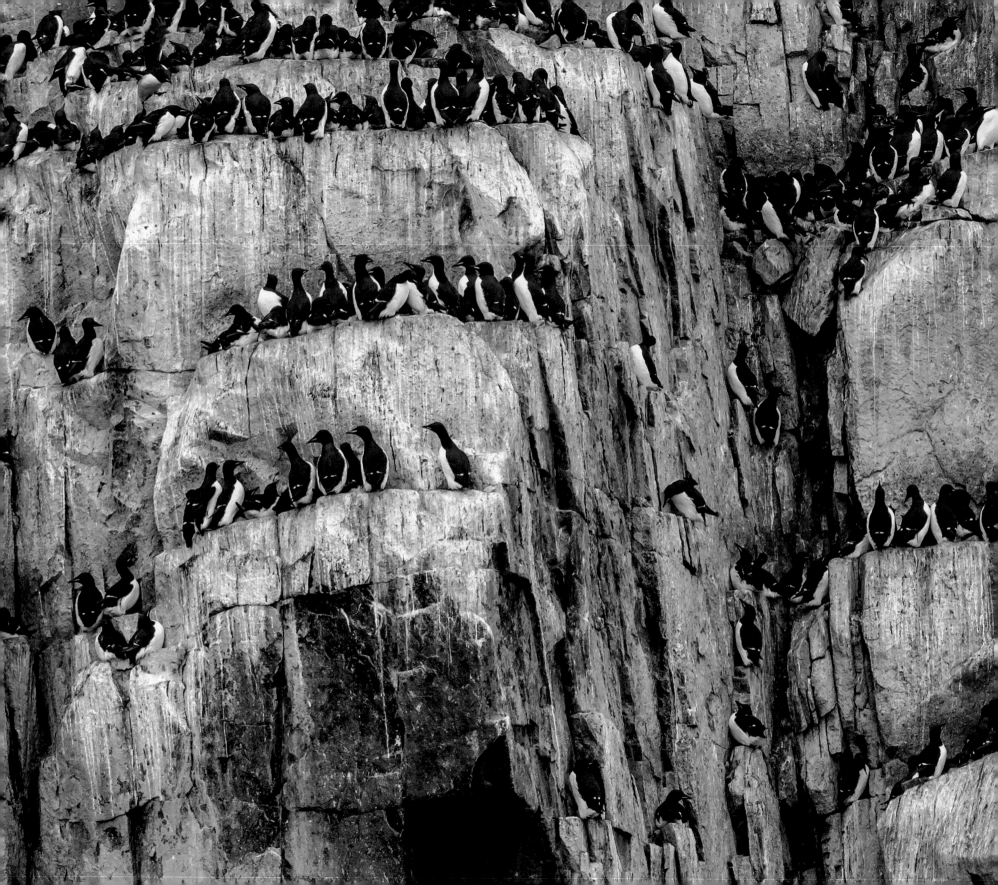

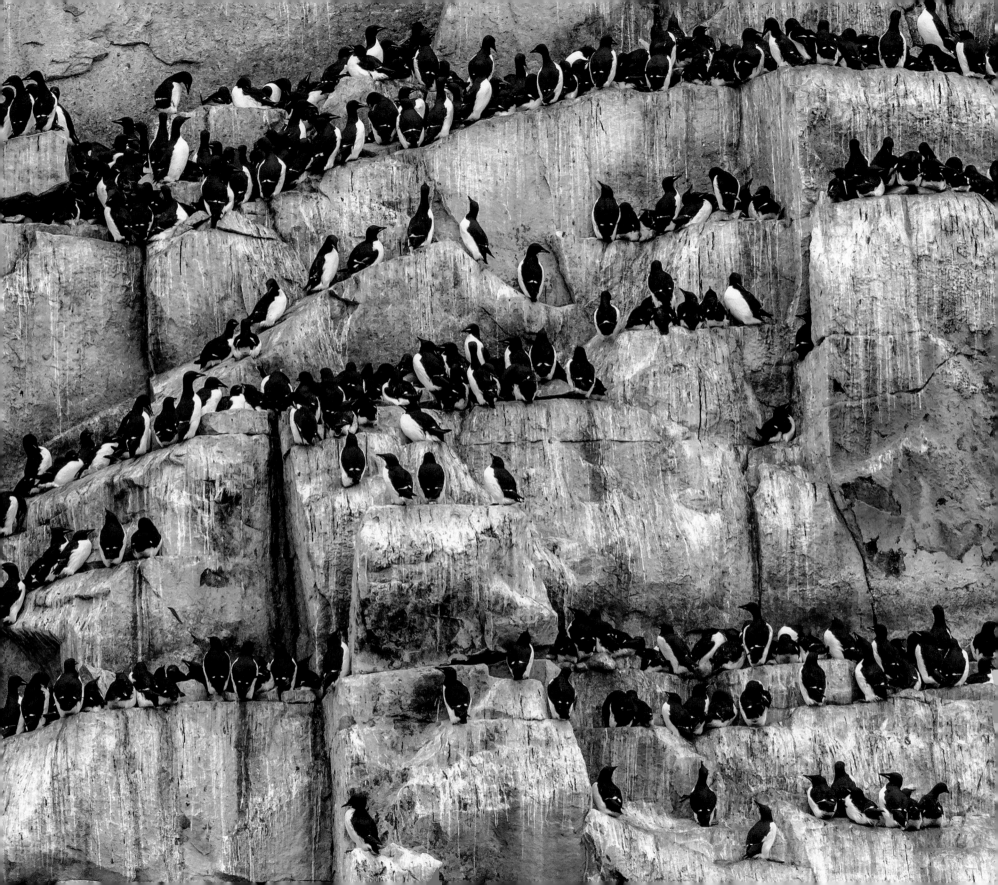

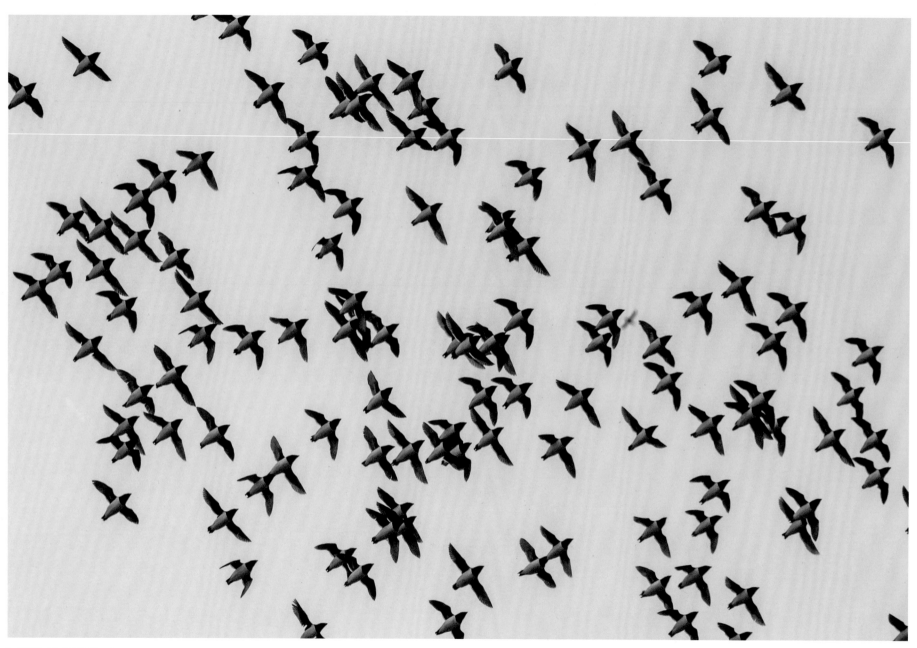

LITTLE AUKS *Alle alle*
SVALBARD, NORWAY

ABOUT THE ANIMALS

KING PENGUINS *Aptenodytes patagonicus (page 98)*
SOUTH GEORGIA ISLAND

King penguins are classic colonizers. They maximize space by keeping their neighbors at beak's length, which creates an interesting visual pattern. So arranged, they use their numbers to protect themselves from the elements by forming a united front against the wind. Should the wind suddenly shift, all the birds likewise shift in order to keep the cold wind at their backs. By incubating their eggs on the top of their feet, king penguins are free to move as the weather conditions dictate, even lying prone on the ice during blizzards. Their fat and feathers envelop a single egg, creating a portable "upside-down nest" that can be transported as needed. This practical arrangement adds to the comic nature of these tuxedoed birds by creating the illusion that they have no feet at all.

King penguins can number in the tens of thousands at nesting colonies on South Georgia Island. As members of the largest family of completely flightless birds, they stand a little over three feet tall. With orange suns setting beneath their chins, matched by bright orange stripes on their bills and tear-shaped auricular patches on each side of their heads, king penguins are a sight to behold. The yellow and orange species-recognition marks concentrated around the head make it easy for penguins to identify each other while swimming. The colorful patches are also the focus of much courtship behavior such as bill- and head-rubbing between mated pairs.

The only one of seventeen species of penguins whose young take a year or more to mature before going to sea, the king breeding cycle lasts fifteen months. A pair may breed early in the season one year, late in the season the next, and not at all in the third. This means that all king penguin chicks must pass at least one, and sometimes two, winters in a crèche. During their first winter, after being abandoned by their parents, the chicks survive entirely off their fat reserves. Still covered in baby down, they huddle together for warmth.

King penguin chicks are left to brave their first winter covered in fluffy brown feathers. The young penguins, appropriately called "woolies," huddle together in crèches to pass the long winter months. Feathers make up 4 to 12 percent of a bird's body weight, and so it takes energy to replace them. Mature feathers are basically dead structures that cannot grow any further. As tough as they are, feathers eventually get worn or break and require replacement. All adult birds molt at least once a year, some species as many as two or three times.

THICK-BILLED MURRE *Uria lumvia (page 102)*
SVALBARD, NORWAY

With numbers estimated at around 20,000,000, thick-billed murres are one of the most abundant birds in the Northern Hemisphere. Their extremely large range, generalist feeding habits, and deep-diving skills all combine for their survival success. In times of changing climates they have demonstrated the ability to adapt both their laying and feeding habits. When it is warmer they lay eggs earlier, and they have switched from eating colder water fish such as Arctic cod to warmer water fish like capelin.

In the winter murres stay at sea in large flocks, but in the summer these three pound black and white birds form immense colonies, sometimes of over a million birds, on narrow ledges and steep cliffs high above the sea. Packed in precariously they require less than one square foot per bird. A breeding pair will lay only a single egg each year. The more experienced pairs will have greater success at raising a chick to fledge as they commandeer the safest nesting spots in the center of the colony where the chicks are less likely to be preyed upon by gulls and crows. After about twenty-five days, the chicks hurl themselves to the water, followed closely by a concerned parent. The parent will feed the chick for another eight weeks at sea.

Skillful divers and swimmers, murres seem to fly underwater as they hunt for small invertebrates and fish. They regularly descend to depths of more than 300 feet, and occasionally below 600 feet, and can remain submerged for more than three minutes.

LITTLE AUKS *Alle alle (page 106)*
SVALBARD, NORWAY

These tiny ten-inch birds remain for much of the year in the high Arctic, sighted as far north as 82 degrees. By August they begin migrating south into the North Atlantic. They nest on cliffs, ledges, and rocky scree, laying one egg. Polar bears, foxes, and other birds predate their eggs, but it doesn't seem to put a dent in the overall population, estimated at 35 million.

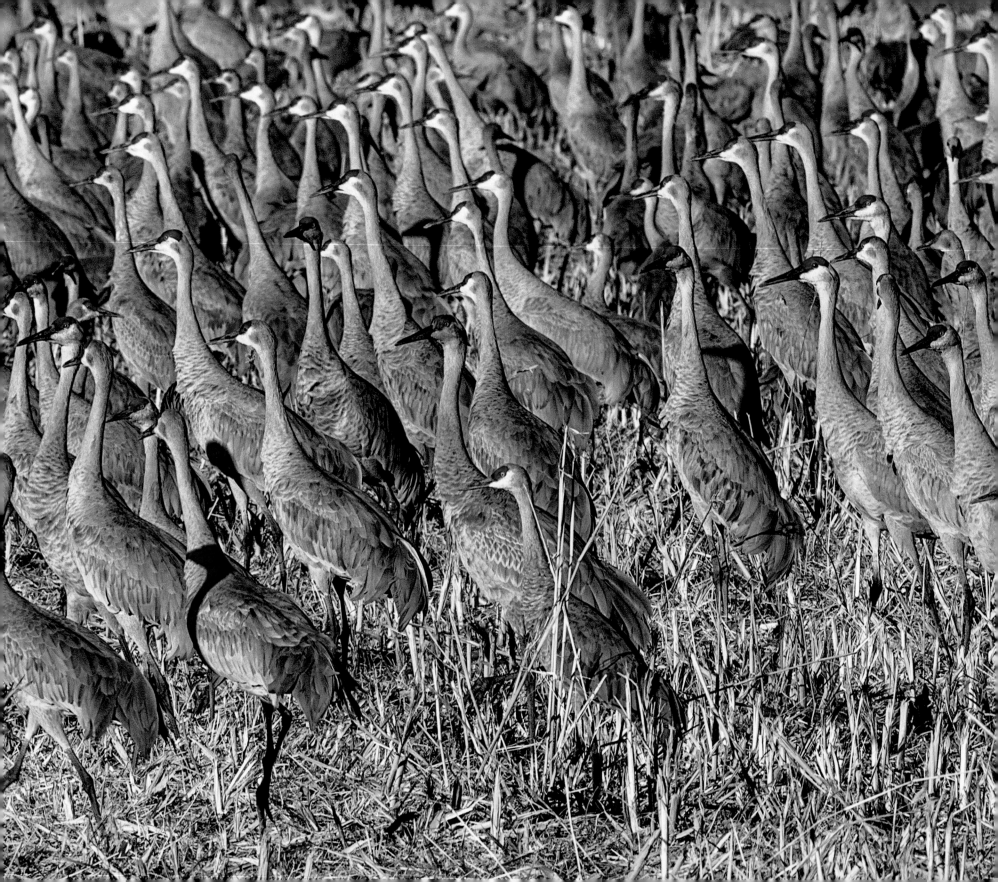

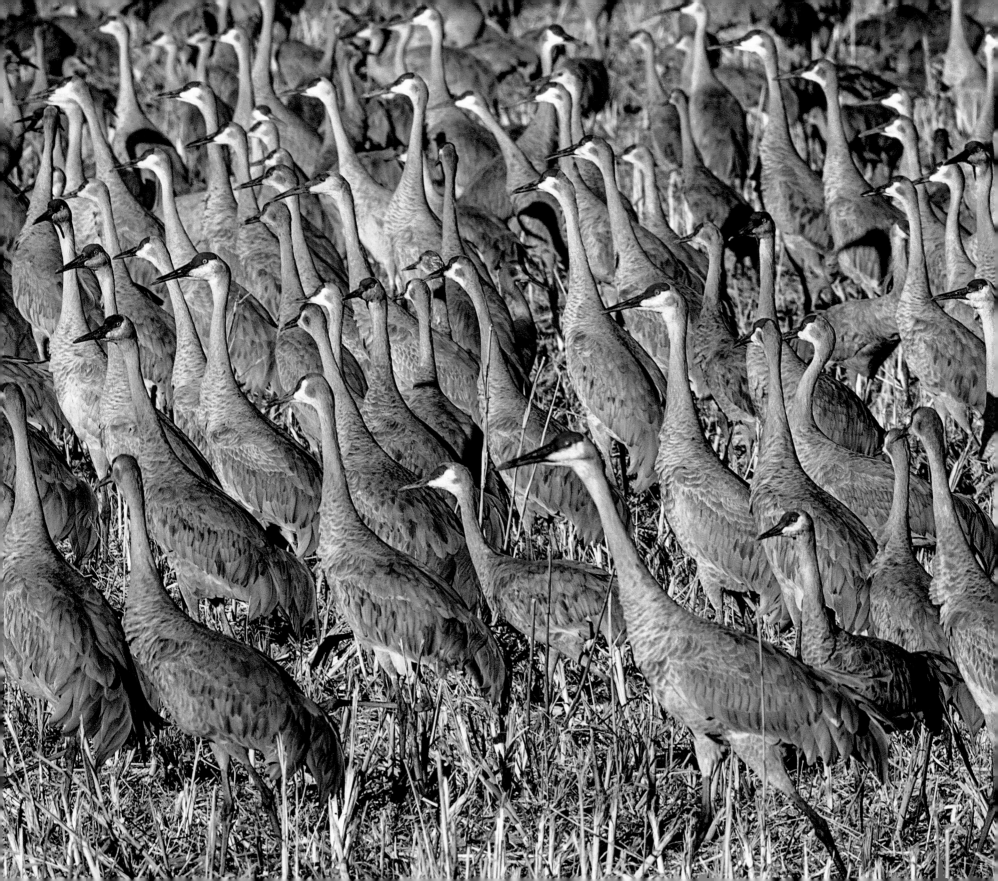

(previous pages & right) **GREATER SANDHILL CRANES** *Grus canadensis*
BOSQUE DEL APACHE NATIONAL WILDLIFE REFUGE, NEW MEXICO, USA

(following pages) **SPRINGBOK** *Antidorcas marsupialis*
ETOSHA NATIONAL PARK, NAMIBIA

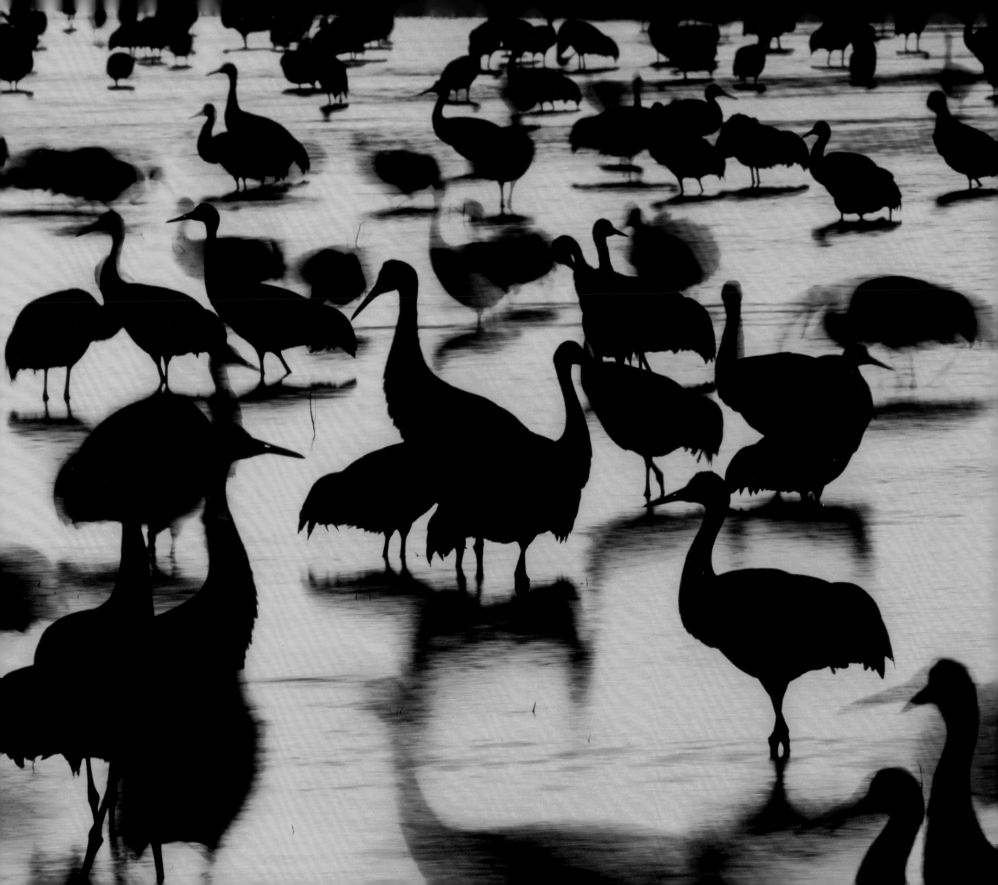

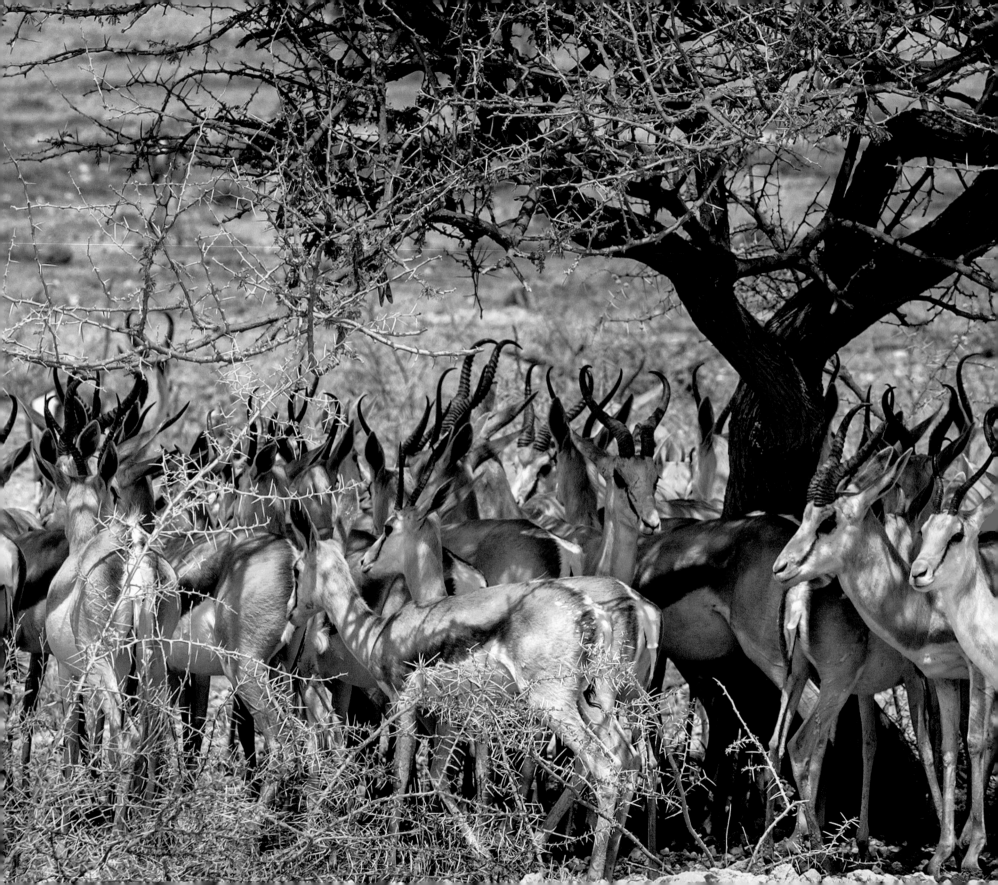

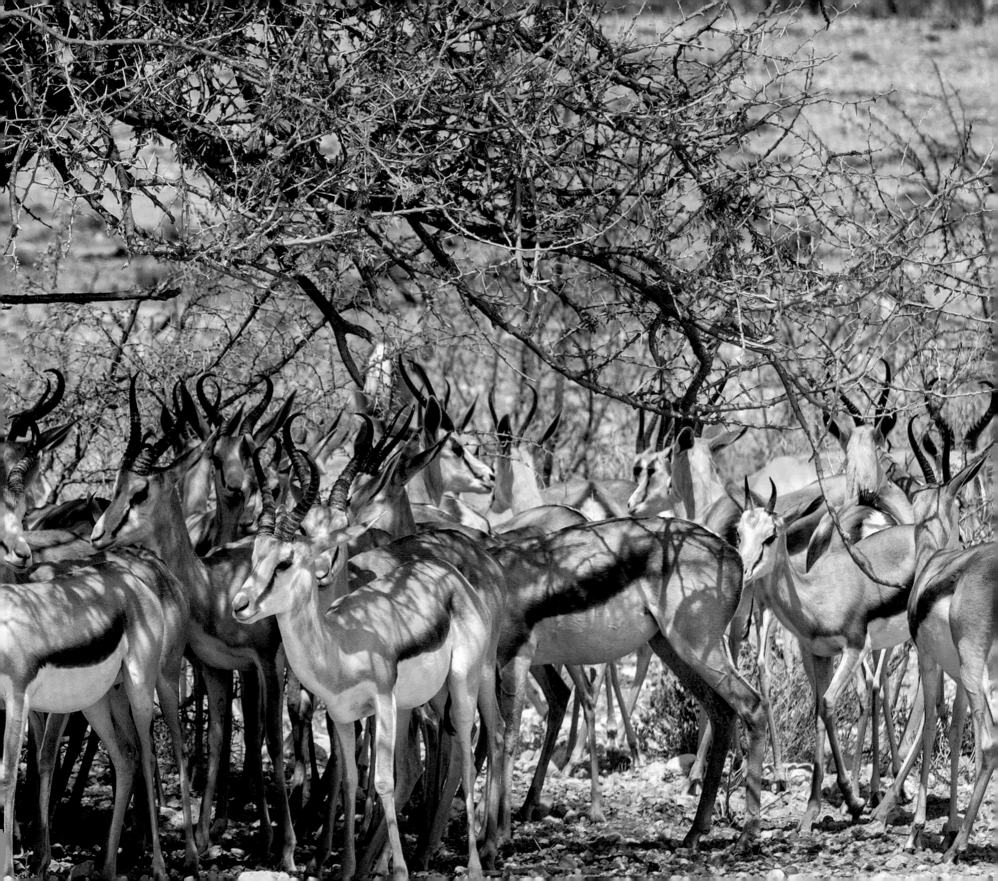

RETICULATED GIRAFFES *Giraffa c. reticulata*
LAIKIPIA, KENYA

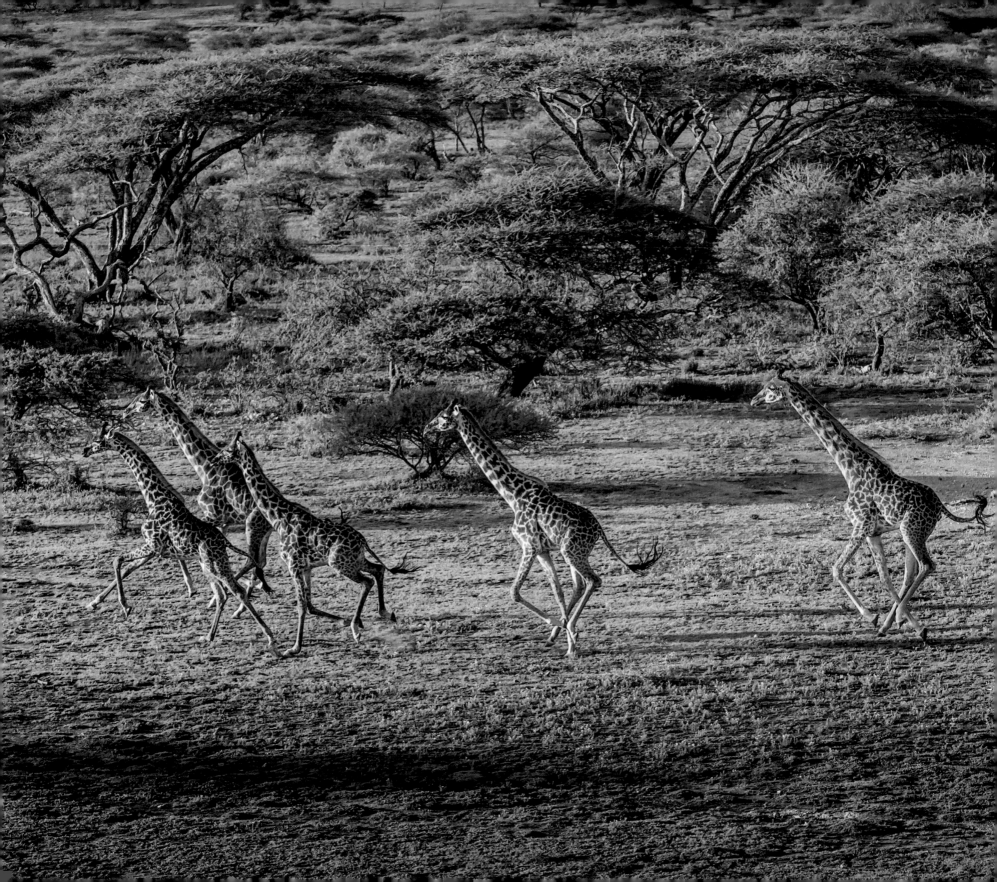

RETICULATED AND **MASAI GIRAFFES** *Giraffa c. reticulata* and *Giraffa c. tippelskirchi*
SERENGETI NATIONAL PARK, TANZANIA

117

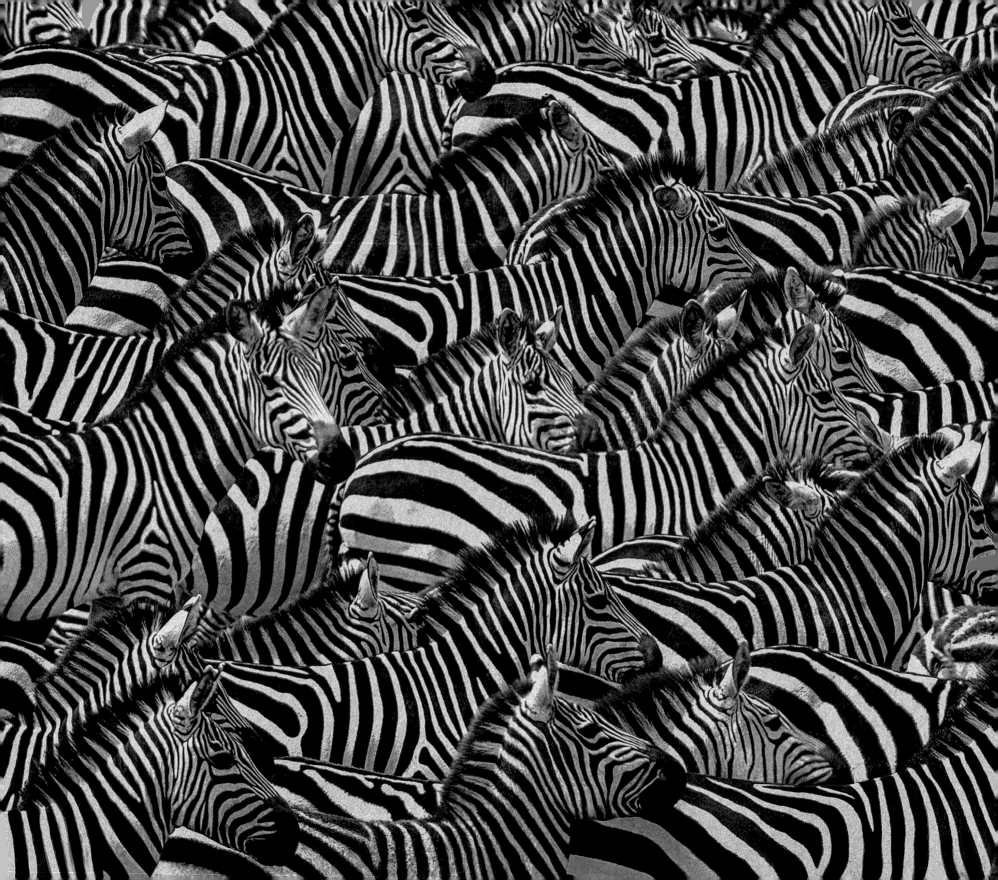

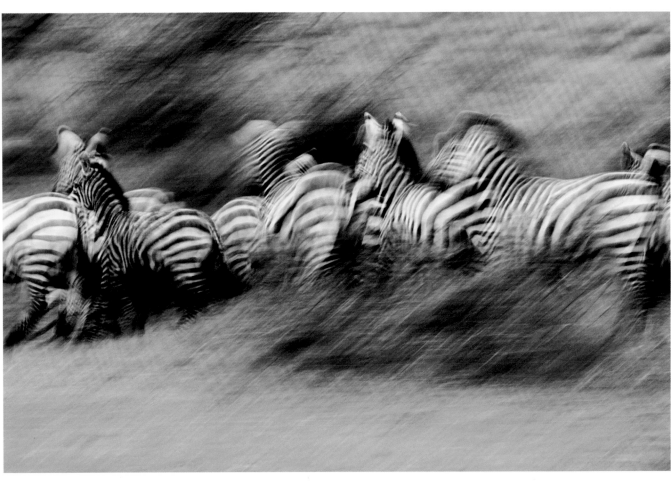

(these pages) **PLAINS ZEBRAS** *Equus quagga boehmi*
MASAI MARA NATIONAL RESERVE, KENYA *(left)*
SERENGETI NATIONAL PARK, TANZANIA *(above)*

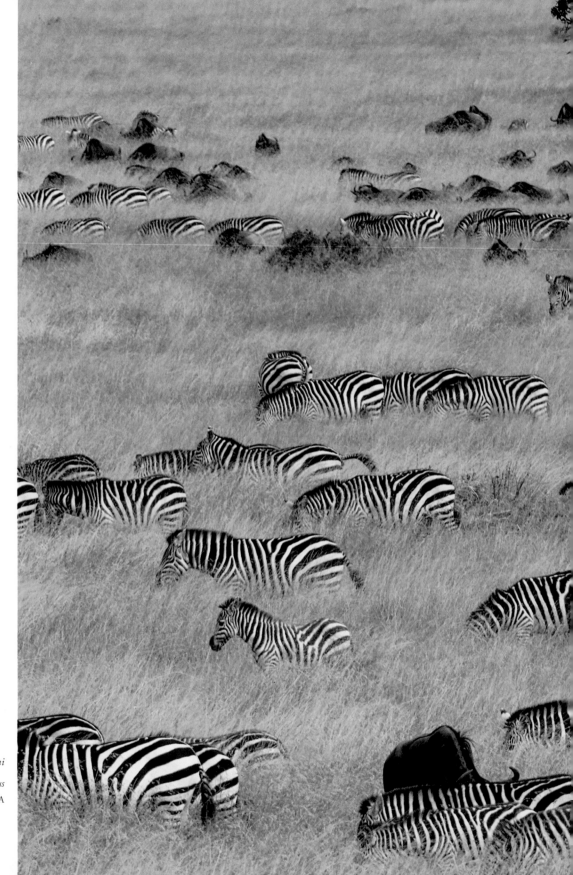

PLAINS ZEBRAS *Equus quagga boehmi*
EASTERN WHITE-BEARDED WILDEBEEST *Connochaetes taurinus albojubatus*
AMBOSELI NATIONAL PARK, KENYA

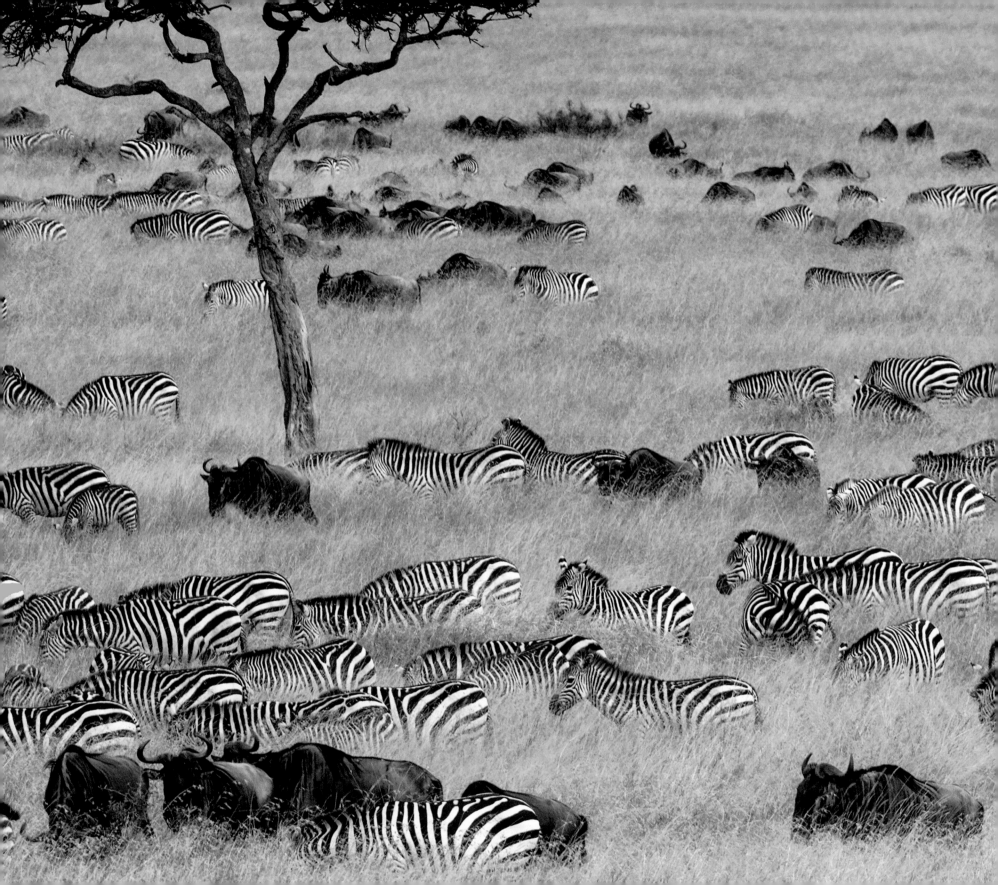

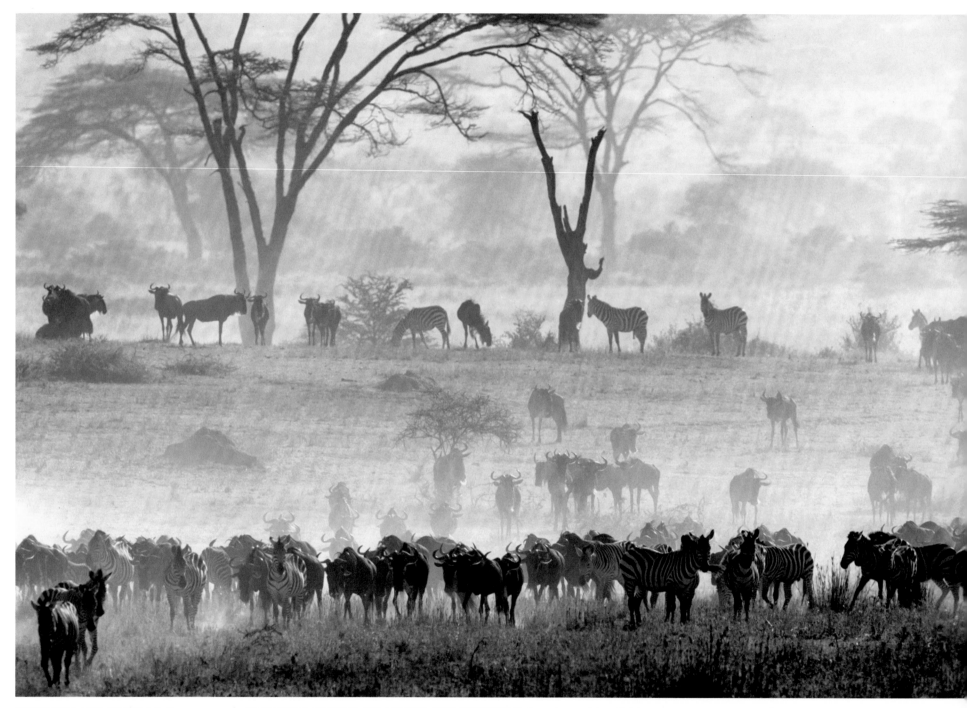

BURCHELL'S ZEBRAS *Equuas quagga* | **EASTERN WHITE-BEARDED WILDEBEEST** *Connochaetes taurinus albojubatus*
MASAI MARA NATIONAL RESERVE, KENYA

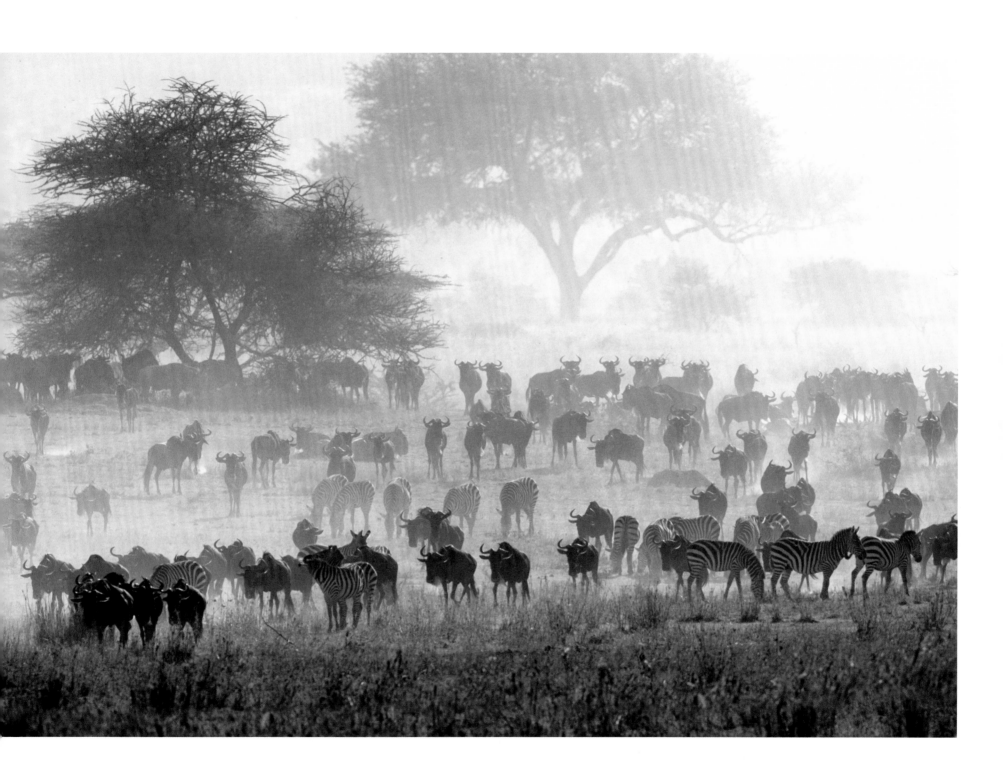

ABOUT THE ANIMALS

GREATER SANDHILL CRANES *Grus canadensis (page 108)*
BOSQUE DEL APACHE NATIONAL WILDLIFE REFUGE, NEW MEXICO, USA

Flocks of greater sandhill cranes, members of the oldest living family of birds in the world, can be seen flying over the open wetlands of New Mexico's Bosque del Apache National Wildlife Refuge. The refuge is a primary wintering area for more than 12,000 of these regal birds. Six subspecies of sandhill cranes inhabit North America and Cuba. Of these, three are migratory and inhabit the West, where they winter in New Mexico, Texas, Mexico, and parts of the Gulf Coast. When they migrate, cranes fly in long lines across the sky, using rising thermals to carry them to altitudes as high as 13,000 feet. While aloft, or when alarmed, the cranes' sonorous, trumpeting calls can be heard for several miles. The calls are produced through extraordinarily long windpipes, which have been likened to French horns.

One of North America's largest birds, sandhill cranes stand up to four feet tall with a six- to seven-foot wingspan. For the most part, they are shy, wary birds. Yet John Audubon once described being driven into a river up to his neck to escape an angry sandhill crane with a broken wing. Each year, 500,000 migrating sandhill cranes converge in March along the eighty-mile stretch of the Platte River between Champman and Overton, Nebraska, to rest and refuel before continuing their migration north. With 10,000 to 20,000 birds packed per mile, it is the largest single gathering of cranes in the world, constituting roughly 80 percent of the total sandhill crane population in North America.

SPRINGBOK *Antidorcas marsupialis (page 112)*
ETOSHA NATIONAL PARK, NAMIBIA

Slender and long-necked, the springbok used to occur in huge numbers in the dry grasslands, bushland, and shrubland of southwestern and southern Africa. Their migration or *trekbokken* was legendary—a million or more animals would thunder across the land, taking days to pass through towns and creating a dust storm. *Trekbokken* no longer occurs due to hunting and fencing, but a portion the springbok's former abundance can still be seen across Namibia, the Kalahari, and in the grasslands of the south.

It is good that the springbok are still plentiful as they are the preferred prey of the big African cats and hyenas. Large raptors will take springbok lambs. Humans like them too, and they are raised in game farms for their venison—they are easily tamed and thrive in captivity.

The graceful and brightly-colored springbok can pronk or stot ten feet into the air when alarmed by predators or at play. They have a skin flap that is most often hidden, running from the middle of the back to the tail. When they are excited, this fold is everted to form a conspicuous crest of long bristly pure white hairs. They are extremely fast, capable of running over fifty miles per hour. They can go without drinking as long as their food contains more than 10 percent water. During the summer they seek refuge in the shade of trees, though in cooler weather they may feed throughout the day.

RETICULATED AND MASAI GIRAFFES
Giraffa c. reticulata and *Giraffa c. tippelskirchi (page 116)*
SERENGETI NATIONAL PARK, TANZANIA

The tallest living terrestrial animal, the giraffe tops out at over eighteen feet tall. Using their unparalleled height in combination with a seventeen-inch tongue, they are able to reach forage in their favored acacia trees that no other animals can reach. They spend twenty hours a day eating, since they need to eat so much, up to seventy-five pounds of leaves per day.

Giraffe are also remarkable because of their coat patterns, which distinguish the nine subspecies. They are adorned with dark chestnut brown blotches of various shapes and sizes on a buff ground color. For instance, the reticulated giraffe has polygonal patches with thin white lines, and the Masai giraffe has jagged, star-shaped blotches all the way down to its feet. Like a fingerprint, each giraffe's coat pattern is unique. The coat patterns and colors also serve as camouflage, which is critical for the survival of the calves.

Giraffe move with the seasons, but not nearly as far as other plains ungulates. They live in open woodland, concentrating near rivers in the dry

season and dispersing into the trees during the rains. The acacia leaves have a high moisture content, so giraffe don't need to drink that often. But when they do, these timid and shy animals need to be alert to their number one predator, the lion. It's a long way down to the river or watering hole and it's easier for a lion or even a crocodile to take them when they are drinking. Their sight is especially acute, and in combination with their height, the giraffe have the greatest range of vision of any land animal. Social organization is loose; they do not form herds, just widely ranging groups, the most stable of which are made up of females and calves.

PLAINS ZEBRAS *Equus quagga (page 118)*
MASAI MARA NATIONAL RESERVE, KENYA

Zebras are one of the only true wild horses left in the world today. An estimated 300,000 live on the African plains, where they often wander great distances during the dry season in search of feed and water. Like all horses, these nomadic grazers are fast runners with good endurance, which enables them to outrun predators. Consequently, lions and leopards rely on ambush to capture these fleet-footed equines. Ever alert, zebras have excellent hearing, and their eyes are located high on the sides of their heads so they can keep watch while grazing. Their bedazzling stripes are thought to confuse the eyes of predators, allowing a herd of zebras to disappear in a mirage at the horizon. Because tailgating and grooming are so important to the social cohesion of zebra herds, it is thought that their stripes and dramatic rump patterns may also have evolved as visual markers to direct both their following and grooming behaviors.

Zebras use their ears to convey mood as well as to listen for the approach of predators. Like mobile radar, their ears can swivel in all directions. When a herd of zebras stands at full attention, all eyes and ears facing forward, their body language warns that danger is near. In order to survive in the eat-or-be-eaten world of the African plains, baby zebras have to hit the ground running. Within an hour of birth, they can stand on long wobbly legs to begin their lifelong race across the grasslands.

BURCHELL'S ZEBRAS *Equus burchelli (page 122)*
ETOSHA NATIONAL PARK, NAMIBIA

Zebras are the only striped members of the horse family. As with human fingerprints, it is impossible to find two zebras with identical stripes. In fact, there is such a wide variation in pattern that some zebras are black with white stripes, and some even appear spotted. Their beautiful markings, however, have imperiled the species, as many are poached for their dramatic hides. Zebras are highly social, vocal animals that bray and bark to each other. They usually live in herds of five to twenty-five animals, typically females with young led by a stallion. During the dry season, zebras congregate in herds of a hundred or more and are often found in association with wildebeest. Their frequent need for water keeps them in close proximity to drinking holes.

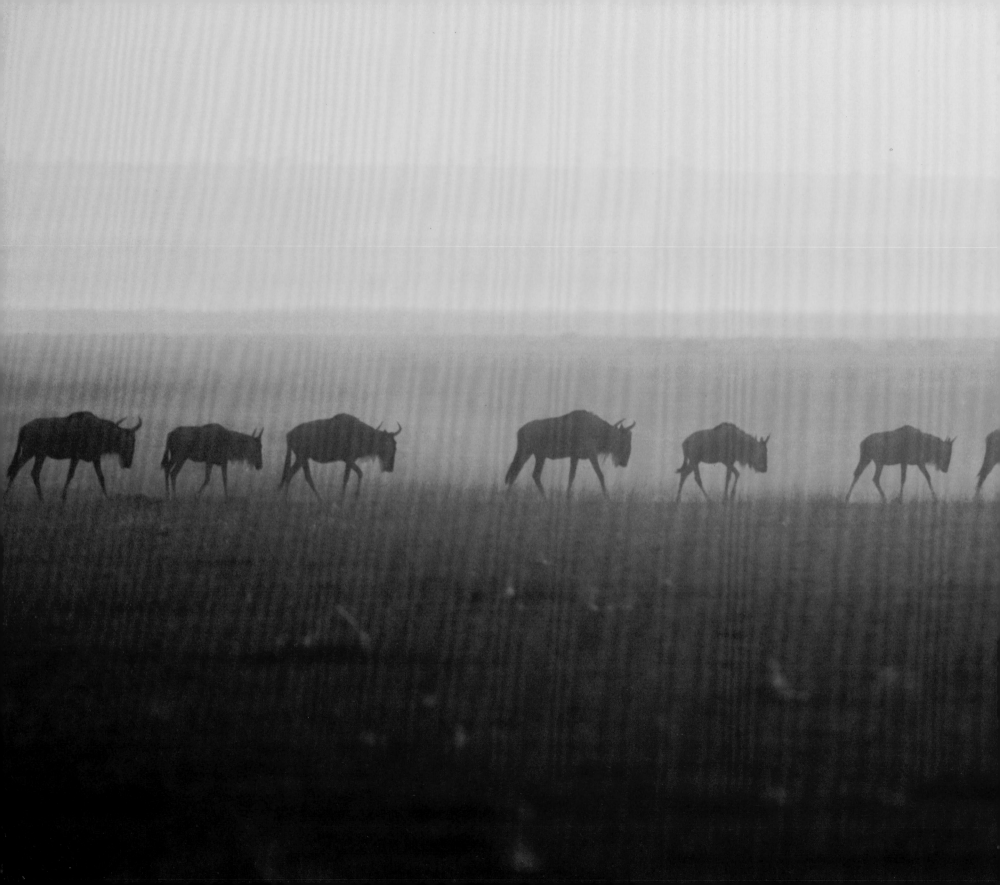

EASTERN WHITE-BEARDED WILDEBEEST *Connochaetes taurinus albojubatus*
AMBOSELI NATIONAL PARK, KENYA

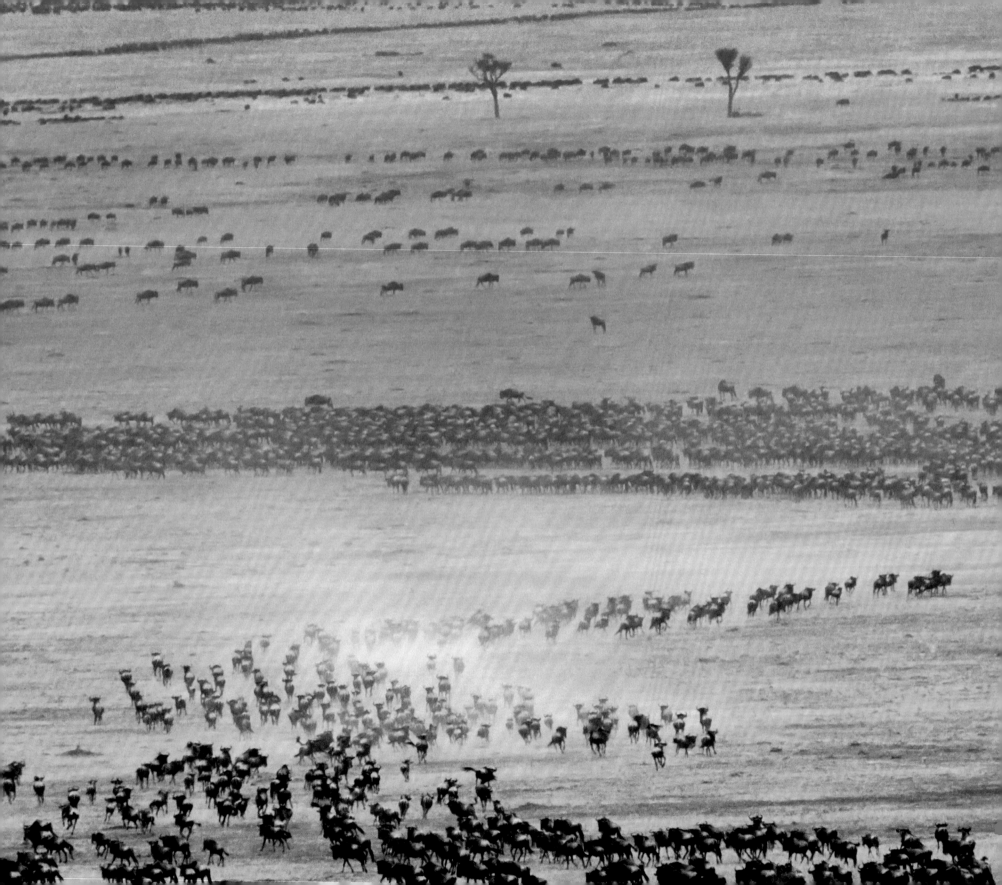

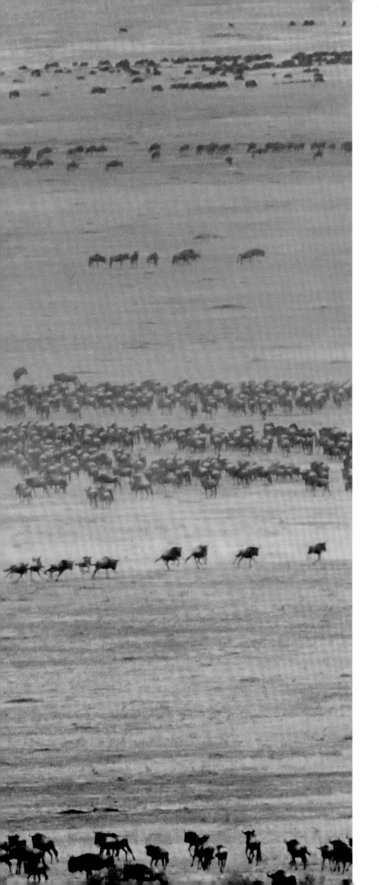

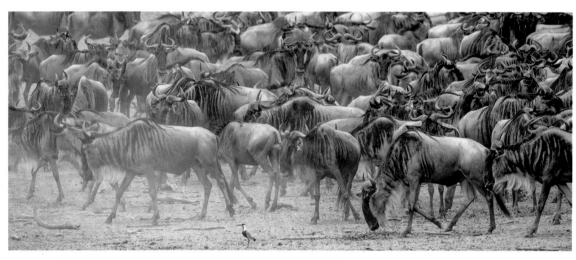

(these pages) **EASTERN WHITE-BEARDED WILDEBEEST** *Connochaetes taurinus albojubatus*
MASAI MARA NATIONAL RESERVE, KENYA

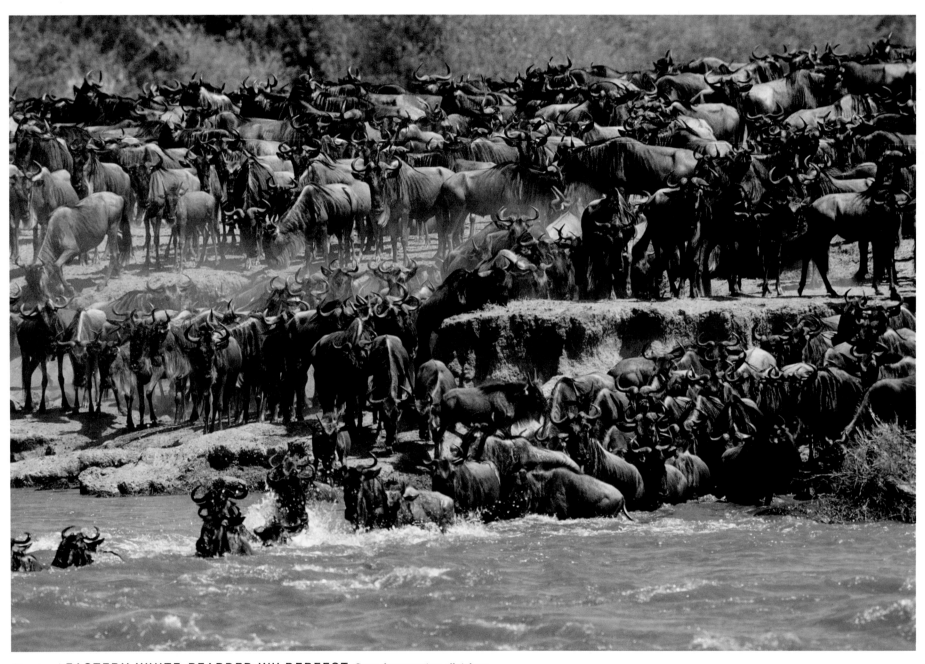

(these pages) **EASTERN WHITE-BEARDED WILDEBEEST** *Connochaetes taurinus albojubatus*
MASAI MARA NATIONAL RESERVE, KENYA

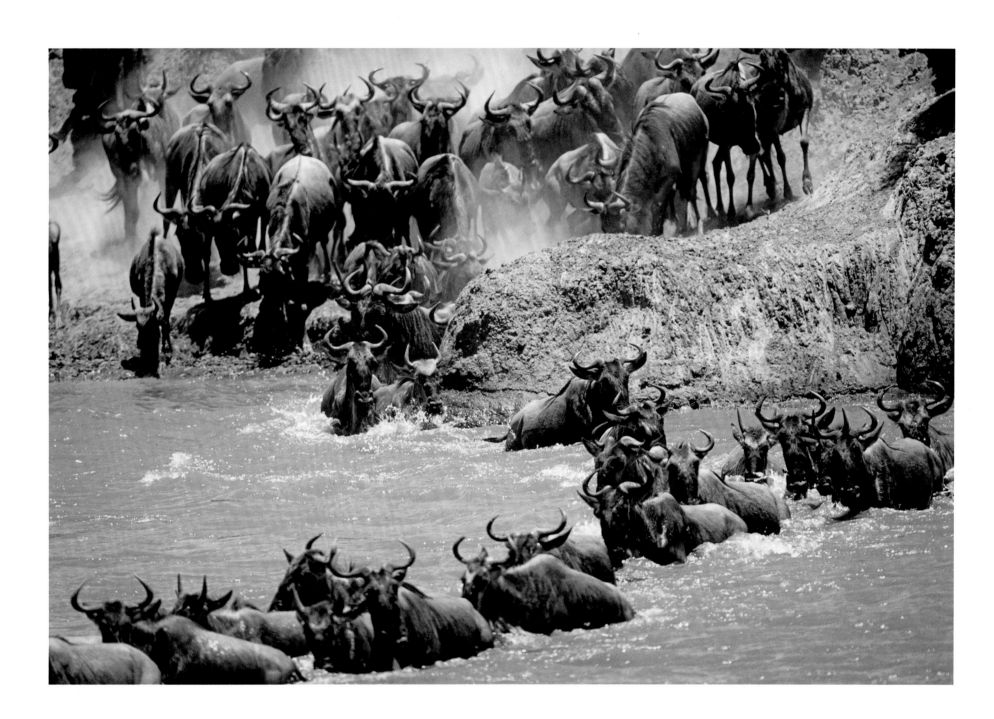

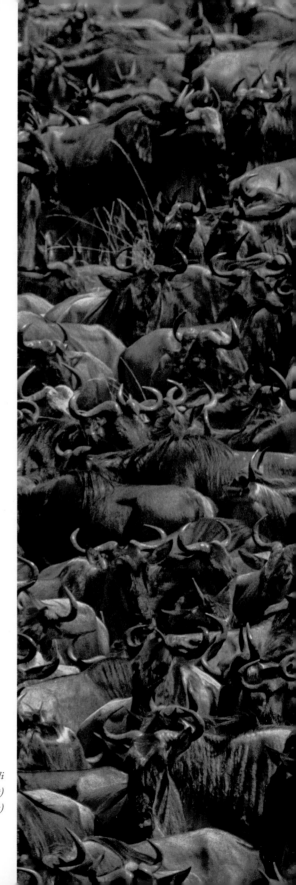

EASTERN WHITE-BEARDED WILDEBEEST *Connochaetes taurinus albojubatus* | **PLAINS ZEBRAS** *Equus burchelli*
MASAI MARA NATIONAL RESERVE, KENYA *(right)*
NGRONGORO CONSERVATION AREA, TANZANIA *(following pages)*

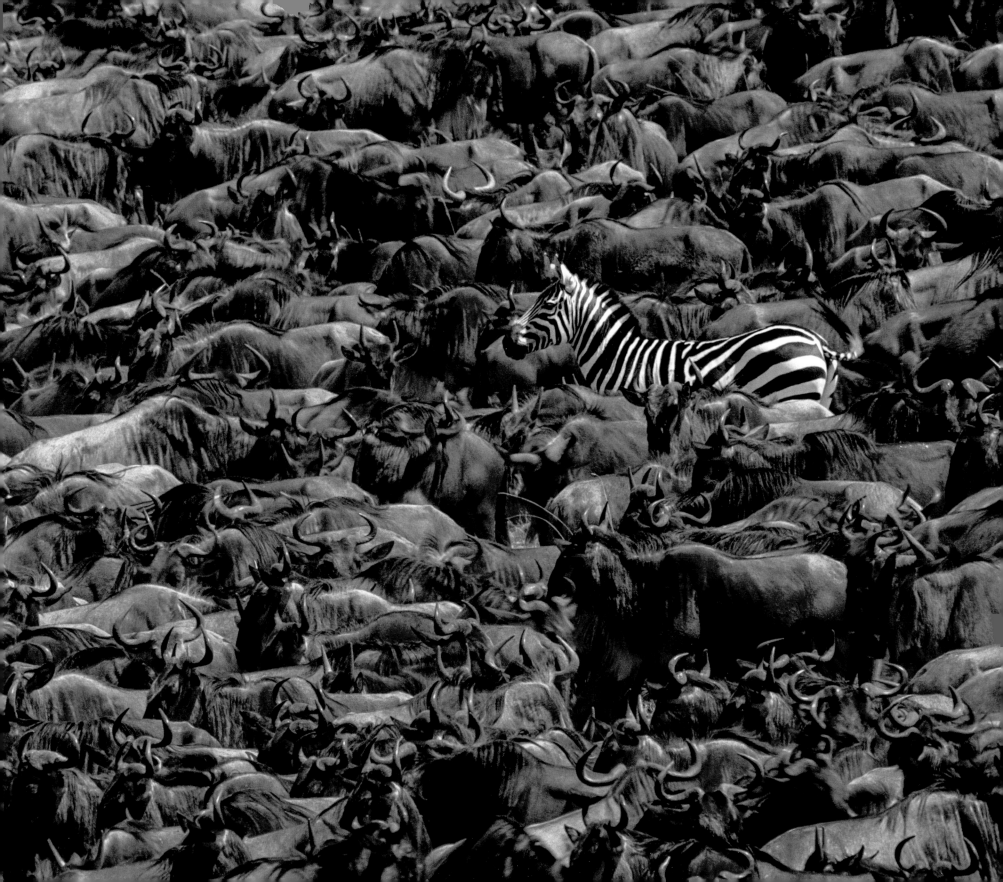

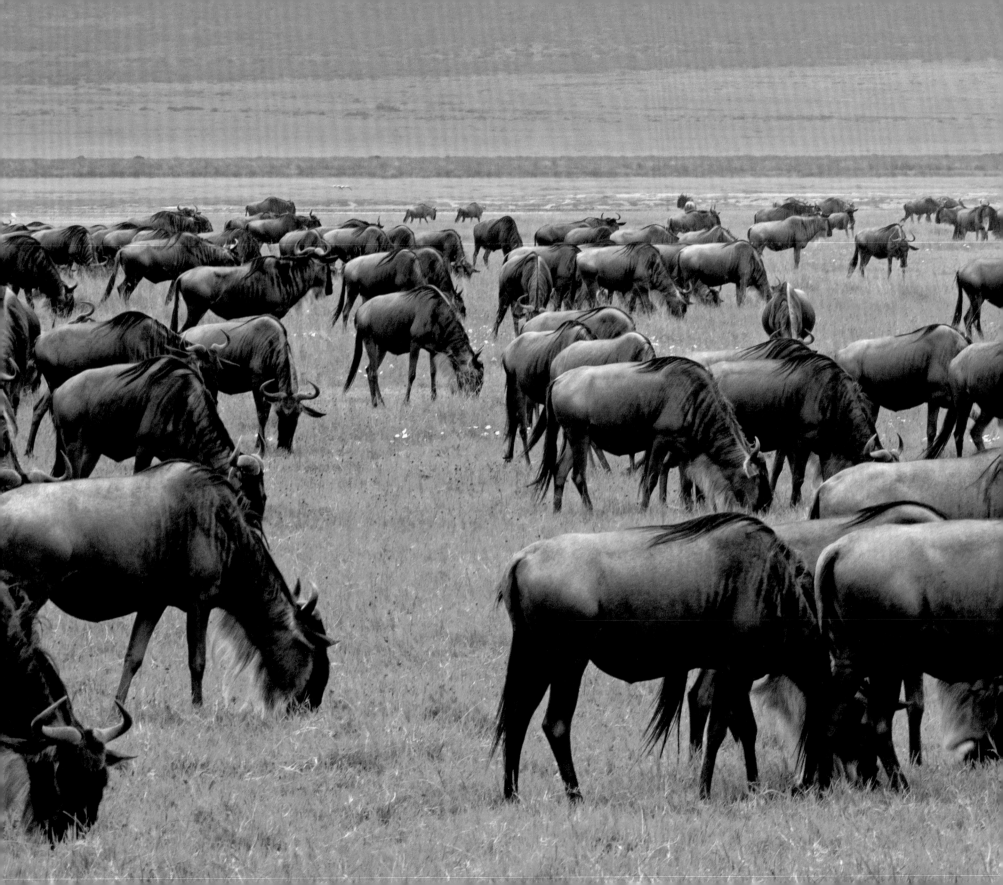

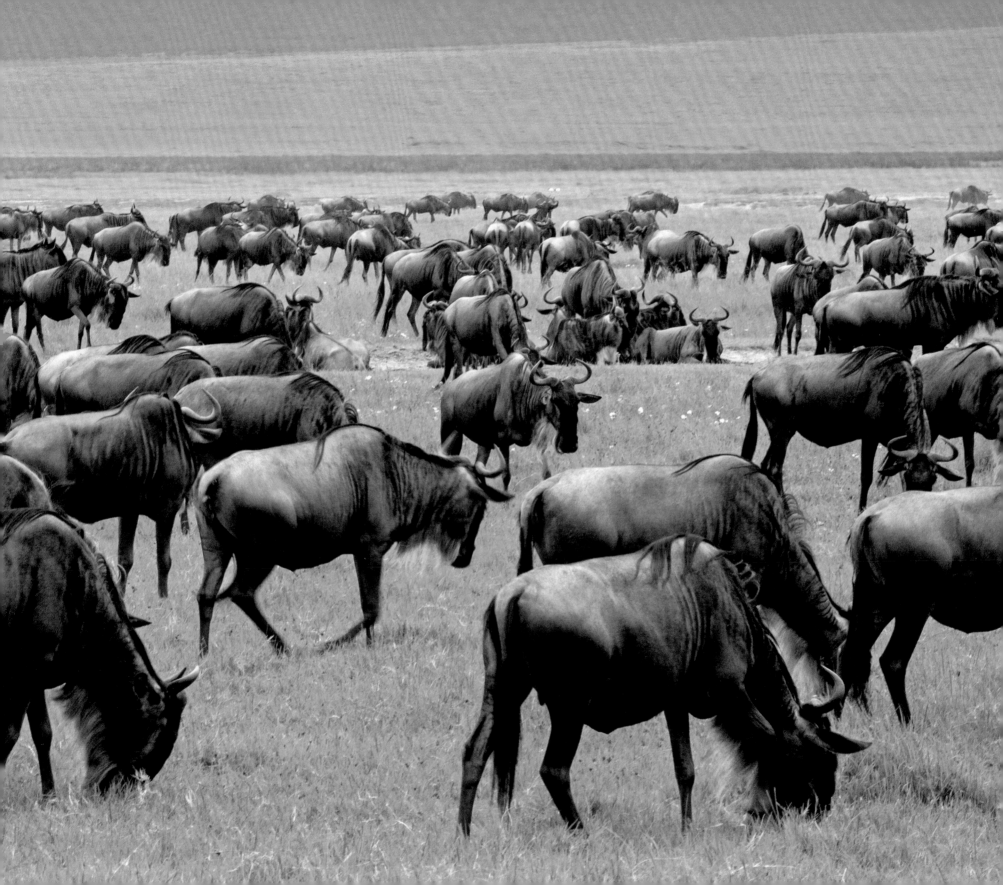

(these & previous pages) **EASTERN WHITE-BEARDED WILDEBEEST** *Connochaetes taurinus albojubatus*
SERENGETI NATIONAL PARK, TANZANIA

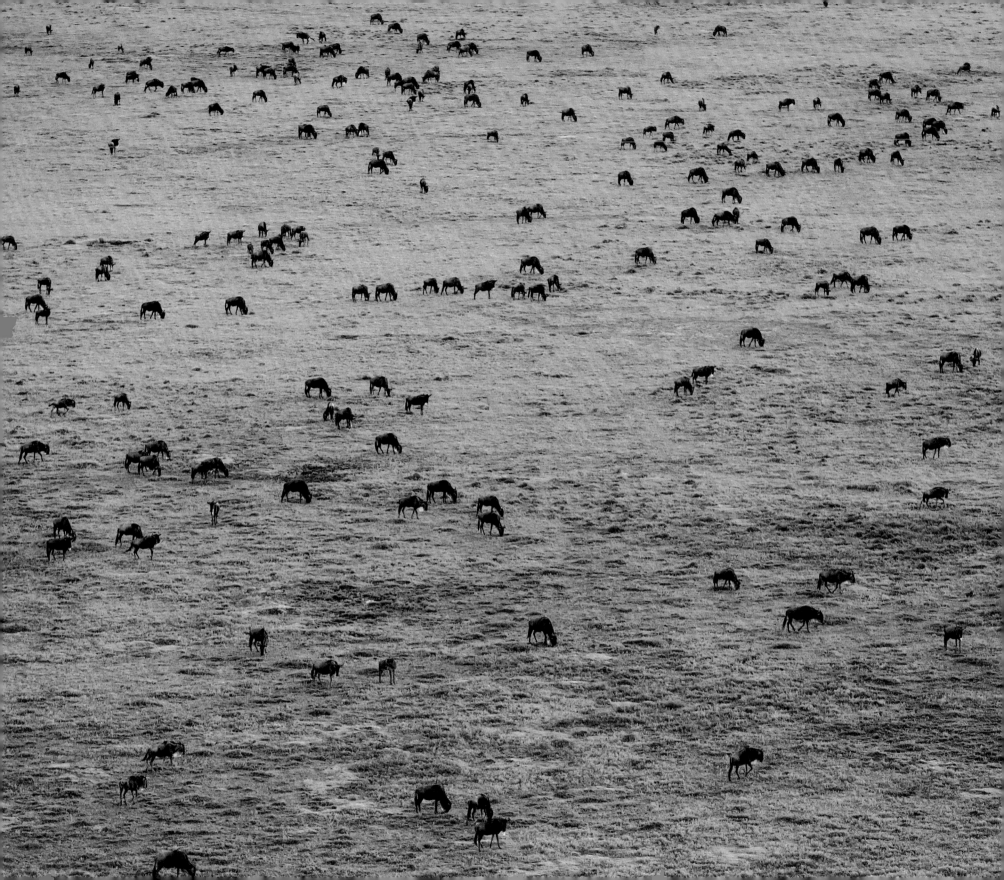

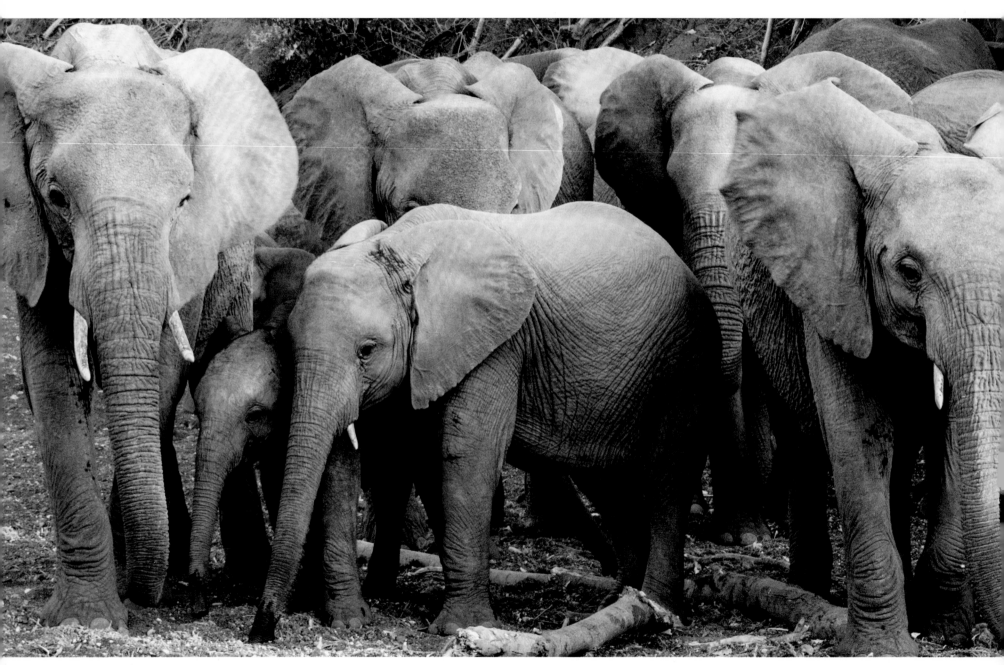

AFRICAN ELEPHANTS *Loxodonta africana*
MASHATU GAME RESERVE, BOTSWANA

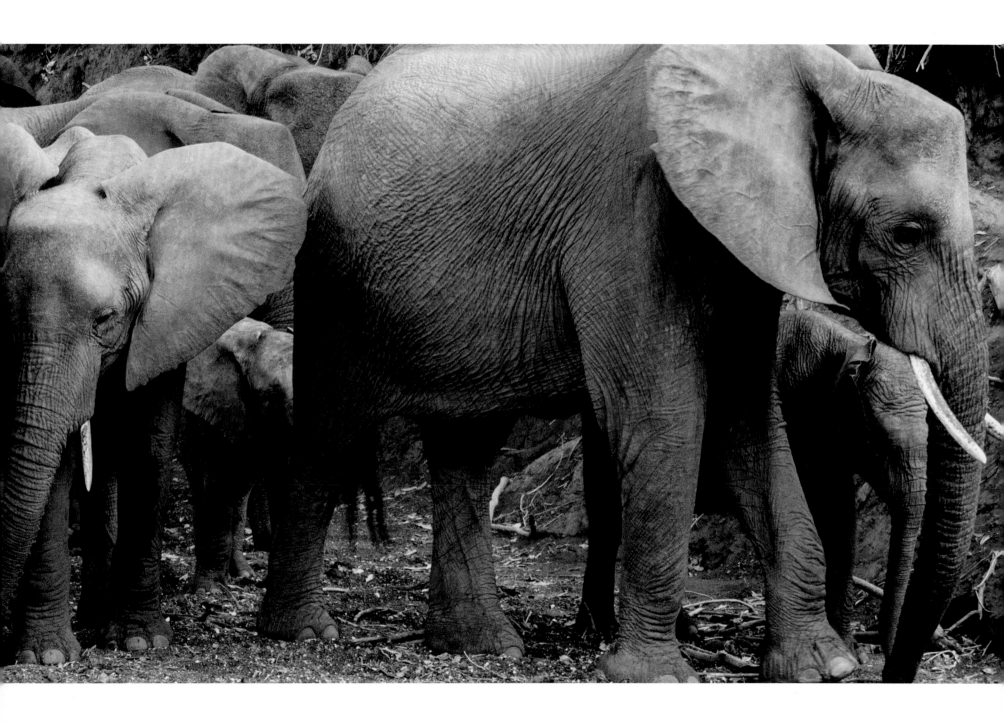

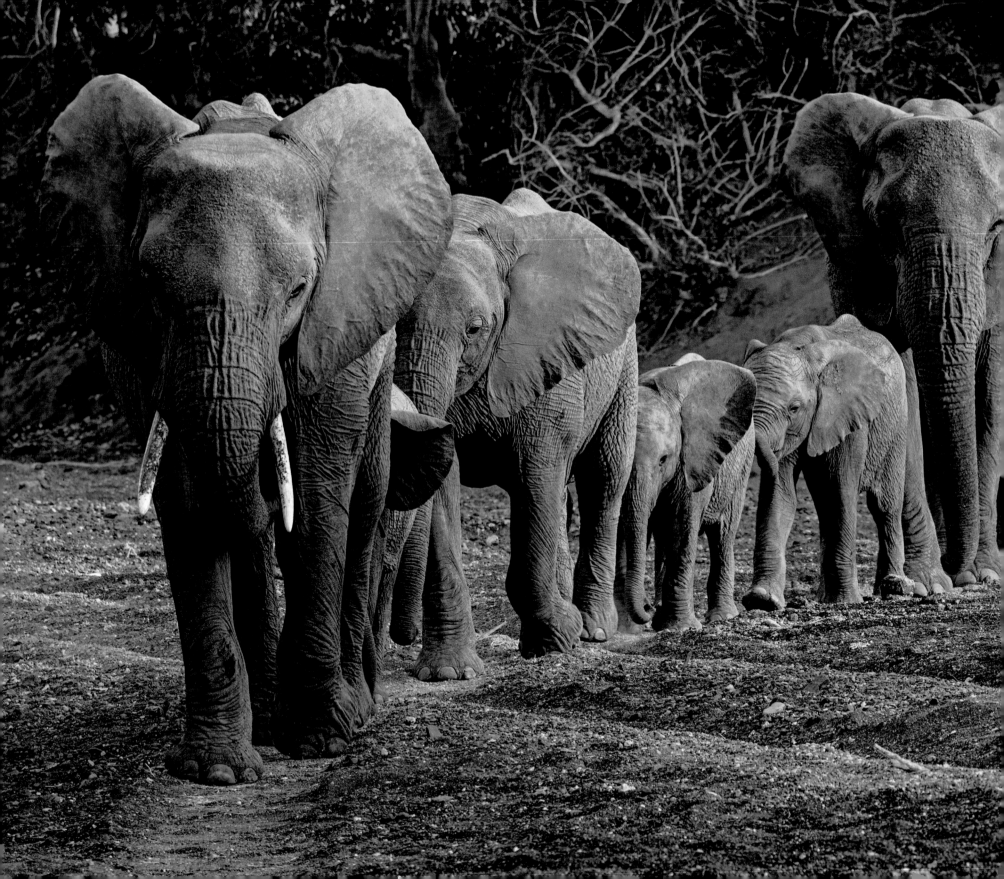

AFRICAN ELEPHANTS *Loxodonta africana*

MASHATU GAME RESERVE, BOTSWANA

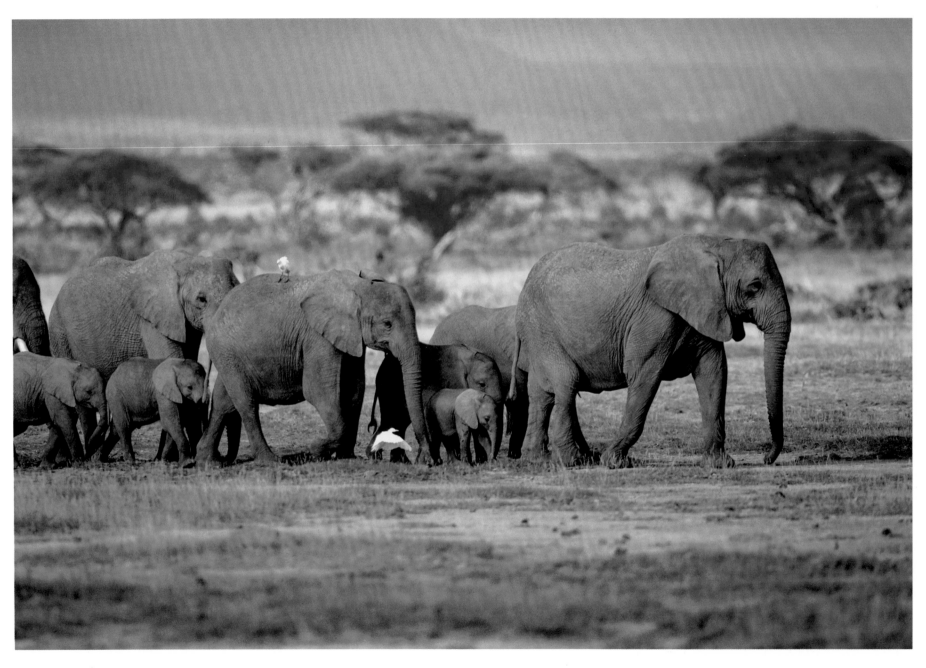

(these pages) **AFRICAN ELEPHANTS** *Loxodonta africana*
AMBOSELI NATIONAL PARK, KENYA

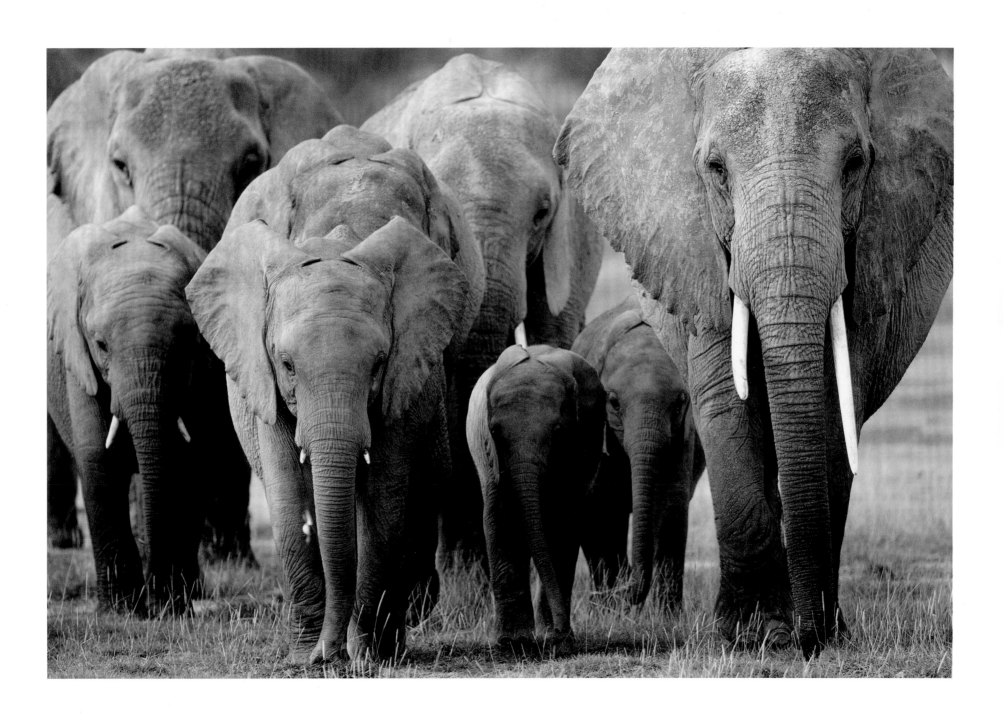

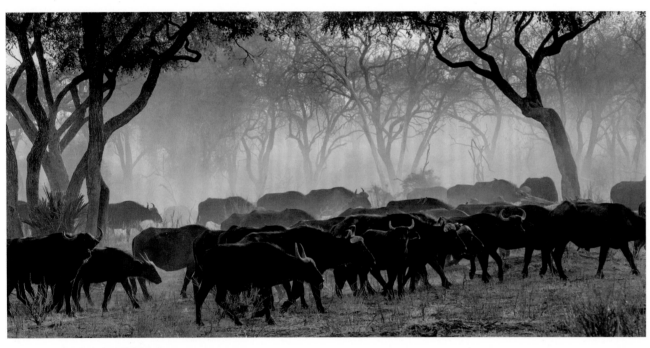

(these pages) **CAPE BUFFALO** *Syncerus caffer caffer*

OKAVANGO DELTA, BOTSWANA *(above)*

AMBOSELI NATIONAL PARK, KENYA *(right)*

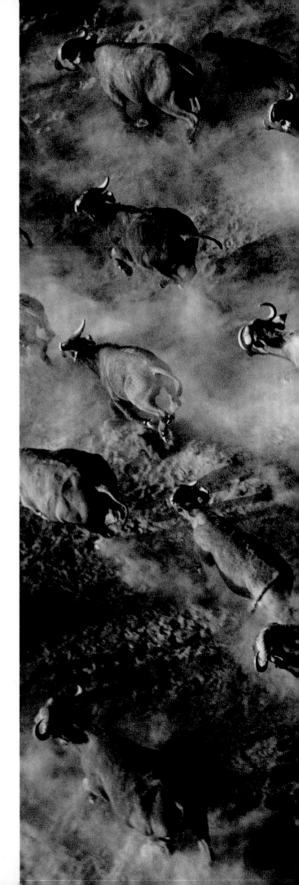

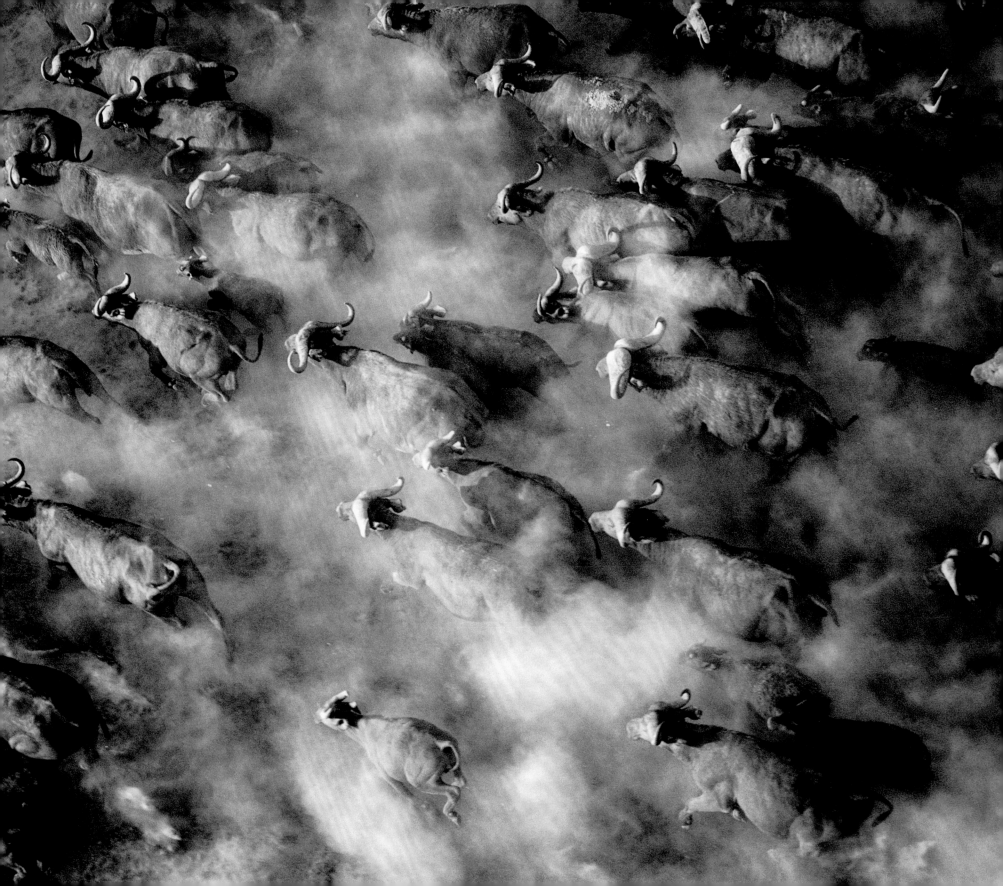

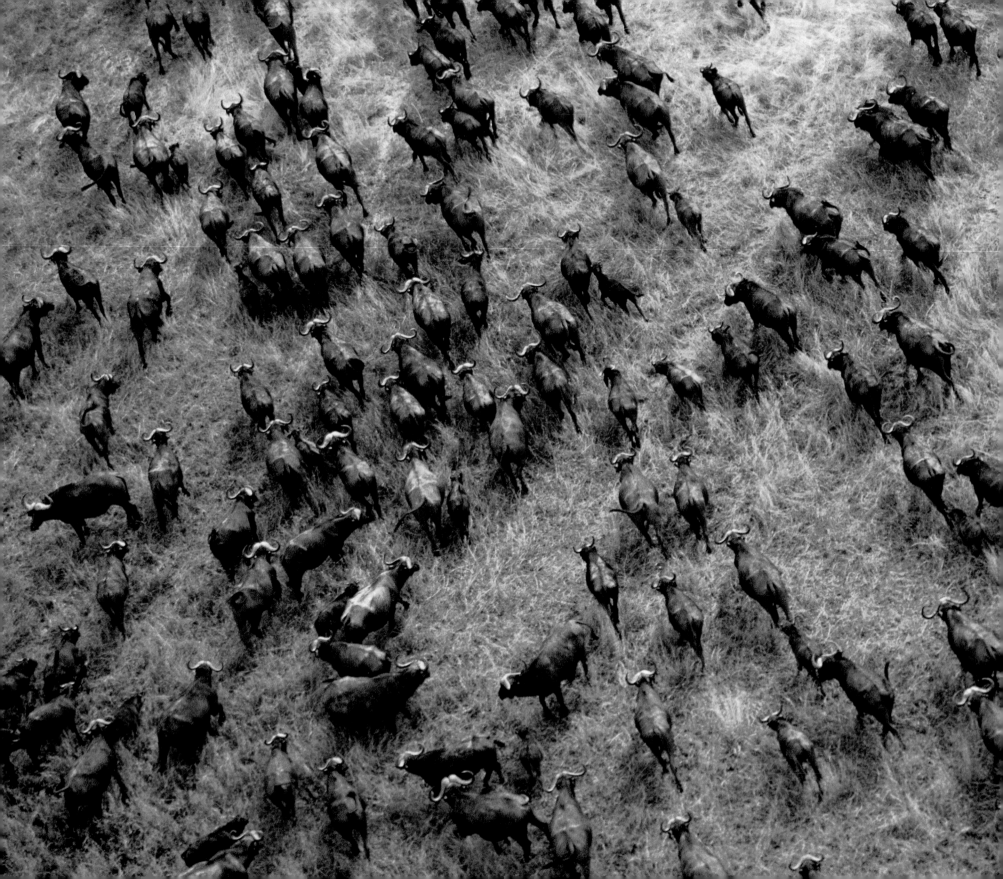

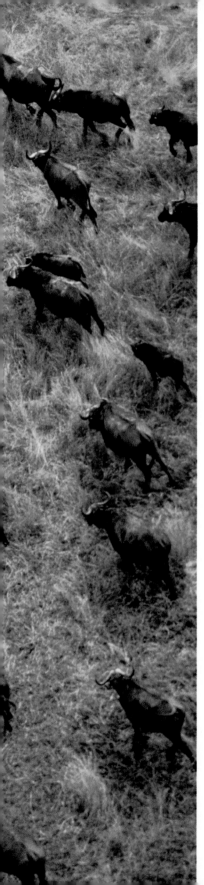

CAPE BUFFALO *Syncerus caffer caffer*
LONDOLOZI PRIVATE GAME RESERVE, SOUTH AFRICA

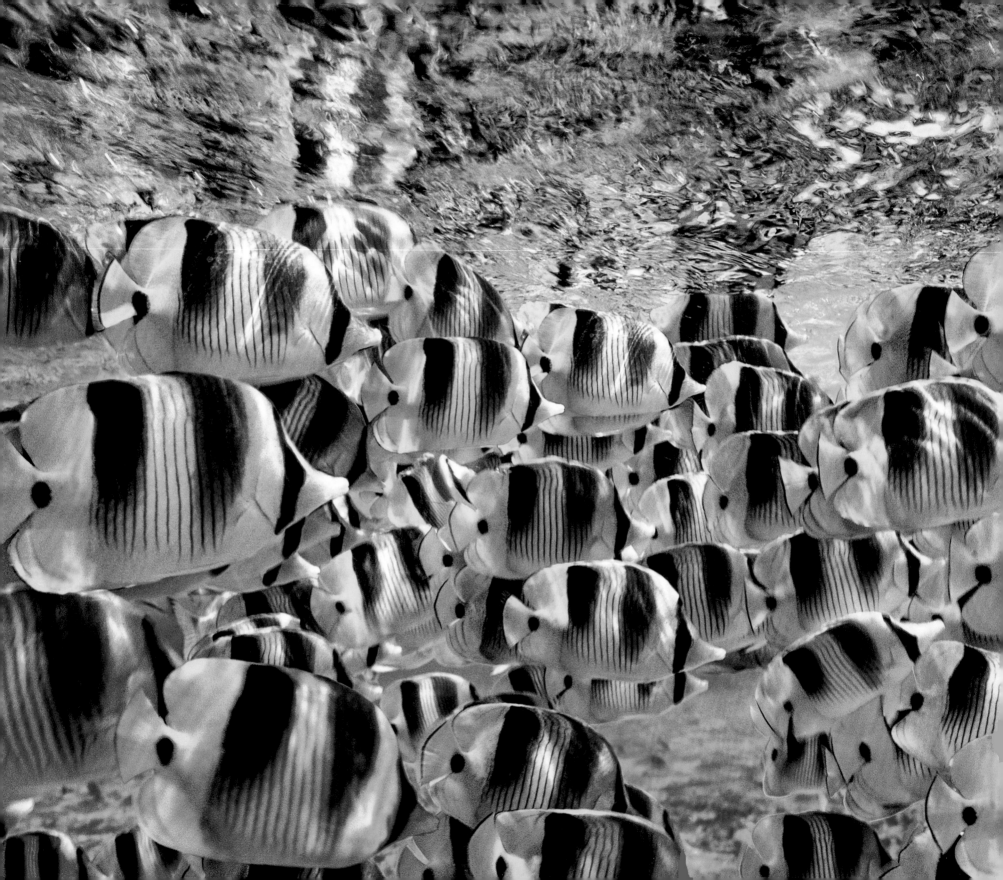

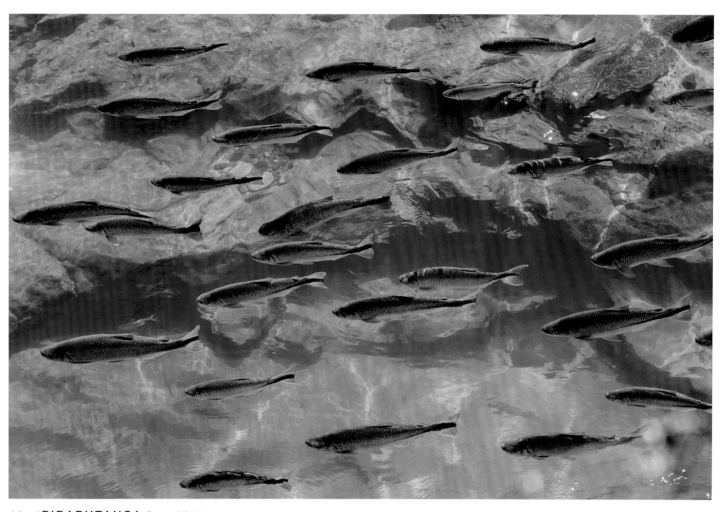

(above) **PIRAPUTANGA** *Brycon hilarii*
MATO GROSSO DO SUL, BRAZIL

(left) **PACIFIC DOUBLE-SADDLE BUTTERFLYFISH** *Chaetodon ulietensis*
BORA BORA, FRENCH POLYNESIA

ABOUT THE ANIMALS

EASTERN WHITE-BEARDED WILDEBEEST
Connochaetes taurinus albojubatus (page 126)
KENYA AND TANZANIA

It has been said that the gnu, or wildebeest, has "the forequarters of an ox, the hindquarters of an antelope, and the tail of a horse." Their name, *gnu*, is derived from the Hottentot word *'t' gnu*, which describes their loud bellowing snort. These large bearded antelope are unusual in more ways than in just their name and anatomy. Wildebeest are picky eaters and prefer only a few species of grasses—at certain heights—and they choose range where waterholes are infrequent, even though they need to drink more water than most grazing species. Females synchronize their births, grouping together to produce as many as twenty calves per hour. They give birth standing up—kneeling only on their front knees—to literally drop their calves onto the plains.

Tanzania's Serengeti National Park protects roughly half of a grassland ecosystem that feeds over two million plains mammals—the largest such congregation on Earth. Kenya's Masai Mara marks the northern portion of this 9,600-square-mile area as well as the northern limits of an annual migration that takes vast herds of wildebeest, gazelle, and zebra on a clockwise route in search of seasonal food and water. Increasing competition for these critical resources threatens Africa's wildlife and the parks that protect them. Because cattle convey wealth and status to those who own them, there is cultural pressure for families to own as many as possible. Yet unlike Africa's native antelope, cattle need more water, tear up grass by the roots, and leave the earth trampled into hard-packed wasteland, especially around waterholes. During times of drought, they leave little vegetation to regenerate, causing both livestock and wildlife to starve.

Similar to a group of Adélie penguins hesitant to enter the water for fear of a chance encounter with a voracious leopard seal, milling wildebeest are reluctant to enter the swift currents and crocodile-infested waters of Kenya's Mara River. Finally, after much crowding, bellowing, and sparring, the animals at the edge of the river are pushed in, and the rest of the herd promptly follows. Each year, wildebeest follow a 500-mile clockwise migration from the southeastern Serengeti plains to the western woodlands, then north to Kenya's Masai Mara. By the time the herds return with the rains to the Serengeti, they will have covered at least 1,000 miles. By allowing large areas of vegetation time to regenerate, this pattern of rotating migration helps maximize the number of grazers the land can support. American cattle ranchers use a similar technique of pasture rotation to preserve their grazing areas.

AFRICAN ELEPHANTS *Loxodonta africana (page 138)*
BOTSWANA AND KENYA

African elephants once migrated over much of the Dark Continent. Now these living relics are restricted to national parks and other habitat islands surrounded by encroaching humanity. Adult males stand ten feet high at the shoulders and weigh close to six tons. Yet despite their size as the planet's heaviest land animal, elephants walk almost silently through the vegetation on their enormous cushioned feet. This ability, coupled with their coloring—dust-covered by day and black at night—allows these giants to move through the landscape almost undetected. At night, it's easier to walk into an elephant than to see one. By day, they spend considerable time browsing. Their feeding habits are quite destructive, as they routinely topple large trees just to nibble a few leaves at the top. Restricted to shrinking habitat areas that allow no exit for the elephants and no chance for the vegetation to regenerate, the elephants will eventually destroy their own habitat—a habitat also needed by other wildlife. In parks where this is a problem, elephant population control measures have been initiated. In other areas, such as Zambia's Luangwa Valley National Park, this hasn't been necessary. Once called the "Valley of Elephants," the Luangwa Valley was famous for its large herds. In just a few years, 80 percent of the elephants were killed by poachers wielding automatic rifles.

Depending on the quality of their habitat, elephants can spend up to eighteen hours a day feeding. They manipulate their food with their trunks—the longest animal noses in the world. A combination of upper lip and nose, the trunk can be used for grabbing and smelling at the same time. The African elephant has two "fingers" at the tip of its trunk which it uses to grab small objects. More than 40,000 muscles and tendons in the trunk enable an elephant to pick up a peanut or to lift a heavy log. Thou-

sands of migratory elephants congregate in Botswana's Okavango Delta each year. Often, when crossing the deep-water channels, only the tips of their trunks are visible above the surface of the water, serving as handy pachyderm snorkels.

CAPE BUFFALO *Syncerus caffer caffer* (page 144)
BOTSWANA, KENYA, AND SOUTH AFRICA

Cape buffalo are armed and dangerous. Both sexes sport massive curved horns, which sit atop their heads like Viking helmets. They can be deadly when aimed at predators or people. Cape buffalo are actually wild cattle. When alarmed, they produce an explosive snort, then raise their heads high looking for danger. Sounding such an alarm usually brings the entire herd to the defense of the frightened animal. So effective is this system of group defense that even blind and lame buffalo have been able to survive within the herd. Weighing up to 1,800 pounds, Cape buffalo can be especially dangerous if wounded or cornered. Hunters have reported numerous incidents of injured buffalo seeking revenge through ambush, circling through the undergrowth to charge the next person who passes.

Cape buffalo form cohesive herds that vary in size from a few animals to a thousand or more. If not in small bachelor herds, bulls can be solitary. During the rut, the heavyweight males frequently grunt, bellow, and clash. Such combat often results in serious injury. Adding to their rogue appearance, the bulls are usually caked in mud, which dries to form a protective coat against insect bites and excessive solar radiation.

PACIFIC DOUBLE-SADDLE BUTTERFLYFISH
Chaetodon ulietensis (page 148)
BORA BORA, FRENCH POLYNESIA

Butterflyfish are day-active predators that feed on benthic invertebrates. They use vision to find their prey and feed on conspicuous reef invertebrates such as sponges, tunicates, corals, and mollusks. To avoid being eaten, these prey species have gone to great extremes, developing spines, heavy armor, toxins, and even unpalatable tastes in order to thwart attack.

In what amounts to an evolutionary arms race between predator and prey, fish such as the butterflyfish have had to become increasingly specialized in order to overcome these invertebrate defenses. Some butterflyfish, armed with small sharp teeth, sneak up on armored prey to snip off pieces of their soft parts that are exposed when they feed. Others dine on the tentacles of polychaete worms and the mucus secreted by corals.

Butterflyfish have developed a few tricks of their own in order to avoid being eaten. Their stout dorsal and anal spines make them tough to swallow, and in a pinch, they can swim backwards. With pancake-thin bodies, they can wedge themselves into inaccessible cracks. Their bright colors and pattern of vertical black stripes help to break up the outline of their bodies. The black lines also cause a camouflage effect called "flicker fusion" to occur in the eyes of predators. When a striped fish swims across a field of vertical plant stems, the rapid movement of the stripes across the stems causes them to fuse, creating an optical illusion that makes the fish disappear.

PIRAPUTANGA *Brycon hilarii (page 149)*
MATO GROSSO DO SUL, BRAZIL

Despite being called South American trout, piraputangas are not related to trout at all. They are widely dispersed in freshwater habitats from southern Mexico to Argentina. They are equal opportunity feeders, preying on small fish, animals, and mollusks, as well as seeds, fruits, and other plant material such as leaves and algae. They will actually jump out of the water to feed on low-hanging fruit. Seed dispersal by the fish may have important effects on the surrounding riparian forests.

During flood season the fish form large schools and swim hundreds of miles upstream to spawn and feed. The higher waters allow the fish to get over falls that otherwise they could not breach. They are a medium-sized migratory species up to two feet long and can grow to over seven pounds.

Destruction of rainforests, dam building, agricultural and industrial activities, and overfishing all could have serious consequences for this species. Meaty piraputangas are also prized by sport fishermen, and tourists engaged in underwater activities love them because of their beautiful color.

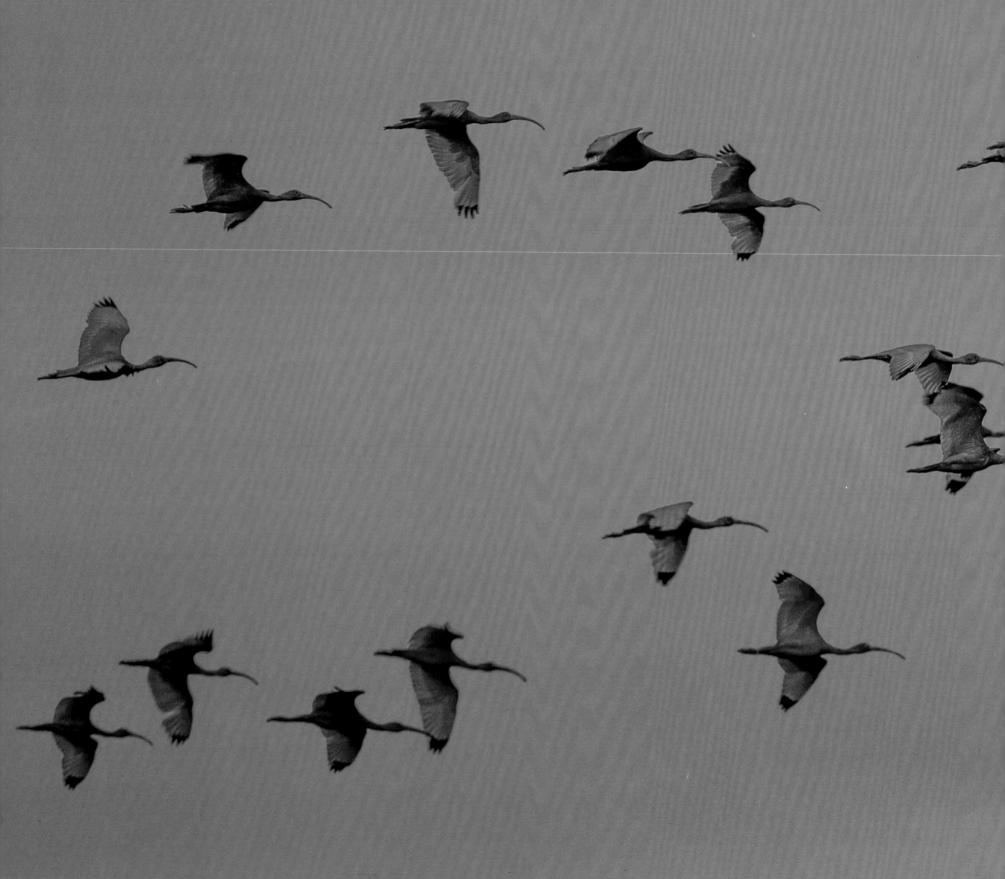

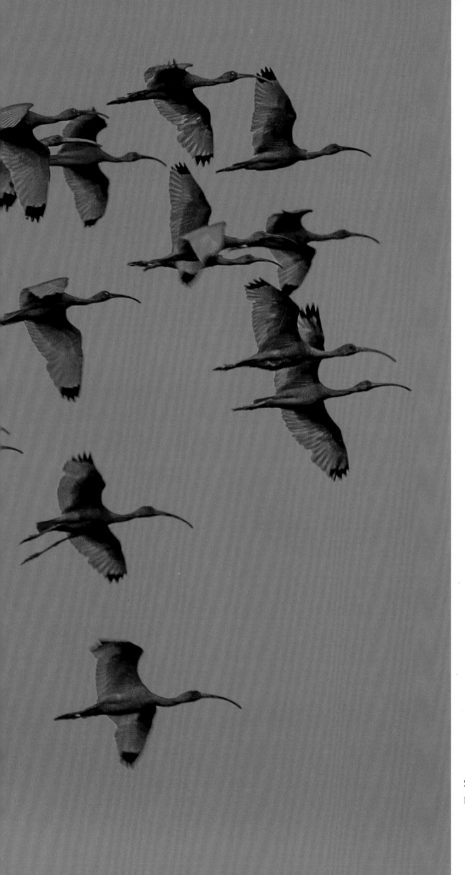

SCARLET IBIS *Eudocimus ruber*
PARA STATE, BRAZIL

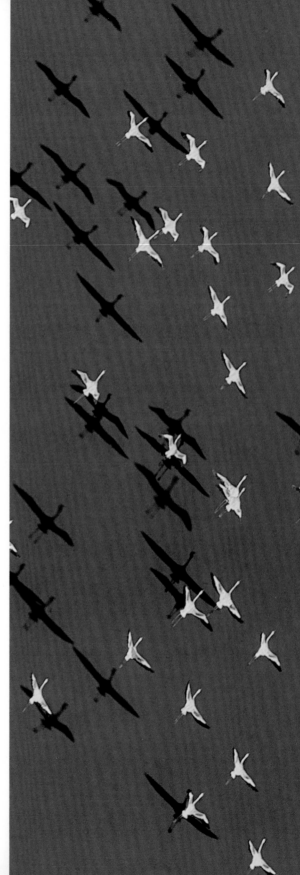

LESSER FLAMINGOS *Phoenicopterus minor*
LAKE NATRON, TANZANIA

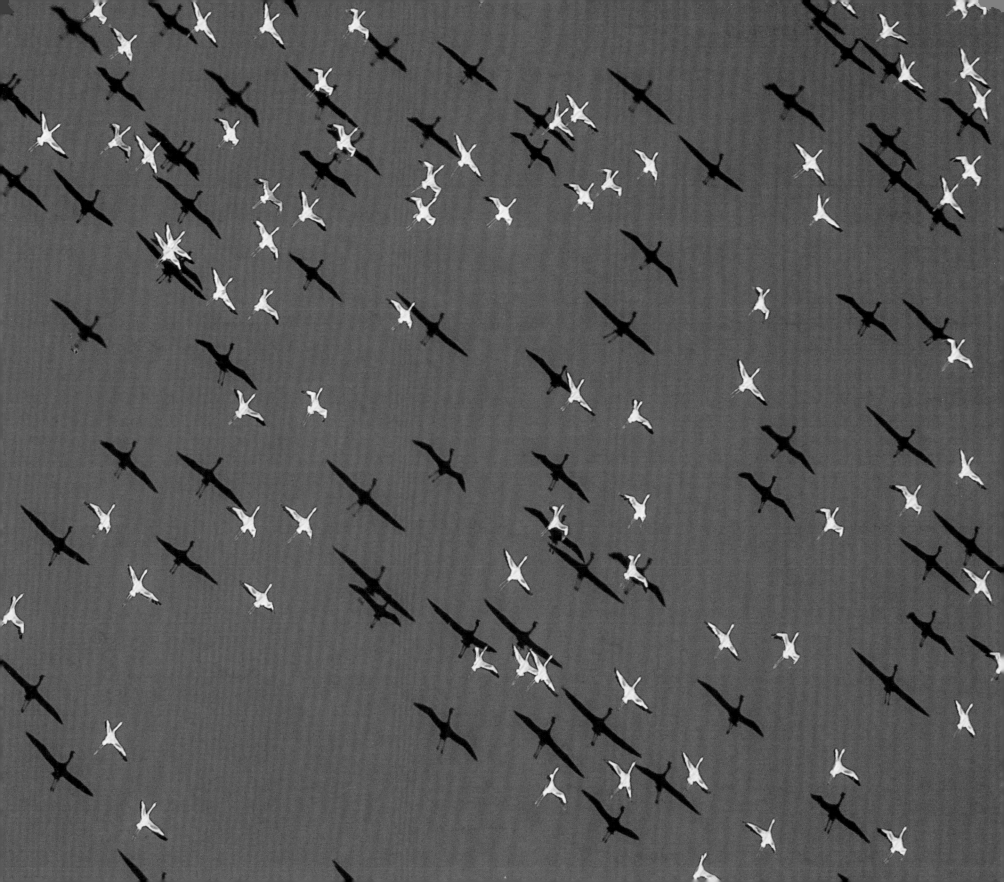

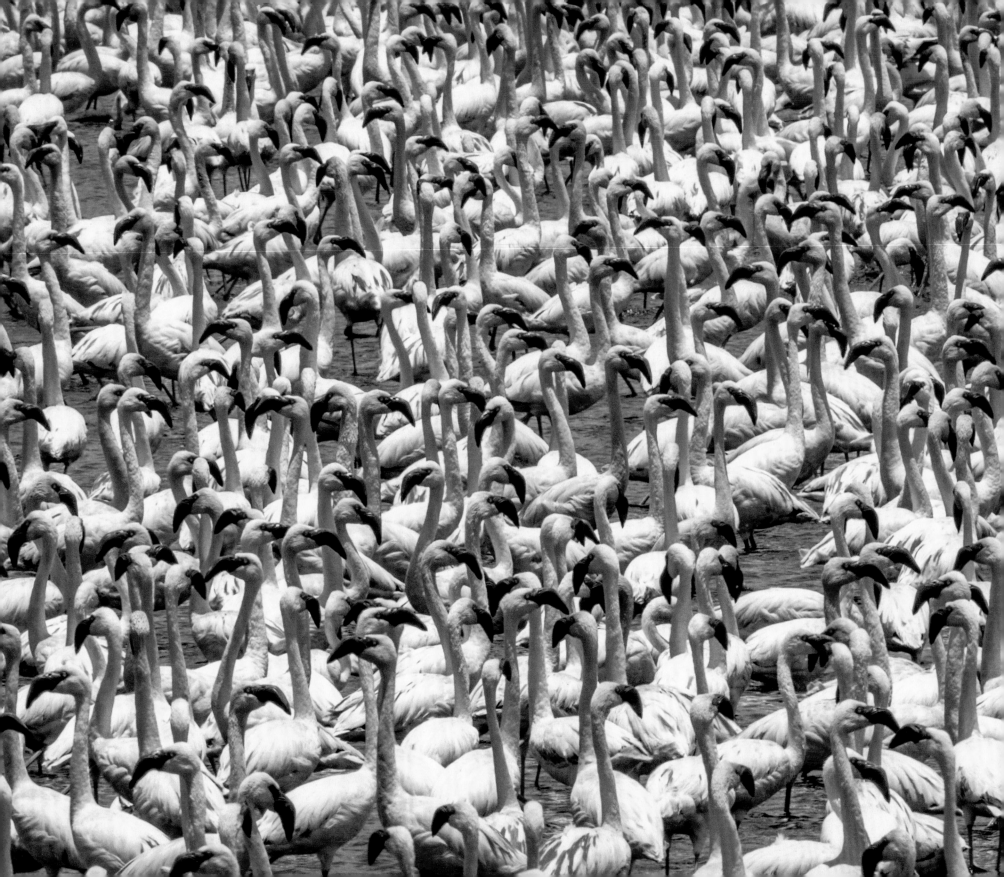

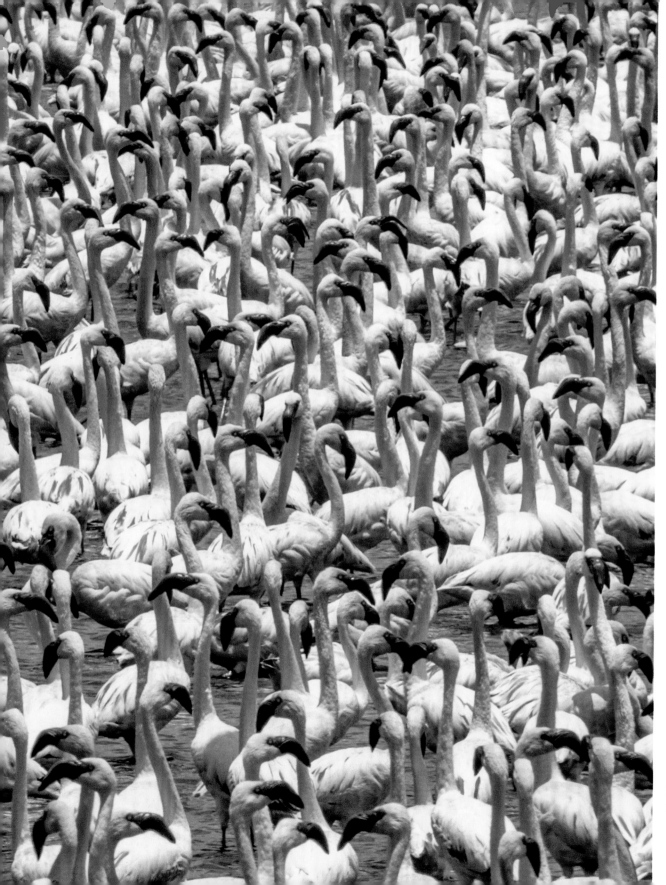

LESSER FLAMINGOS *Phoenicopterus minor*
LAKE NAIVASHA, RIFT VALLEY, KENYA

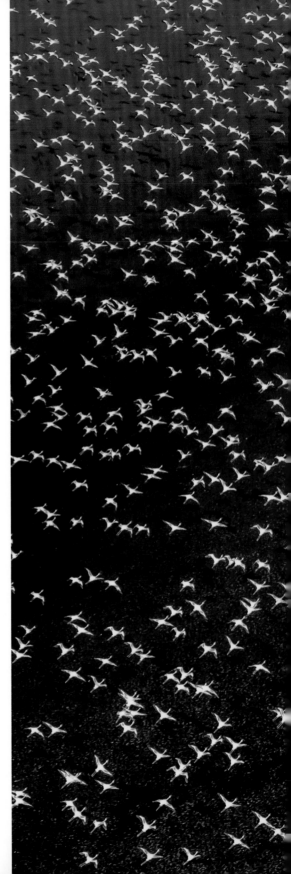

LESSER FLAMINGOS *Phoenicopterus minor*
LAKE NATRON, TANZANIA

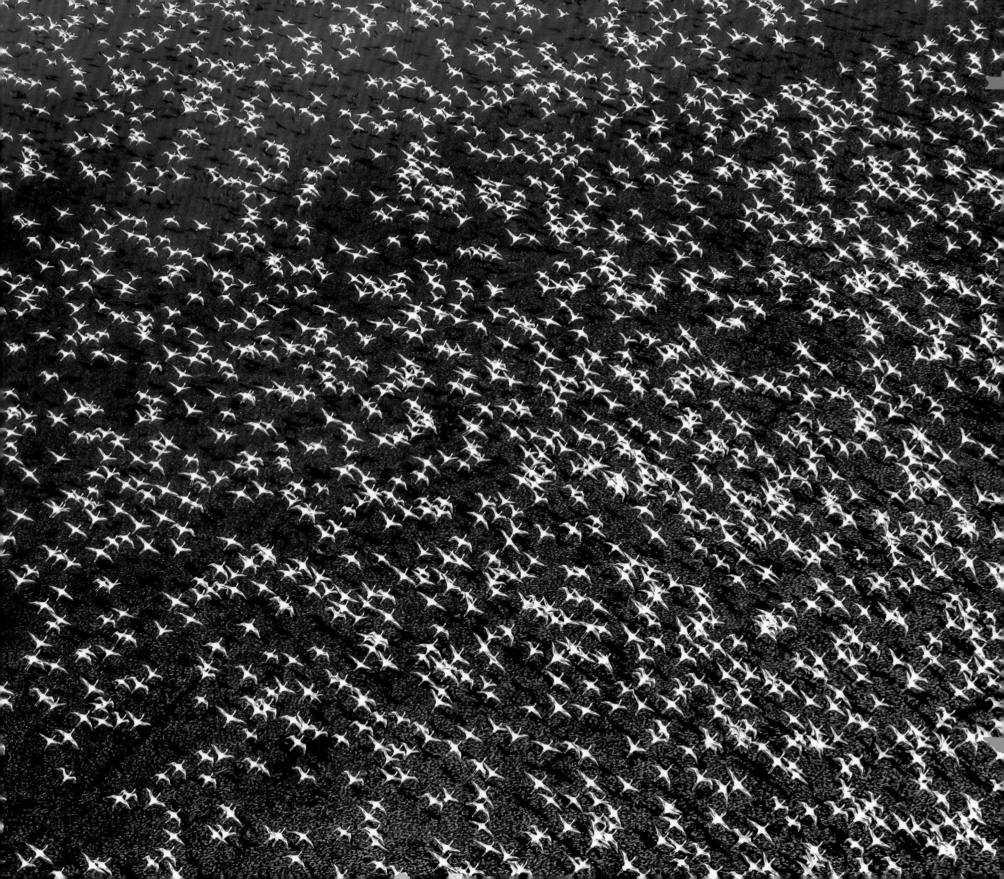

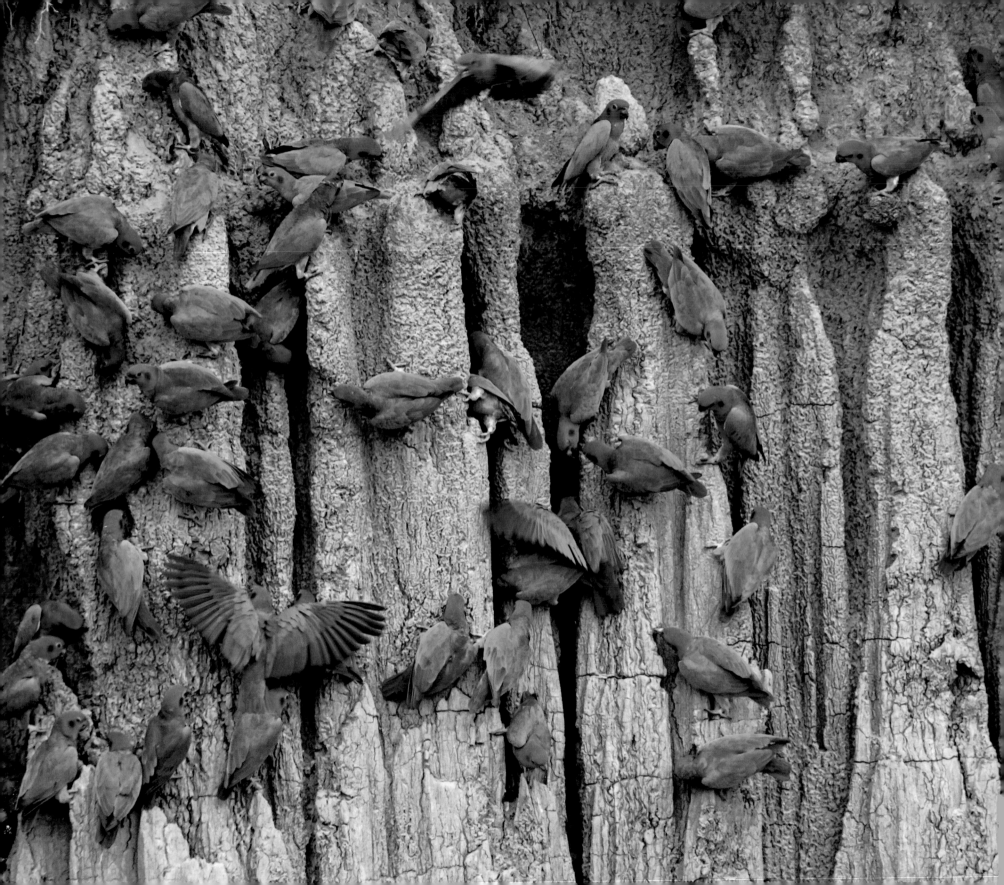

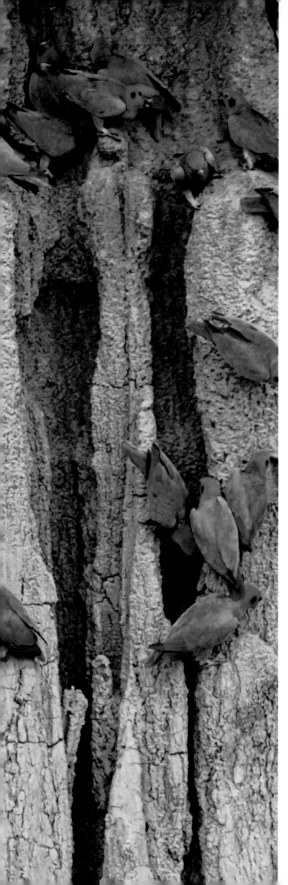

BLUE-HEADED PARROT *Pionus menstruus*
MANÚ NATIONAL PARK, PERU

ABOUT THE ANIMALS

SCARLET IBIS *Eudocimus ruber (page 152)*
PARA STATE, BRAZIL

With their heads thrust forward and long legs trailing, these flame-red birds alternately flap and soar in synchrony. In the late-afternoon glow of sunset, they set their roosting trees ablaze with color. Ibis belong to an ancient group of birds whose fossil record dates back to the Eocene, sixty million years ago. As recently as 5,000 years ago, the sacred ibis was worshipped by the Egyptians, who included them in their religious beliefs and written records, and mummified them for burial with the pharaohs. While the sacred ibis has not bred in Egypt for more than a century, the scarlet ibis is protected as the national bird of Trinidad. Native to the tropical mangrove swamps, muddy estuaries, and tidal flats along the coasts and beaches of northern South America, these gregarious birds roost in large numbers. Even their nestlings socialize early, climbing about in the trees two to three weeks before they are able to fly. Both sexes look alike. Their long, downcurved bills are used to probe the mud for crabs and mollusks. All species of ibis native to North America are currently protected by law.

LESSER FLAMINGOS *Phoenicopterus minor (page 154)*
TANZANIA AND KENYA

It is said that the greatest wildlife success story in East Africa's Rift Valley is that of the flamingos. More than half of the world's entire flamingo population inhabits the many salt lakes there. Just two species, the lesser and greater flamingos, contribute to this remarkable proliferation of pink-feathered birds. Of the two, the lesser flamingos are the most abundant, creating an avian ballet of long, sinuous necks and graceful, slender legs.

Until the 1950s, one of the biggest unsolved ornithological mysteries was that of where the Rift Valley's three million flamingos nested. Lake Magadi and Lake Natron lie in the deepest, hottest trough of the Central Rift Valley and are two of the most alkaline lakes in the Rift. Only sixteen inches of rain fall here each year, yet 130 inches of saline spring water and runoff evaporates from the area annually. The lakes serve as caustic heat traps where the water-soluble alkali—derived from sodium carbonate, or soda—becomes highly concentrated. The combination of heat and salt is inhospitable to most wildlife, but lesser flamingos, adapted to feed on soda algae, thrive under these harsh conditions.

Naturalist Leslie Brown was the first to spot two large breeding colonies from the air, located several miles off-shore on the Lake Natron soda flats. His subsequent attempt to reach them on foot was nearly fatal. Setting out alone with only a small water bottle, Brown quickly discovered that the flamingos' environment was hostile, even deadly. A thick soda crust overlay a deep quagmire of sulphurous ooze, and with each step he broke through the surface to battle the foul-smelling mud. At times he crawled on his hands and knees in the hot sun, afraid to stop moving for fear of getting stuck. Fatigue finally forced him to turn back before he could reach the breeding colony. He then had to hike more than seven miles and drive another forty-five before he reached help. When Brown finally arrived in the town of Magadi, he spent three days in a hospital, and another week wrapped in bandages. While hiking, soda crystals had filled his boots and turned his legs into a minefield of painful red blisters—which turned black when exposed to air. Brown eventually tried once more to reach the isolated flamingo colony, and succeeded—but then never again set foot on the deadly shores of Lake Natron, its waters stained tomato-soup red by the algae that thrive on soda.

Although flamingos move up and down the Rift Valley, they use Lake Magadi and Lake Natron as their major source of food. Lesser flamingos subsist on a diet of algae, while greater flamingos augment their menu with brine shrimp and small crustaceans supported by the spirulina algae. This plentiful food supply attracts an estimated two million flamingos to the small four- by six-mile lake. Although the birds harvest tons of feed every day, the supply is barely diminished due to the algae's fast generation

in the intense ultraviolet light near the equator—and at 5,767 feet above sea level. Lake Magadi's specialized environment has created one of the greatest bird spectacles in the world.

Named after the fabled red phoenix of Greek mythology, flamingos have the longest legs in proportion to body length of any bird. There are six different species. The lesser flamingo, standing three feet tall with bright red eyes and legs, is the smallest of them all, yet they occur in such vast numbers in the East African lake district as to transform soda shorelines into an ebbing, flowing river of pink. Occasionally the vermilion-winged birds mysteriously disappear altogether in clouds of steam blown across the lakes from nearby hot springs.

BLUE-HEADED PARROT *Pionus menstruus (page 160)*
MANÚ NATIONAL PARK, PERU

These chunky, foot-tall, blue-headed parrots are one of the most common in Amazonian South America; they are highly adaptable, living in warm, humid woodland, semi-open and agricultural areas, and flooded forests. This extremely large range allows them to be successful as a species, and while their numbers are decreasing somewhat, it is a slow trend. They are voracious eaters, eating wild fruit and seeds, and sometimes despoiling grain and banana crops. They are also very noisy—though not as noisy as Amazon parrots—calling with high-pitched screeches and shrill screams.

Outside the February to March breeding season, they band together in large flocks and move about in search of food. Their flight from roosting sites in treetops and palm frond spikes is a spectacular colorful burst. Manú National Park's biological diversity exceeds that of any place on Earth, with more than 800 bird species alone, including the blue-headed parrot. The vertical cliffs above rivers come alive with colorful parrots nibbling on minerals embedded in the clay. The minerals counter toxins the birds ingest when eating certain nuts and fruits.

PHOTO INFORMATION

PAGE 2: Bat Stars (*Patiria miniata*), Haida Gwaii, British Columbia, Canada
Wading through the shallow tide pools of the Haida Gwaii, I came upon this colorful gathering of bat stars. Never before had I seen such a remarkable combination of vibrant hues in the wild. Since this book is not only a collection of migrations but also of art based on nature, I felt compelled to include this perfect example of patterns of both color and shape.
Nikon F4, Nikkor 50mm macro lens, f/11 at 1/8 second, Fujichrome 100

PAGES 3–4: Eastern White-Bearded Wildebeest (*Connochaetes taurinus albojubatus*), Serengeti National Park, Tanzania
Dust is kicked up by the churning hooves of wildebeest. January is the height of the migration, when millions of animals are on the move.
Canon EOS-1D X, EF70–200mm f/4L IS USM lens, f/5.6 for 1/8000 second, ISO 2500

PAGES 8–9: Southern Carmine Bee-Eaters (*Merops nubicoides*), South Luangwa National Park, Zambia
These turquoise-splashed bee-eaters were nesting by the hundreds in this sandy riverbank. The bright sunshine reflected off the Luangwa River, lighting the muddy walls in soft, even tones.
Canon EOS-1Ds Mark III, EF500mm f/4L IS USM lens, f/4 for 1/320 second, ISO 400

PAGE 11: Elk or Wapiti (*Cervus canadensis*), National Elk Refuge, Wyoming, USA
The most successful perspective from which to display patterns is from the air. Aerials create a more dynamic composition and provide a pattern otherwise absent from the ground.
Nikon F4, Nikkor 80–200mm zoom lens, f/8 for 1/125 second, Fujichrome 50

PAGE 12: King Penguins (*Aptenodytes patagonicus*), South Georgia Island
A few intrepid adult penguins move amidst a sea of woolly juveniles. "Woollies" are the chicks from the previous season; they live the whole year on the beach in feathers that look like velvet. The sunshine of the subantarctic sun gives them golden auras.
Canon EOS-1D X, EF200–400mm f/4L IS USM lens, f/32 for 1/80 second, ISO 1250

PAGES 14–15: Demoiselle Cranes (*Grus virgo*), Jawai, Rajasthan, India
These elegant cranes nest in the open steppe of Mongolia, but they overwinter in the warmer climes of India after making a near-impossible migration over the Himalayas. Here villagers provide thousands of pounds of grain daily for the tens of thousands of cranes that flock to the area.
Canon EOS 5D Mark II, EF500mm f/4L IS USM lens, f/25 for 1/160 second, ISO 400

PAGE 16, TOP: Demoiselle Cranes (*Grus virgo*), Jawai, Rajasthan, India
Heads down feeding, cranes metamorphose into abstract ovate shapes punctuated by linear tail feathers. Even though the light was somewhat harsh, their soft gray coloration absorbed the rays of the desert sun.
Canon EOS-1D X, EF100–400mm f/4.5–5.6L IS II USM lens, f/14 for 1/1600 second, ISO 1000

PAGE 16, BOTTOM: Demoiselle Cranes (*Grus virgo*), Jawai, Rajasthan, India
Startled cranes move en masse and start to take flight. Their dark, elegant necks create a bold curvilinear pattern.
Canon EOS-1D X, EF100–400mm f/4.5–5.6L IS II USM lens, f/14 for 1/1600 second, ISO 1000

PAGE 17: Demoiselle Cranes (*Grus virgo*), Jawai, Rajasthan, India
In flight cranes are supremely elegant, flying with their heads stretched straight forward on long necks and feet stretched behind on long legs.
Canon EOS-1D X, EF100–400mm f/4.5–5.6L IS II USM lens, f/13 for 1/4000 second, ISO 2000

PAGE 18: Red-Crowned Cranes (*Grus japonensis*), Hokkaido, Japan
Cleanly white against a cold blue sky, these revered and highly endangered cranes circle in for a landing. This small resident population of about 1,200 birds in Japan survives the icy winter by feeding at stations established by local conservationists.
Canon EOS-1Ds Mark III, EF500mm f/4L IS USM, f/16 for 1/500 second, ISO 400

PAGE 20: Steller's Sea-Eagle (*Haliaeetus pelagicus*), Hokkaido, Japan
Dark heavy raptors perch on jumbled sea ice waiting for handouts from local commercial fishermen.
Canon EOS 5D Mark III, EF70–200mm f/2.8L IS II USM lens, f/10 for 1/2000 second, ISO 800

PAGE 24: Red-Winged Blackbirds (*Agelaius phoeniceus*), Bosque del Apache National Wildlife Refuge, New Mexico, USA
Concealed in tall grass, a flock of four or five thousand blackbirds can be completely hidden until they are startled and burst into the air. The presence of predatory sharp-shinned hawks and merlins made them group even tighter. When threatened, the blackbirds appeared to become one bird, a flock of many bodies controlled by a single brain, flying in tight formation.
Nikon N90s, Nikkor 200–400mm zoom, f/4 for 1/60 second, Fujichrome Velvia

PAGES 26–27: Guanaco (*Lama guanicoe*), Torres del Paine National Park, Chile
Nearly the same color as the environment they inhabit, a herd of guanacos moves across the shrubby steppe.
Canon EOS 5D Mark III, EF500mm f/4L IS USM lens, f/16 for 1/400 second, ISO 400

PAGES 28–29: Caribou (*Rangifer tarandus*), Katmai National Park and Preserve, Alaska, USA
While flying along the shores of Bristol Bay, we spied this small herd of caribou moving across the tidal flats. Tracks and shadows lend depth and direction to this otherwise flat image.
Canon EOS-1D X, EF70–200mm f/4L IS USM lens, f/7.1 for 1/3200 second, ISO 4000

PAGES 30–31: Caribou (*Rangifer tarandus*), Arctic National Wildlife Refuge, Alaska, USA
Caribou gather on a patch of ice and snow to get some relief from the heat and flies that plague them in the short Arctic summer. This photo shoot was for the first season of my television show, *Art Wolfe's Travels to the Edge.*
Canon EOS-1Ds Mark II, 70.0–200.0 mm lens, F/2.8 for 1/4000 second, ISO 200

PAGES 32–33: Caribou (*Rangifer tarandus*), Brooks Range, Alaska, USA
Speed is a conceptual image. Capturing it successfully depends on experimentation. Here I have panned the camera sideways with the motion of the caribou.
Canon EOS-1Ds Mark II, EF70–200mm f/2.8 lens, f/22 for 1/20 second, ISO 200

PAGE 34: Dunlin (*Calidris alpina*), Skagit Flats, Washington, USA
I am always amazed by the flight of these tiny shorebirds, how they are able to shift direction en masse in a nanosecond. This image is a study in shape, texture, and tone: triangular wings, undulating water, and gradations of gray.
Canon EOS-1Ds Mark II, EF70–200 mm lens, f/8.0 for 1/250 second, ISO 800

PAGE 35: Western Sandpipers (*Calidris mauri*) | Dunlin (*Calidris alpina*), Bowerman Basin, Grays Harbor, Washington, USA
I crept within twenty feet of these birds, hoping to get better detail. The early morning sun cast a warm, rich light on the rusty backs of the sleeping flock.
Nikon N90s, Nikkor 135mm, f/16 for 1/30 second, Fujichrome 100

PAGES 36–37: Elk or Wapiti (*Cervus canadensis*), National Elk Range, Wyoming, USA
Long shadows cast by the low winter sun populated a snowy field with spectral images of elk. In an attempt to capture the longest shadows, I made arrangements to photograph from a helicopter just before sunset. Joined by a biologist, we were able to assess their behavior and maneuver around the herd without disturbing the animals.
80–200mm zoom, F/8 at 1/125 second, Fujichrome 50

PAGES 38–39: Snow Geese (*Anser caerulescens*), Skagit Valley, Washington, USA
One of my favorite subjects is the tens of thousands of snow geese that have migrated from Siberia and the North Slope down to the rich fields of the Skagit River Valley. The tilled fields offer a feast for these migrating birds, and you can see thousands of geese just a few feet away.
Canon EOS 5D Mark II, EF70–200mm f/4L IS USM +1.4x lens, f/13.0 for 1/400 second, ISO 400

PAGE 40: Snow Geese (*Anser caerulescens*), Skagit Valley, Washington, USA
One of the more familiar and recognizable wildlife migrations is that of geese. Their flight in V-formation reduces drag and increases efficiency and range. By systematic rotation, the birds flying at the front and tips of the V are able to avoid exhaustion.
Canon EOS-1Ds Mark II, EF500mm lens, f/8.0 for 1/640 second, ISO 100

PAGE 41: Snow Geese (*Anser caerulescens*), Skagit Valley, Washington, USA
Obliterating the sky in their masses, thousands of snow geese take flight at once. The eye is easily confused by the multiple layers of birds.
Canon EOS-1Ds Mark II, EF500mm lens, f/8.0 for 1/640 second, ISO 200

PAGES 44–45: Whooper Swans (*Cygnus cygnus*), Hokkaido, Japan
These swans are wild, spending most of the year in the Siberian Arctic before migrating to Japan. During the winter months, these much-loved birds are fed grain by the locals and they quickly lose their fear of people.
Canon EOS-1D X, EF70-200mm f/2.8L IS II USM lens, f/25.0 for 1/1000 second, ISO 1000

PAGES 46–47: Whooper Swans (*Cygnus cygnus*), Hokkaido, Japan
Steam coming off the lake makes for an ethereal early morning. These swans are overwintering in a mostly frozen lake; they congregate in areas warmed by hotsprings.
Canon EOS-1D X, EF70-200mm f/2.8L IS II USM lens, f/18.0 for 1/1000 second, ISO 1250

PAGE 48: Monarch Butterflies (*Danaus plexippus*), Mexico
Like many other images in this collection, this photograph was carefully planned before I arrived on location. Each fall thousands of monarch butterflies converge on a small patch of forest in the high mountains near Mexico City. Cloaked in metallic orange-and-yellow butterfly wings, the evergreen trees are transformed into a living landscape. Each afternoon as the temperature rose, the butterflies warmed up and began to flutter around. It was impossible to walk through this magical, stirring forest without being covered by butterflies.
Nikon N90s, Nikkor 200-400mm zoom lens, f/11 for 1/30 second, Fujichrome 100

PAGE 49: Ladybird Beetles (*Hippodamia convergens*), White Horse, Washington, USA
Standing on the craggy peaks of the Cascades, I was taken in by the vast panoramas. I glanced down to discover a tiny, thriving colony at my feet. Living cloisonné, ladybugs swarmed in the stony crevices.
Nikon F4, Nikkor 50mm macro lens, f/4 with flash, Fujichrome 100

PAGE 50: Indiana Bats (*Myotis sodalis*), Ozarks, Arkansas, USA
To get this shot, I crawled three-fourths of a mile on my knees with a backpack that scraped the cave ceiling. It was in the middle of winter and very cold. The cave opened up into a large chamber where approximately five thousand hibernating bats hung from the ceiling just five feet above the floor. I was allowed into the cave with biologist Michael Harvey, who conducts a census once every winter. Because the heat from our bodies could wake the tiny two-inch bats from their winter slumber, putting them at risk in the cold temperatures, we had to work fast. I was permitted to shoot only one roll of film in a ten-minute period. Dr. Harvey quickly counted the bats using a yardstick that he held near their heads, calculating three hundred bats per square foot. I photographed them with a macro lens and two flash units while bending backward under the low cave ceiling. I like this image because it takes awhile to realize that you are looking at little bat noses and mouths. It is such a tight shot that it becomes an abstract.
Nikon N90s, Nikkor 50mm macro lens, f/22 with flash, Fujichrome Velvia

PAGE 54: Sockeye Salmon (*Oncorhynchus nerka*), Katmai National Park and Preserve, Alaska, USA
Photographing through the surface of the water both distorts the shape of the fish and intensifies their blazing red bodies and jade green heads.
Canon EOS-1D X, EF200-400mm f/4L IS USM EXT lens, f/10.0 for 1/250 second, ISO 4000

PAGE 55: Sockeye Salmon (*Oncorhynchus nerka*), Wood River Lakes Region, Hansen Creek, Alaska, USA
Consulting the Department of Fisheries at the University of Washington, I determined that the best place in North America to find the brightest spawning salmon was Alaska. The water is the clearest, and the streams are narrow enough to cause the salmon to mass in great numbers. To capture the pattern of these colorful fish, I used a stepladder to gain a slightly different and higher perspective. The salmon formed a solid mass of fish as they struggled to squeeze past barriers created by logs and waterfalls.
Nikon F4, Nikkor 80-200mm zoom lens, f/11 for 1/30 second, Fujichrome 100

PAGES 56–57: Green Sea Turtle (*Chelonia mydas*), Mnemba Island, Tanzania
Braving air attacks from birds, the last of the year's hatchlings struggled across the sand to the sea. Lapping waves gentling ushered them into the marine environment, also fraught with danger for these tiny turtles. Mnemba Island is one of only two protected nesting sites for the endangered turtle in Zanzibar.
Canon EOS-1D X, EF24-70mm f/4L IS USM lens, f/10.0 for 1/1250 second, ISO 4000

PAGES 58–59: Long-Beaked Common Dolphins (*Delphinus c. capensis*), Sea of Cortez, Baja California, Mexico
Here, a school of hundreds of dolphins plays alongside our boat. This recreation lasted for well over an hour. The Sea of Cortes receives more sunlight than any other ocean on Earth, resulting in one of the world's richest marine environments.
Canon EOS-1Ds Mark III, EF70-200mm f/4L IS USM lens, f/5.6 for 1/1000 second, ISO 800

PAGE 60: Beluga Whales (*Delphinapterus leucas*), Somerset Island, Canadian Arctic
I made the arrangements with the Canadian Wildlife Department to fly above these beluga whales long before I departed for Canada. When the day arrived, we circled over the whales in a Twin Otter plane. The pilot skillfully slowed the aircraft to sixty miles per hour, allowing me to get this shot. Above the shoreline of Somerset Island in the Canadian Arctic, an aerial perspective confirmed the arrival of nearly two thousand whales, a number impossible to witness from sea level.
Nikon N90s, Nikkor 80-200mm zoom lens, f/4 for 1/250 second, Fujichrome 100

PAGE 61: Humpback Whales (*Megaptera novaeangliae*), Vava'u, Tonga
Tonga is one of the few places on Earth where you can actually swim with whales. The whales remain in the warm waters with their new calves until they gain enough weight to survive the migration back to Antarctica. While following them at a very respectable distance, I was able to see them disappear into the depths.
Canon EOS-1D X, EF16-35mm f/2.8L II USM lens, f/7.1 for 1/160 second, ISO 400

PAGE 64: Northern Gannets (*Morus bassanus*), Newfoundland, Canada
Similar to other birds that nest in colonies, northern gannets build their nests at beak's length apart. The nests are comfortable distanced, yet dense enough to allow the birds to thrive in the safety of numbers. This flock was nesting on a smooth plain hundreds of feet above the white-capped waters of the North Atlantic. Overcast conditions enhanced the contrast between the gannets' golden heads and stark white bodies.
Nikon F4, Nikkor 200-400mm zoom lens, f/16 for 1/25 second, Fujichrome 100

PAGE 66: Black-Browed Albatross (*Diomedea melanophrys*) | Rockhopper Penguins (*Eudyptes chrysocome*), Falkland Islands
Loathe to leave their vulnerable chicks unguarded, albatross parents perch atop their nests made of packed mud. Interspersed among the albatross, rockhopper penguins are dwarfed by the elevated network. Unlike many other albatross species of this region, the black-browed albatross nest close together. They remind me of flamingos in their ability to construct neat nests out of the surrounding mud. I could walk around the edge of the rookery without disturbing them.
Nikon N90s, Nikkor 200-400mm zoom lens, f/22 for 1/125 second, Fujichrome Velvia

PAGE 67: Black-Browed Albatross (*Diomedea melanophrys*), Falkland Islands
Remote Steeple Jason Island hosts the largest black-browed albatross rookery in the world.
Canon EOS-1Ds Mark II, EF70-200mm f/4L lens + 2x, f/64.0 for 1/4 second, ISO 400

PAGE 68: Marbled Godwit (*Limosa fedoa*), Western Willet (*Tringa semipalmata*), and Short-Billed Dowitcher (*Limnodromus griseus*), Laguna San Ignacio, Baja California, Mexico
This large flock of shorebirds was concentrated on the only beach left exposed by the high tide. I was able to situate myself on a hill above them, which enabled me to get all the birds in focus without having to use the smallest aperture settings. This was important because small aperture settings require longer exposures, which I wanted to avoid given the moving birds.
Canon EOS-3, EF400mm lens, f/11 for 1/30 second, Fujichrome Astia

PAGE 69: Elegant Terns (*Sterna elegans*), Isla de Rasa, Mexico
Filling the frame from corner to corner with terns displays the strong repetition of shapes throughout and illustrates how the pattern becomes the subject.
Nikon F4, Nikkor 80-200mm lens, f/22 for 1/15 second, Fujichrome Velvia

PAGES 70–71: Crab-Plover (*Dromas ardeola*), Mnemba Island, Tanzania
Running on stilt-like gray legs, crab-plovers search for prey in the surf.
Canon EOS-1D X, EF200-400mm f/4L IS USM EXT lens, f/36.0 for 1/640 second, ISO 4000

PAGE 73: White-Cheeked Terns (*Sterna repressa*), Mnemba Island, Tanzania
I just love how the light reflected off the white-sand beach and highlighted the undersides of these terns.
Canon EOS-1D X, EF100-400mm f/4.5-5.6L IS II USM lens, f/25.0 at 1/800 second, ISO 4000

PAGES 74–75: White-Cheeked Terns (*Sterna repressa*), Mnemba Island, Tanzania
Against the bright blue equitorial sky, raucous black-and-white terns slice through the sky.
Canon EOS-1D X, EF100-400mm f/4.5-5.6L IS II USM lens, f/25.0 at 1/1000 second, ISO 4000

PAGE 78: Northern Pintails (*Anas acuta*), Honshu, Japan
Normally frightened by people, these ducks overcome their fear during the harsh winter months to accept the presence of the Japanese farmers who feed them grain. The full light of midday details the texture and color of the birds.
Nikon F4, Nikkor 50mm macro lens, f/16 for 1/15 second, Fujichrome 100

PAGE 79: Bald Eagles (*Haliaeetus leucocephalus*), Southeast Alaska, USA
Every fall, up to 3,000 eagles congregate on the banks of the Chilkat River to feed on spawned-out salmon. Since bald eagles are typically portrayed in lofty solo flight or perched regally on high pinnacles, it was strange to see these symbols of nobility and strength grounded and hunkered over the last vestiges of dead fish. The clarity of the single eagle in the center magnifies the feeding frenzy of the other birds. (Digital composite)
Nikon N90s, Nikkor 200-400mm zoom lens, f/16 for 1/4 second, Fujichrome Velvia

PAGES 80–81: Harlequin Ducks (*Histrionicus histrionicus*), Iceland
These colorful ducks are so difficult to photograph; they move quickly, popping in and out of the surf, and their dark coloration camouflages them into obscurity.
Canon EOS 5DS R, EF200-400mm f/4L IS USM lens, f/13.0 for 1/500 second, ISO 1000

PAGES 82–83: Northern Elephant Seals (*Mirounga angustirostris*), Año Nuevo State Reserve, California, USA
The freshly molted silver-gray coats contrast beautifully with the chestnut tones of the faded coats from the previous year.
Hasselblad Xpan, Xpan 4/90mm lens, f/22 for 1/15 second, Fujichrome Velvia

PAGE 86: Pacific Walrus (*Odobenus rosmarus divergens*), Round Island, Alaska, USA
Round Island hosts this all-male beach party every summer. With no females present, these comical subjects drop their usual competitive guard and settle in. Working atop a high cliff, I utilized depth of field and perspective to allow the patterns of these large marine mammals to come forward. The overcast light emphasized their varying flesh tones.
Nikon F3, Nikkor 300mm 2.8 lens, f/11 for 1/15 second, Fujichrome 100

PAGE 87: Pacific Walrus (*Odobenus rosmarus divergens*), Walrus Islands State Game Sanctuary, Alaska, USA
While taking a long exploratory flight along the coast of Bristol Bay, we landed near a haul out of walrus. The Pacific walrus have larger tusks than their Atlantic cousins.
Canon EOS 5DS R, EF200-400mm f/4L IS USM EXT lens, f/10.0 for 1/160 second, ISO 400

PAGES 88: Eastern Pacific Harbor Seal (*Phoca vitulina richardii*), Bristol Bay, Alaska, USA
Bristol Bay is an incredibly productive marine sanctuary. Huge runs of salmon and other fisheries are at odds with oil and mineral development upriver from the bay.
Canon EOS-1D X, EF70-200mm f/4L IS USM lens, f/7.1 for 1/2500 second, ISO 4000

PAGE 89: Eastern Pacific Harbor Seal (*Phoca vitulina richardii*), Washington, USA
Tiny Gertrude Island in the southern Puget Sound is a haven for harbor seals. The spit is a favorite, and protected, haul out.
Canon EOS-1DS, 500.0 mm lens, f/18.0 for 1/80 second, ISO 200

PAGES 90–91: Cape Fur Seals (*Arctocephalus pusillus*), Cape Cross, Namibia
The seemingly lifeless landscape of the Namibian coast abuts the cold waters of the South Atlantic, which is teeming with marine life. The stark contrast between the two is abrupt. The water is very cold, the landscape very hot. On the thin margin between the two, nearly one hundred thousand Cape fur seals congregate. My goal was to convey the pattern and density created by these beached seals. The trick was to capture as many seals in focus as I possibly could without sacrificing the sense of scale.
Nikon N90s, Nikkor 80-200mm zoom lens, f/22 for 1/15 second, Fujichrome

PAGES 92–93: Emperor Penguins (*Aptenodytes forsteri*), Halley Bay, Antarctica
These penguins were nesting on frozen sea ice on top of a glacier in early November. I climbed up through the glacier to the top of a 300-foot ice cliff in order to get an aerial view of the birds.
Nikon N90s, Nikkor 200-400mm zoom lens, f/11 for 1/15 second, Fujichrome Velvia

PAGES 94–95: Adélie Penguins (*Pygoscelis adeliae*), Paulet Island, Antarctica
It's rush hour in the Antarctic as hundreds of tuxedoed penguins race for the sea.
Canon EOS-1Ds Mark II, EF70-200mm lens, f/10.0 for 1/500 second, ISO 500

PAGES 98: King Penguins (*Aptenodytes patagonicus*), South Georgia Island
I have countless shots like this in both my analog and digital files, but none as sharp from top to bottom as this photographed with a Leica.
LEICA S, Apo-Elmar-S 180 CS lens, f/8.0 for 1/15 second, ISO 100

PAGE 99, TOP: King Penguins (*Aptenodytes patagonicus*), South Georgia Island
It takes fourteen to sixteen months for king penguin chicks to mature enough to go to sea.
Canon EOS-1D X, EF200-400mm f/4L IS USM lens, f/25.0 for 1/80 second, ISO 1250

PAGE 99, ABOVE: King Penguins (*Aptenodytes patagonicus*), South Georgia Island
Far more comfortable in water than on land, king penguins bob about in the surf close to shore.
Canon EOS-1D X, EF200-400mm f/4L IS USM EXT lens, f/16.0 for 1/2500 second, ISO 4000

PAGES 100–101: King Penguins (*Aptenodytes patagonicus*), South Georgia Island
King penguin colonies are continuously occupied, as the breeding cycle is so long. The juveniles gather together in a crèche guarded by a few adult birds. The blue water beyond adds depth.
Canon EOS-1D X, EF200-400mm f/4L IS USM lens, f/22.0 for 1/500 second, ISO 4000

PAGE 102: Thick-Billed Murre (*Uria lumvia*), Svalbard, Norway
Every year murre pairs lay their single egg directly on bare rock.
Canon EOS-1D X, EF200-400mm f/4L IS USM lens, f/11.0 for 1/1000 second, ISO 2000

PAGE 103: Thick-Billed Murre (*Uria lumvia*), Svalbard, Norway
I am amazed at the habitat that these birds call home. The narrow ledges on precipitous cliffs are obviously comfortable for them and no one else.
Canon EOS-1D X, EF200-400mm f/4L IS USM EXT lens, f/13.0 for 1/1250 second, ISO 2000

PAGES 104–105: Thick-Billed Murre (*Uria lumvia*), Svalbard, Norway
The granite cliffs of Svalbard were carved by glaciers out of a plateau over the course of repeated ice ages. Now every fissure, crack, ledge, and outcrop is occupied by birds.
Canon EOS-1D X, EF200-400mm f/4L IS USM lens, f/11.0 for 1/1250 second, ISO 2000

PAGE 106: Little Auks (*Alle alle*), Svalbard, Norway
A whirring overhead announced the flyby of hundreds of little auks. Their short wings beat fast to keep them aloft. In winter storms they have been blown as far south as the Caribbean.
Canon EOS-1D X, EF200-400mm f/4L IS USM EXT +2x III lens, f/14.0 for 1/6400 second, ISO 4000

PAGES 108–109: Greater Sandhill Cranes (*Grus canadensis*), Bosque del Apache National Wildlife Refuge, New Mexico, USA
In the Rio Grande Valley fields of grain are left unharvested to ensure ample feed for thousands of hungry migrants.
Canon EOS-1Ds Mark III, EF500mm f/4L IS USM +1.4x lens, f/20.0 for 1/320 second, ISO 400

PAGES 111: Greater Sandhill Cranes (*Grus canadensis*), Bosque del Apache National Wildlife Refuge, New Mexico, USA
As the Rio Grande was tapped, dammed, and diverted, the natural wetlands dried up, and as the water disappeared, so did the wildlife. After years of habitat restoration by the Civilian Conservation Corps, the refuge at Bosque del Apache was established in 1939. It is a tremendous place to enjoy wildlife.
Canon EOS-1Ds Mark III, EF500mm f/4L IS USM lens, f/32 for 1.6 second, ISO 400

PAGE 112–113: Springbok (*Antidorcas marsupialis*), Etosha National Park, Namibia
A herd of springbok huddles in the shade of a thorn acacia. The shadows cast by the shrubby tree add to the overall confusion of horns, stripes, legs, and branches.
Canon EOS-1D X, EF70-200mm f/2.8L IS II USM lens, F/7.1 for 1/2500 second, ISO 400

PAGES 114–115: Reticulated Giraffes (*Giraffa c. reticulata*), Laikipia, Kenya
Six giraffes browse the thorn acacia in central Kenya's scrublands. Late afternoon light combined with an aerial perspective add to the graphic appeal of this image.
Canon EOS 5D, EF70-200mm f/2.8L IS USM, F/2.8 for 1/2000 seconds, ISO 400

PAGES 116–117: Reticulated and Masai Giraffes (*Giraffa c. reticulata* and *Giraffa c. tippelskirchi*), Serengeti National Park, Tanzania
With their long legs and neck and very short body, giraffes on the move can appear rather ungainly. But they are fast, running up to thirty-five miles an hour.
Canon EOS-1D X, EF70-200mm f/4L IS USM lens, F/5.6 for 1/2500 seconds, ISO 2500

PAGE 118: Plains Zebras (*Equus quagga boehmi*), Masai Mara National Reserve, Kenya
Designed to confuse a charging predator, the dramatic black-and-white stripes of the zebra herd produce an optical illusion. Whereas the dark-colored wildebeest stand out against the vegetation, an entire herd of zebras can disappear in the cryptic confusion of light and dark. From a distance, their black-and-white stripes turn to gray as they vanish in a wavy mirage at the horizon. The play of shape, line, and texture allows the art of the animals to come forward, and the image becomes less a herd of zebras than a movement of lines. (Digital composite)
Nikon N90s, Nikkor 200-400mm lens, f/16 for 1/160 second, Fujichrome Velvia

PAGE 119: Plains Zebras (*Equus quagga boehmi*), Serengeti National Park, Tanzania
Having spent much of my career trying to shoot the sharpest, most well-defined photographs, the technique of shooting impressionistically is refreshing. I made this image by panning along with the zebras, which blurs the fore- and background and highlights the motion.
Nikon F4, Nikkor 200-400mm lens, f/13 for 1/40 second, Fujichrome Velvia

PAGES 120–121: Plains Zebras (*Equus quagga*) | Eastern White-Bearded Wildebeest (*Connochaetes taurinus albojubatus*), Masai Mara National Reserve, Kenya
East Africa's open savannah hosts the largest terrestrial migration remaining on the planet. When seasonal grass flourishes, great nomadic herds of zebra and wildebeest commute from Tanzania to Kenya.
Canon EOS-1Ds Mark II, 500mm lens, F/22 for 1/50 seconds, ISO 400

PAGES 122–123: Burchell's Zebras (*Equus burchelli*) | Eastern White-Bearded Wildebeest (*Connochaetes taurinus albojubatus*), Amboseli National Park, Kenya
North of Kilimanjaro, the swamps of Amboseli offer some of the finest wildlife viewing in the world. The best times to photograph are at the margins of the day, so I am often up before sunrise and out until after sunset. This solitary line of wildebeest moves in the orange glow of a summer sunrise.
Nikon F3, Nikkor 200-400mm lens, f/11 for 1/125 second, Kodak Ektachrome

PAGE 126: Eastern White-Bearded Wildebeest (*Connochaetes taurinus albojubatus*), Masai Mara National Reserve, Kenya
There are very few places in the world where you can see hundreds of thousands of animals moving together at once. When each animal is the size of a wildebeest, the biomass is quite impressive.
Nikon N90s, Nikkor 800mm lens, f/16 for 1/15 second, Fujichrome Velvia

PAGES 128–129: Eastern White-Bearded Wildebeest (*Connochaetes taurinus albojubatus*), Masai Mara National Reserve, Kenya
An intrepid spur-winged plover holds its ground amidst a herd of wildebeest. It is undoubtedly dining on insects and other invertebrates churned by the thousands of hooves.
Canon EOS-1Ds Mark II, 500mm lens, F/7.1 for 1/150 second, ISO 125

PAGE 130: Eastern White-Bearded Wildebeest (*Connochaetes taurinus albojubatus*), Masai Mara National Reserve, Kenya
Deathly afraid of crocodiles lurking in the water, wildebeest hover on the banks and finally take the plunge into the Mara River.
Nikon N90s, Nikkor 200-400mm lens, f/11 for 1/250 second, Fujichrome Velvia

PAGE 131: Eastern White-Bearded Wildebeest (*Connochaetes taurinus albojubatus*), Masai Mara National Reserve, Kenya

This scene was photographed from a high bank on the opposite side of the Mara River.
Canon EOS-1N, EF600mm lens, f/11 for 1/250 second, Fujichrome Astia

PAGES 132–133: Eastern White-Bearded Wildebeest (*Connochaetes taurinus albojubatus*) | Plains Zebra (*Equus quagga boehmi*), Masai Mara National Reserve, Kenya
The lone Plains zebra engulfed by a sea of moving wildebeests caught my attention. I waited for the confused zebra to turn into the herd, and I framed it off-center to add a sense of tension.
Nikon N90S, Nikkor 600mm lens, f/16 for 1/30 second, Fujichrome Velvia

PAGES 134–135: Eastern White-Bearded Wildebeest (*Connochaetes taurinus albojubatus*), Ngorongoro Conservation Area, Tanzania
Early in the wet season the grass is already green in the vast Ngorongoro Crater, which is on the eastern side of the Serengeti. About 20 percent of the wildebeest migrate from the crater to the plains at this time of year.
Canon EOS-1Ds Mark III, EF70-200mm f/4L USM lens, F/20 for 1/80 seconds, ISO 500

PAGES 136–137: Eastern White-Bearded Wildebeest (*Connochaetes taurinus albojubatus*), Serengeti National Park, Tanzania
An aerial perspective offers a wider view of the dispersal of a wildebeest herd during the wet season.
Canon EOS-1D X, EF70-200mm f/4L IS USM lens, F/4 for 1/1600 seconds, ISO 2500

PAGES 138–139: African Elephants (*Loxodonta africana*), Mashatu Game Reserve, Botswana
When it comes to elephants, size matters. They require a massive habitat in which to live, and Mashatu has 72,000 acres of pristine game refuge.
Canon EOS-1D X, EF70-200mm f/2.8L IS II USM lens, f/16 for 1/160 second, ISO 4000

PAGES 140–141: African Elephants (*Loxodonta africana*), Mashatu Game Reserve, Botswana
As elephants move toward a waterhole they are side-lit by the sun. All but one of the elephants is on a well-worn path; they are creatures of habit and quite predictable. They will follow the same path at the same time of day.
Canon EOS 5D Mark III, EF200-400mm f/4L IS USM EXT lens, F/13 for 1/200 seconds, ISO 1600

PAGE 142: African Elephants (*Loxodonta africana*), Amboseli National Park, Kenya
As this herd of elephants walked by, I panned my camera, stopping this herd's migration for a moment on film.
Canon EOS-1N, EF600mm lens, F/4 for 1/250 second, Fujichrome Velvia

PAGE 143: African Elephants (*Loxodonta africana*), Amboseli National Park, Kenya
Every morning this same herd emerged from the forest to drink and bathe in a nearby watercourse. You are never more aware of how fast elephants can move as when they are coming straight at you and you have a smaller lens.
Canon EOS-1N/RS, EF70-200mm lens, f/11 for 1/125 second, Fujichrome Provia

PAGE 144: Cape Buffalo (*Syncerus caffer caffer*), Okavango Delta, Botswana
The Okavango is one of the world's great wetlands, pulsing with life amidst the great Kalahari Desert.
Canon EOS-1D X, EF70-200mm f/2.8L IS II USM lens, f/16 for 1/320 second, ISO 2000

PAGE 145: Cape Buffalo (*Syncerus caffer caffer*), Amboseli National Park, Kenya
From the outset of this project, I visualized an image such as this one, capturing the force, power, and primeval drive of wildlife. Flying above the park in a microlight aircraft, we were thrilled to happen upon this stampeding herd, thundering across the dusty expanse of the Amboseli plain.
Nikon F3, Nikkor 80-200mm zoom lens, f/2.8 for 1/500 second, Fujichrome 100

PAGES 146–147: Cape Buffalo (*Syncerus caffer caffer*), Londolozi Private Game Reserve, South Africa
Adjacent to Kruger National Park, Londolozi was a pioneer in the ecotourism industry in South Africa. Eastablished in 1926, hunting was ended on the reserve in 1971.
Nikon F3, Nikkor 80-200mm zoom lens, f/2.8 for 1/500 second, Fujichrome 100

PAGE 148: Pacific Double-Saddle Butterflyfish (*Chaetodon ulietensis*), Bora Bora, French Polynesia
I was captivated by the brilliance of the myriad fish that live in these tropical waters. Suspended in the crystal sea, the butterflyfish hovered in layered symmetry.
Nikon N90s, Nikonos 20mm lens, f/5.6 for 1/125 second, Fujichrome Velvia Film

PAGE 149: Piraputanga (*Brycon hilarii*), Mato Grosso do Sul, Brazil
Using a polarizer I was able to capture the symmetrical beauty of these fish photographing above the surface of the water.
Canon EOS 5D Mark III, EF70-200mm f/2.8L IS II USM lens, F/5.6 for 1/200 seconds, ISO 800

PAGES 152–153: Scarlet Ibis (*Eudocimus ruber*), Para State, Brazil
Scarlet ibis are waders and inhabit tropical South America and Caribbean islands. We camped for a night in stilted fishermen's huts in the Amazon River nearby a mangrove island where this population of ibises lived.
Canon EOS-1D X, EF500mm f/4L IS USM +1.4x lens, F/7.1 for 1/320 second, ISO 400

PAGES 154–155: Lesser Flamingos (*Phoenicopterus minor*), Lake Natron, Tanzania
I never grow tired of photographing flamingos over the glassy lakes of the Rift Valley. Accompanied by their shadows, a flock of flamingos skims the surface of Lake Natron.
Canon EOS-1D X, EF24-70mm f/4L IS USM lens, F/5.6 for 1/1000 second, ISO 1000

PAGES 156–157: Lesser Flamingos (*Phoenicopterus minor*), Lake Naivasha, Rift Valley, Kenya
Lake Naivasha differs from other lakes of the Rift Valley in that it is freshwater. Not only is it home to over a hundred species of birds, it also has a sizeable hippo population.
Canon EOS-1Ds Mark II, 400mm zoom, F/36 for 1/160 second, ISO 400

PAGE 159: Lesser Flamingos (*Phoenicopterus minor*), Lake Natron, Tanzania
Flamingos migrate up and down the Rift Valley as the water levels change, creating dramatic, visual patterns as they fly en masse. This was shot from a microlight in the cool calm of an early morning. It is impossible to fly in a microlight later in the day—as the ground temperature rises so does thermal turbulence which makes for dangerous conditions.
Canon EOS-1D X, EF24-70mm f/4L IS USM lens, F/5.6 for 1/800 second, ISO 1000

PAGE 160: Blue-Headed Parrot (*Pionus menstruus*), Manú National Park, Peru
A flock of parrots cling to vertical clay cliffs that line the Manú River in Peru's Amazin Basin. The noisy, foot-tall parrots congregate each morning to nibble minerals embedded in the clay. The minerals counter toxins the birds ingest when eating certain nuts and fruits included in their diet.
Canon EOS-1Ds Mark II, EF400mm lens, F/8 for 1/200 second, ISO 400

EARTH AWARE
EDITIONS
PO Box 3088
San Rafael, CA 94912
www.earthawareeditions.com

Find us on Facebook: www.facebook.com/InsightEditions
Follow us on Twitter: @insighteditions

Library of Congress Cataloging-in-Publication Data available.

ISBN: 978-1-60887-714-0

PUBLISHER: Raoul Goff
ACQUISITIONS MANAGER: Robbie Schmidt
ART DIRECTOR: Chrissy Kwasnik
DESIGNER: Jenelle Wagner
EXECUTIVE EDITOR: Vanessa Lopez
PROJECT EDITOR: Greg Solano
PRODUCTION EDITOR: Rachel Anderson
PRODUCTION MANAGER: Blake Mitchum
EDITORIAL ASSISTANT: Warren Buchanan

ROOTS of PEACE REPLANTED PAPER

Insight Editions, in association with Roots of Peace, will plant two trees for each tree used in the manufacturing of this book. Roots of Peace is an internationally renowned humanitarian organization dedicated to eradicating land mines worldwide and converting war-torn lands into productive farms and wildlife habitats. Roots of Peace will plant two million fruit and nut trees in Afghanistan and provide farmers there with the skills and support necessary for sustainable land use.

Manufactured in China by Insight Editions

10 9 8 7 6 5 4 3 2 1